UNFLATTENING

Nick Sousanis

UNFLATTENING

Harvard University Press

CAMBRIDGE, MASSACHUSETTS · LONDON, ENGLAND · 2015

Library of Congress Cataloging-in-Publication Data

Sousanis, Nick.

Unflattening / Nick Sousanis.

pages cm

Includes bibliographical references.

ISBN 978-0-674-74443-1 (pbk. : alk. paper)

1. Visual perception—Comic books, strips, etc. 2. Knowledge, Theory of—

Comic books, strips, etc. 3. Imagery (Psychology)—Comic books, strips, etc.

4. Communication—Methodology—Comic books, strips, etc. 5. Graphic novels.

I. Title.

BF241.S645 2015

153.7—dc23 2014042019

DEDICATION

For Rosalie Anne Goodbear Sousanis and all the possibilities that
lie ahead for her . . .

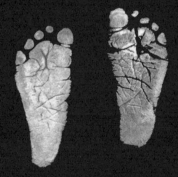

CONTENTS

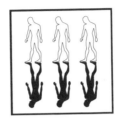

UNFLATTENING

one

FLATNESS

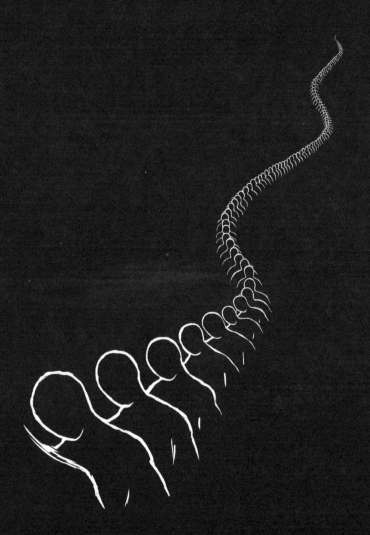

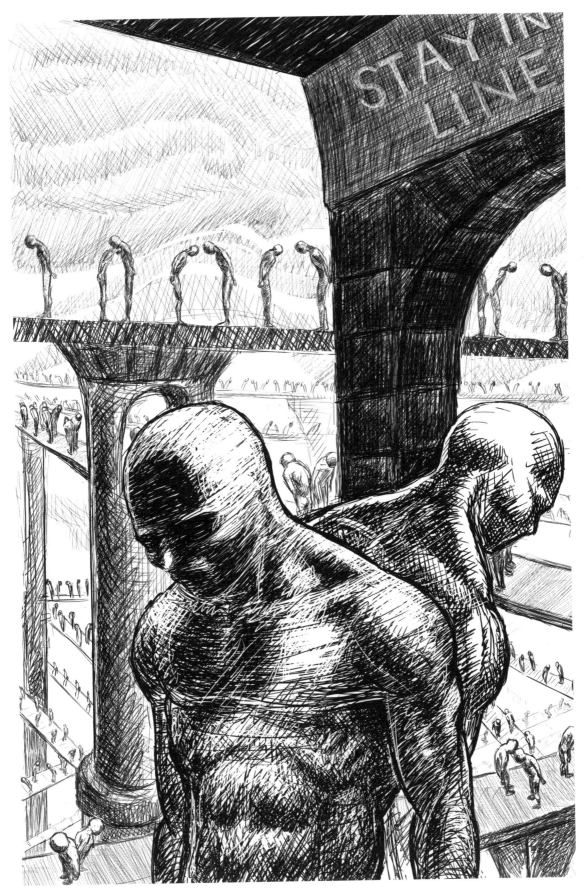

3

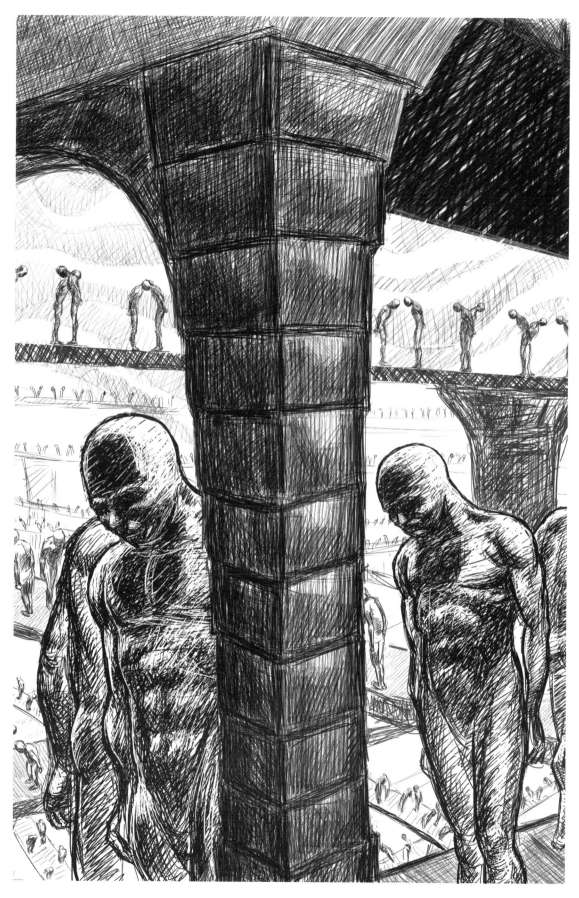

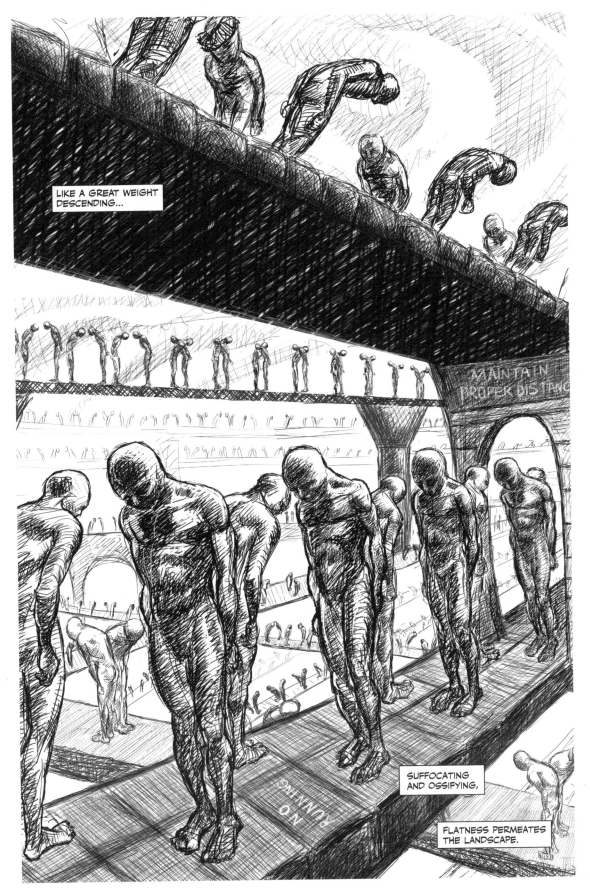

5

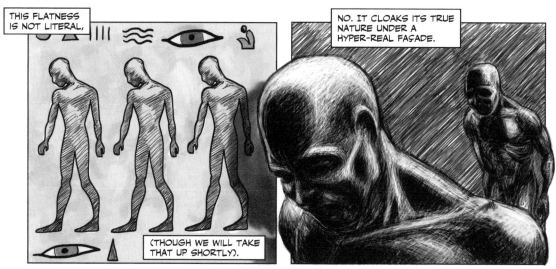

THIS FLATNESS IS NOT LITERAL,

(THOUGH WE WILL TAKE THAT UP SHORTLY).

NO. IT CLOAKS ITS TRUE NATURE UNDER A HYPER-REAL FAÇADE.

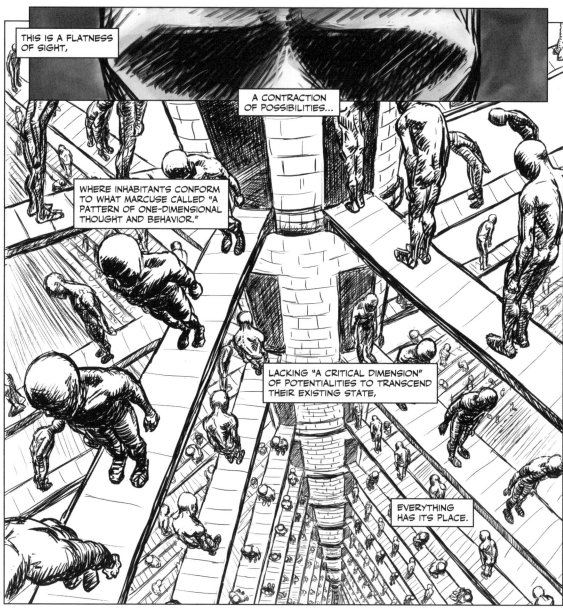

THIS IS A FLATNESS OF SIGHT,

A CONTRACTION OF POSSIBILITIES...

WHERE INHABITANTS CONFORM TO WHAT MARCUSE CALLED "A PATTERN OF ONE-DIMENSIONAL THOUGHT AND BEHAVIOR."

LACKING "A CRITICAL DIMENSION" OF POTENTIALITIES TO TRANSCEND THEIR EXISTING STATE,

EVERYTHING HAS ITS PLACE.

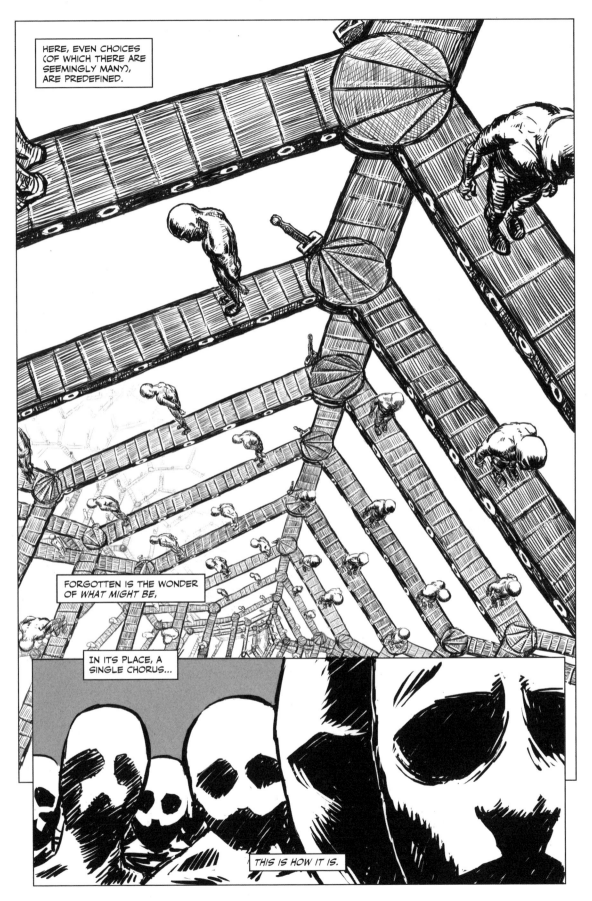

HERE, EVEN CHOICES (OF WHICH THERE ARE SEEMINGLY MANY), ARE PREDEFINED.

FORGOTTEN IS THE WONDER OF *WHAT MIGHT BE,*

IN ITS PLACE, A SINGLE CHORUS...

THIS IS HOW IT IS.

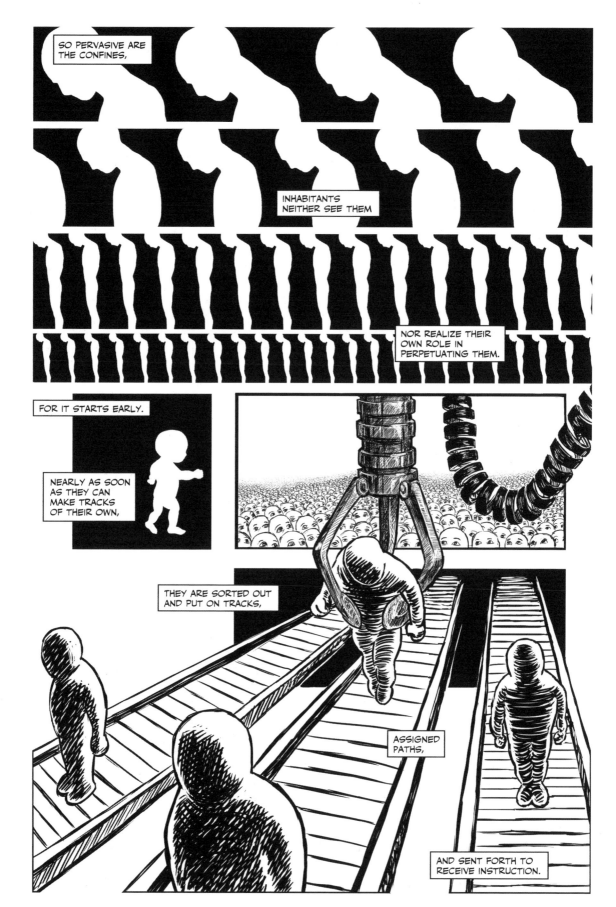

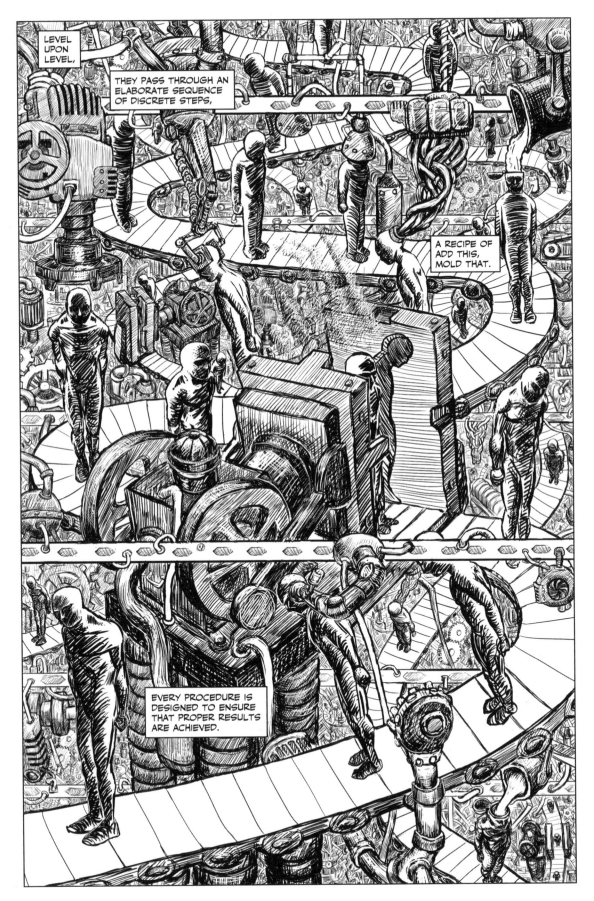

LEVEL UPON LEVEL,

THEY PASS THROUGH AN ELABORATE SEQUENCE OF DISCRETE STEPS,

A RECIPE OF ADD THIS, MOLD THAT.

EVERY PROCEDURE IS DESIGNED TO ENSURE THAT PROPER RESULTS ARE ACHIEVED.

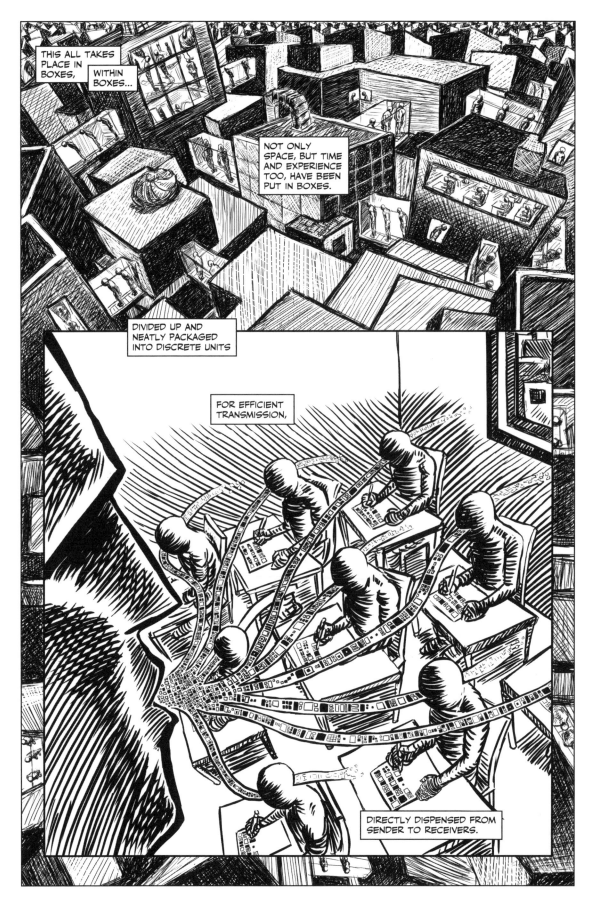

10

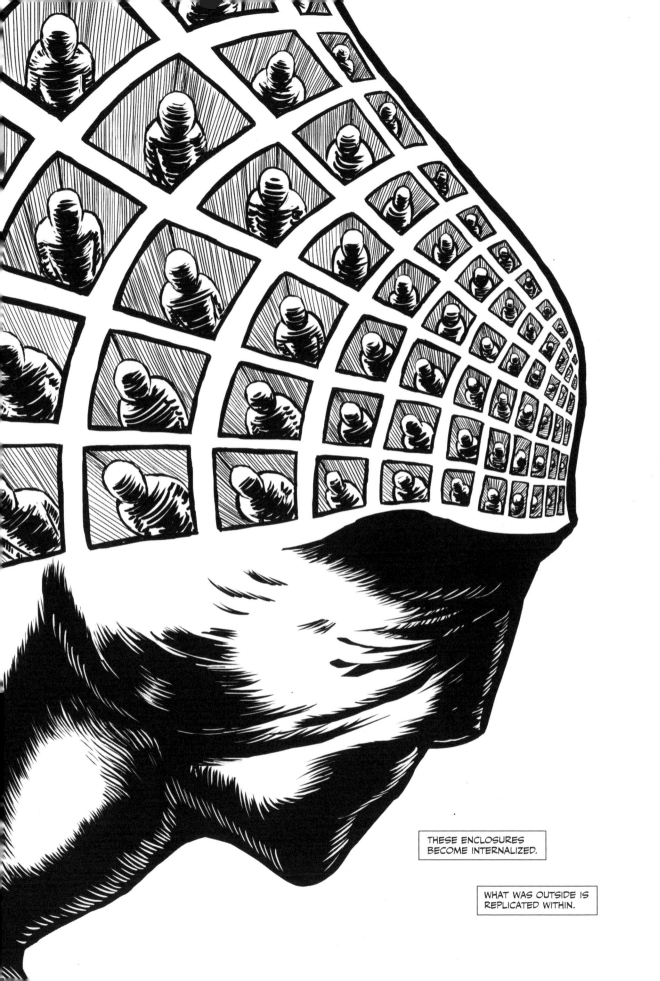

THESE ENCLOSURES
BECOME INTERNALIZED.

WHAT WAS OUTSIDE IS
REPLICATED WITHIN.

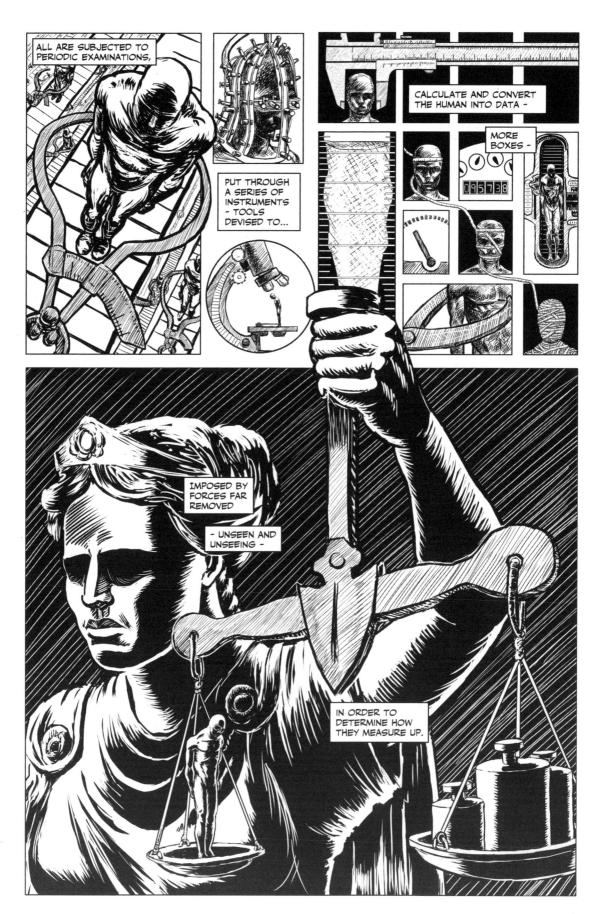

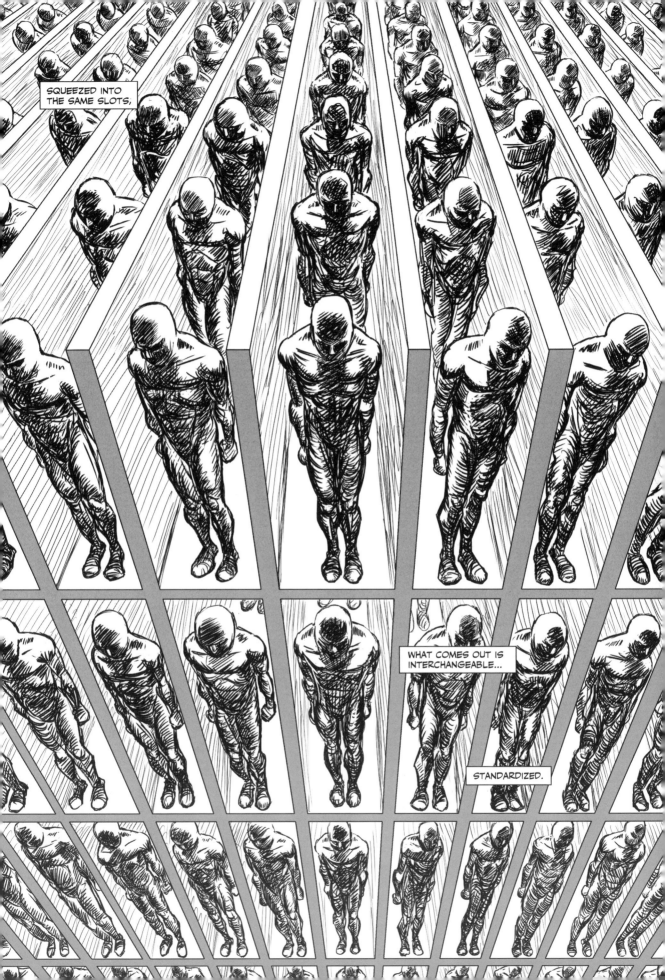

THIS CREATURE, WHO ONCE ATTEMPTED TO DEFINE THE UNIVERSE THROUGH ITS OWN PROPORTIONS,

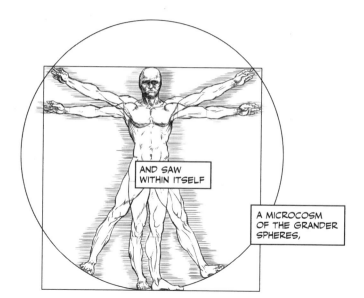

AND SAW WITHIN ITSELF

A MICROCOSM OF THE GRANDER SPHERES,

NOW FINDS ITSELF CONFINED,

BOXED INTO BUBBLES OF ITS OWN MAKING...

ROW UPON ROW...

UPON ROW.

THOUGHT AND BEHAVIOR...

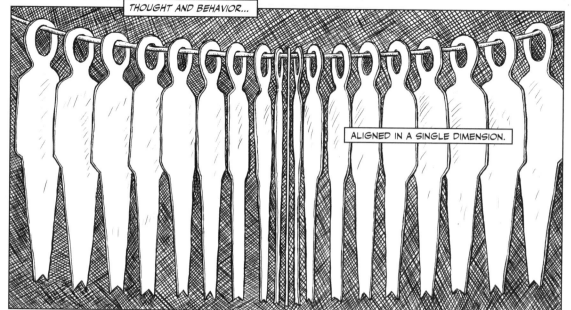

ALIGNED IN A SINGLE DIMENSION.

14

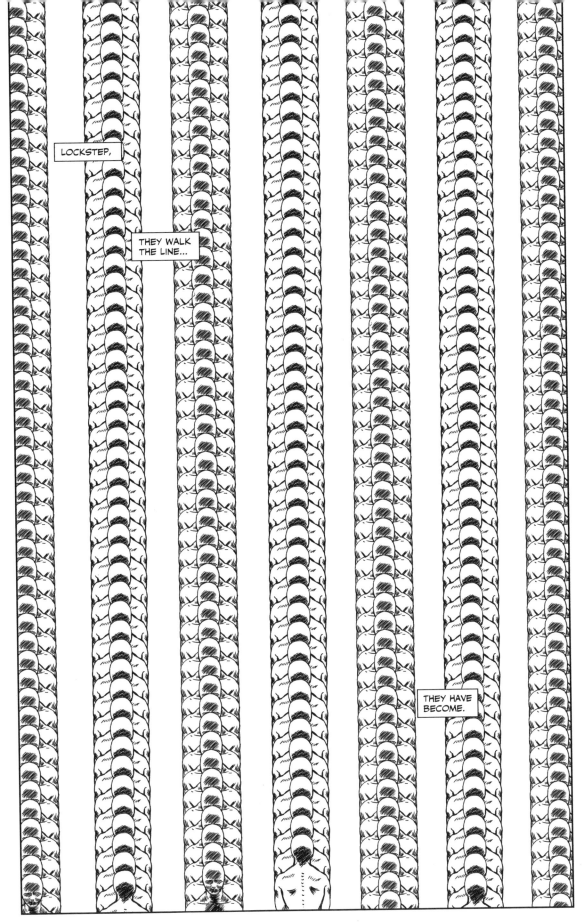

WHAT HAD FIRST OPENED
ITS EYES WIDE –

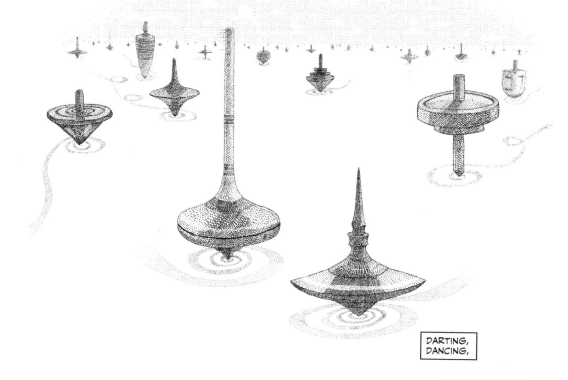

DARTING,
DANCING,

ANIMATED AND
TEEMING WITH
POSSIBILITIES –

HAS NOW BECOME
SHUTTERED,

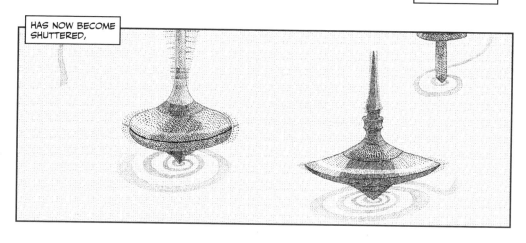

ITS VISION,
NARROWED.

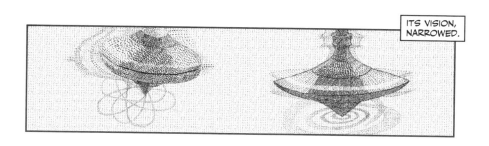

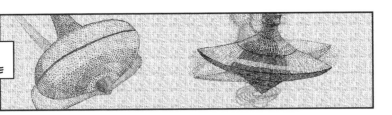

THE POTENTIAL ENERGY IN THIS DYNAMIC CREATURE

CURTAILED,

NEVER SET IN MOTION

LEAVING ONLY FLATNESS.

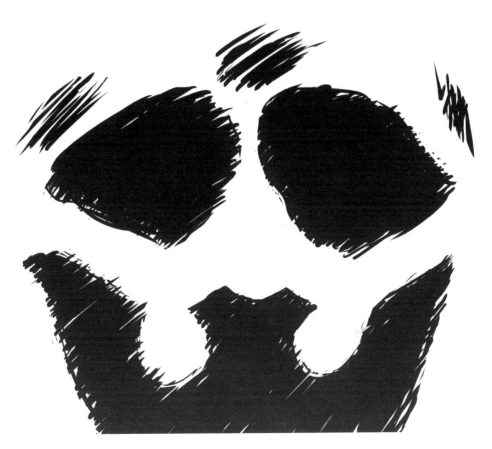

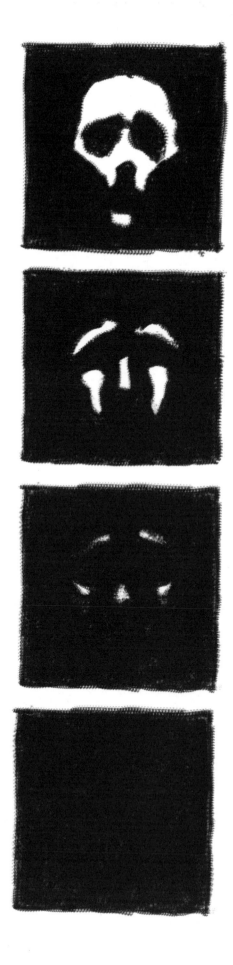

interlude

FLATLAND

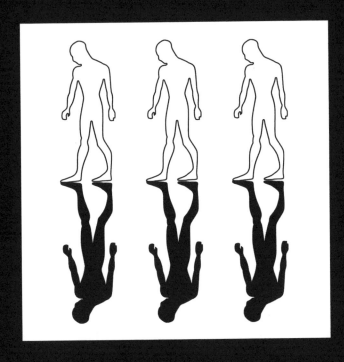

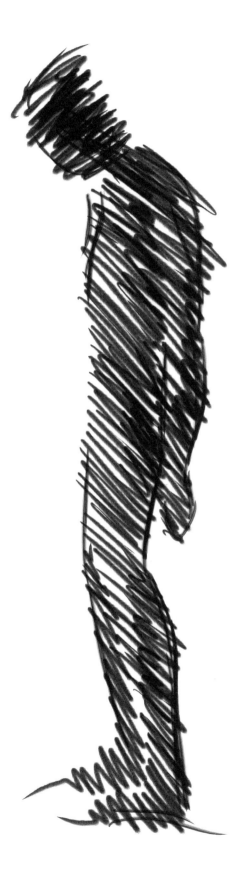

HAVING BEEN, AS MARCUSE PUT IT, "REDUCED TO THE TERMS OF THIS UNIVERSE,"

THEY EXIST AS NO MORE THAN SHADES, INSUBSTANTIAL AND WITHOUT AGENCY.

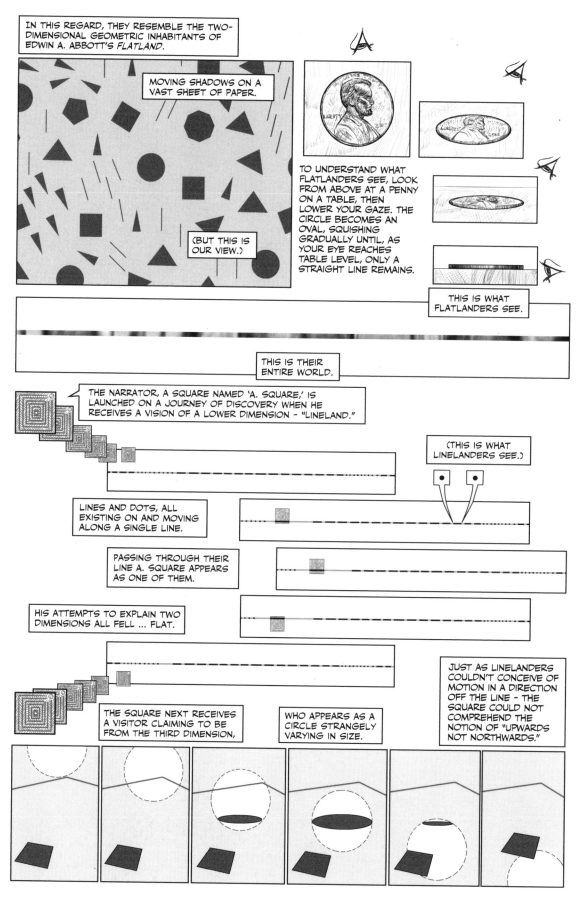

IN THIS REGARD, THEY RESEMBLE THE TWO-DIMENSIONAL GEOMETRIC INHABITANTS OF EDWIN A. ABBOTT'S *FLATLAND*.

MOVING SHADOWS ON A VAST SHEET OF PAPER.

(BUT THIS IS OUR VIEW.)

TO UNDERSTAND WHAT FLATLANDERS SEE, LOOK FROM ABOVE AT A PENNY ON A TABLE, THEN LOWER YOUR GAZE. THE CIRCLE BECOMES AN OVAL, SQUISHING GRADUALLY UNTIL, AS YOUR EYE REACHES TABLE LEVEL, ONLY A STRAIGHT LINE REMAINS.

THIS IS WHAT FLATLANDERS SEE.

THIS IS THEIR ENTIRE WORLD.

THE NARRATOR, A SQUARE NAMED 'A. SQUARE,' IS LAUNCHED ON A JOURNEY OF DISCOVERY WHEN HE RECEIVES A VISION OF A LOWER DIMENSION – "LINELAND."

(THIS IS WHAT LINELANDERS SEE.)

LINES AND DOTS, ALL EXISTING ON AND MOVING ALONG A SINGLE LINE.

PASSING THROUGH THEIR LINE A. SQUARE APPEARS AS ONE OF THEM.

HIS ATTEMPTS TO EXPLAIN TWO DIMENSIONS ALL FELL ... FLAT.

JUST AS LINELANDERS COULDN'T CONCEIVE OF MOTION IN A DIRECTION OFF THE LINE – THE SQUARE COULD NOT COMPREHEND THE NOTION OF "UPWARDS NOT NORTHWARDS."

THE SQUARE NEXT RECEIVES A VISITOR CLAIMING TO BE FROM THE THIRD DIMENSION,

WHO APPEARS AS A CIRCLE STRANGELY VARYING IN SIZE.

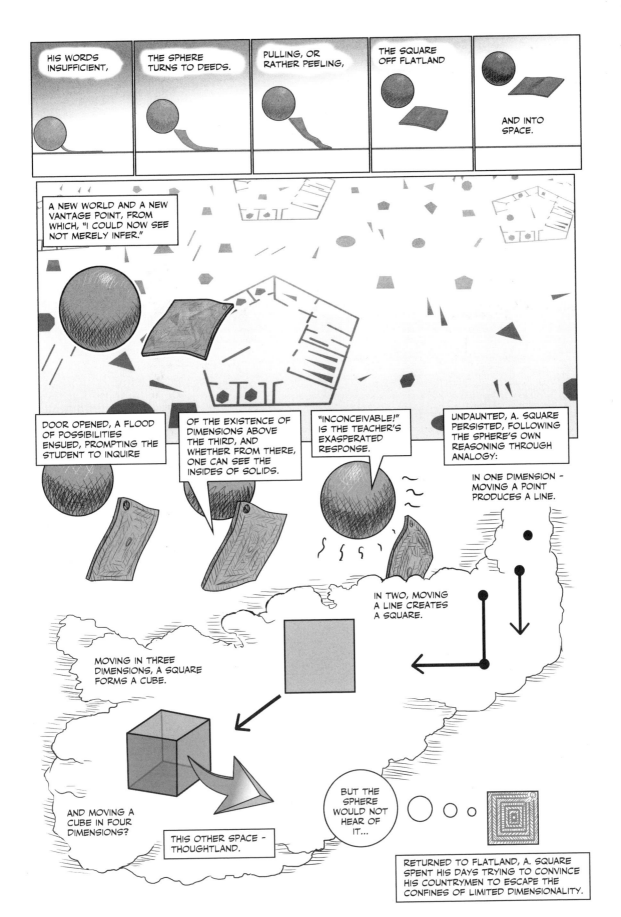

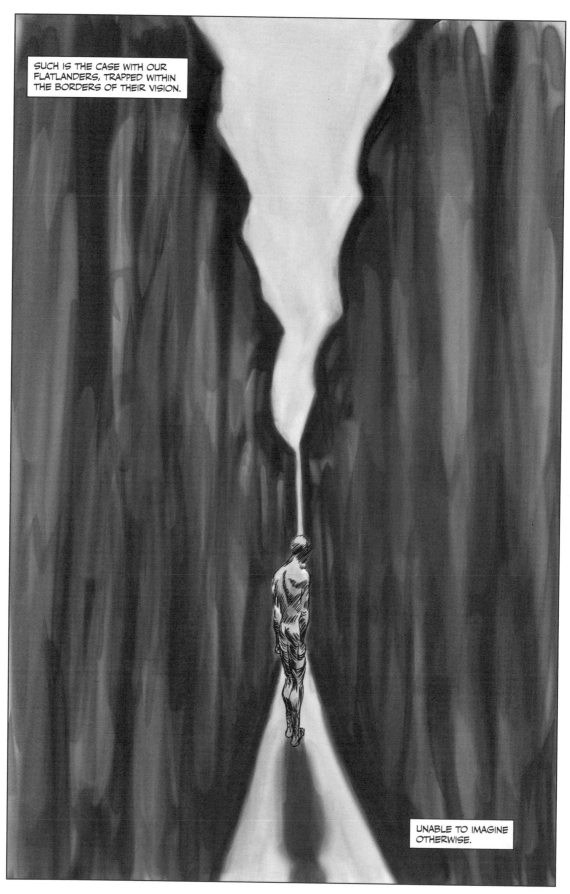

SUCH IS THE CASE WITH OUR FLATLANDERS, TRAPPED WITHIN THE BORDERS OF THEIR VISION.

UNABLE TO IMAGINE OTHERWISE.

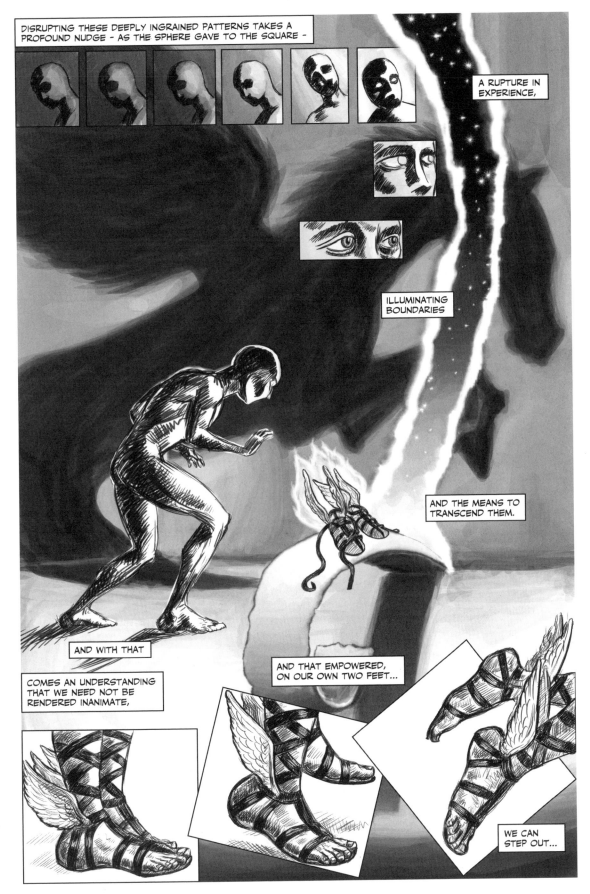

DISRUPTING THESE DEEPLY INGRAINED PATTERNS TAKES A PROFOUND NUDGE - AS THE SPHERE GAVE TO THE SQUARE -

A RUPTURE IN EXPERIENCE,

ILLUMINATING BOUNDARIES

AND THE MEANS TO TRANSCEND THEM.

AND WITH THAT

COMES AN UNDERSTANDING THAT WE NEED NOT BE RENDERED INANIMATE,

AND THAT EMPOWERED, ON OUR OWN TWO FEET...

WE CAN STEP OUT...

AND LOOK
ANEW.

ITALO CALVINO WROTE, "WHENEVER HUMANITY SEEMS
CONDEMNED TO HEAVINESS, I THINK I SHOULD FLY LIKE
PERSEUS INTO A DIFFERENT SPACE. I DON'T MEAN ESCAPING
INTO DREAMS OR INTO THE IRRATIONAL. I MEAN THAT I HAVE
TO CHANGE MY APPROACH, LOOK AT THE WORLD FROM A
DIFFERENT PERSPECTIVE, WITH A DIFFERENT LOGIC AND WITH
FRESH METHODS OF COGNITION AND VERIFICATION."

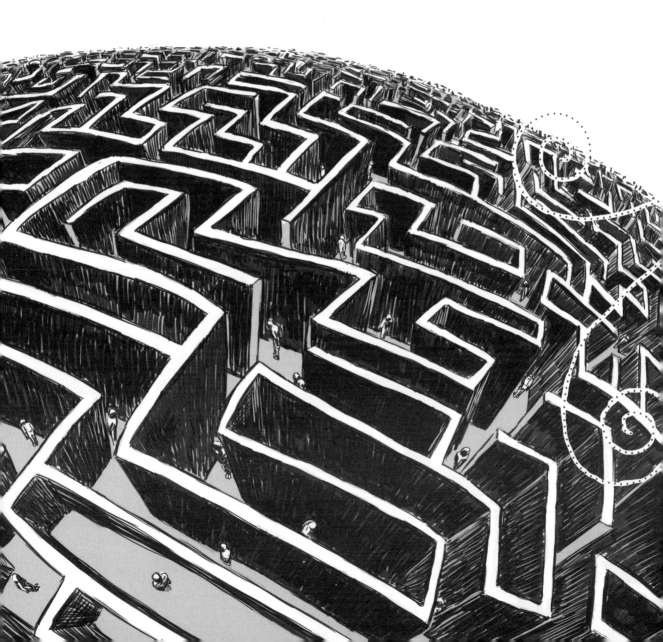

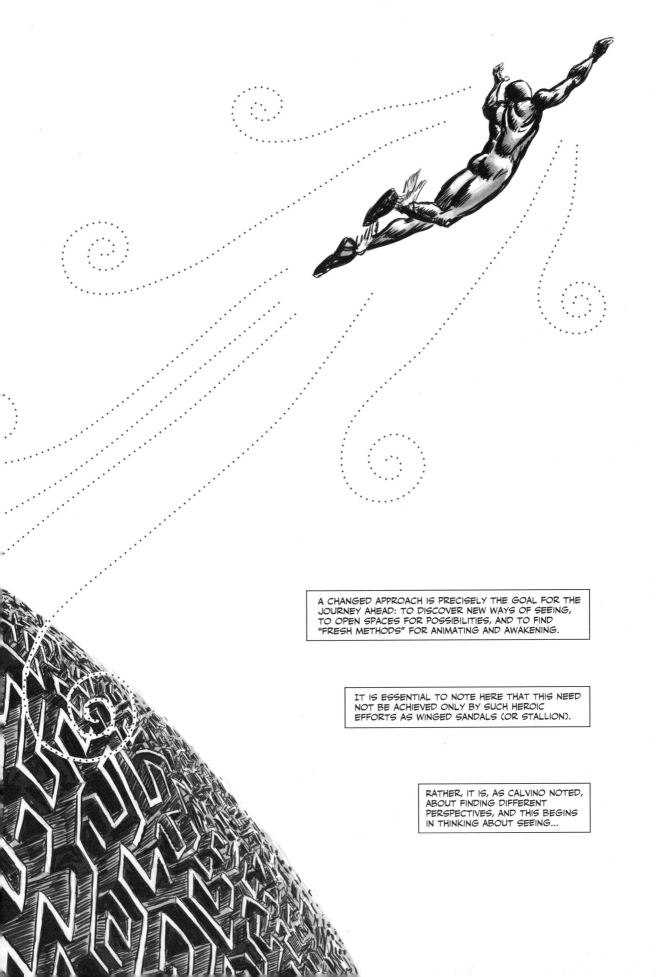

A CHANGED APPROACH IS PRECISELY THE GOAL FOR THE JOURNEY AHEAD: TO DISCOVER NEW WAYS OF SEEING, TO OPEN SPACES FOR POSSIBILITIES, AND TO FIND "FRESH METHODS" FOR ANIMATING AND AWAKENING.

IT IS ESSENTIAL TO NOTE HERE THAT THIS NEED NOT BE ACHIEVED ONLY BY SUCH HEROIC EFFORTS AS WINGED SANDALS (OR STALLION).

RATHER, IT IS, AS CALVINO NOTED, ABOUT FINDING DIFFERENT PERSPECTIVES, AND THIS BEGINS IN THINKING ABOUT SEEING...

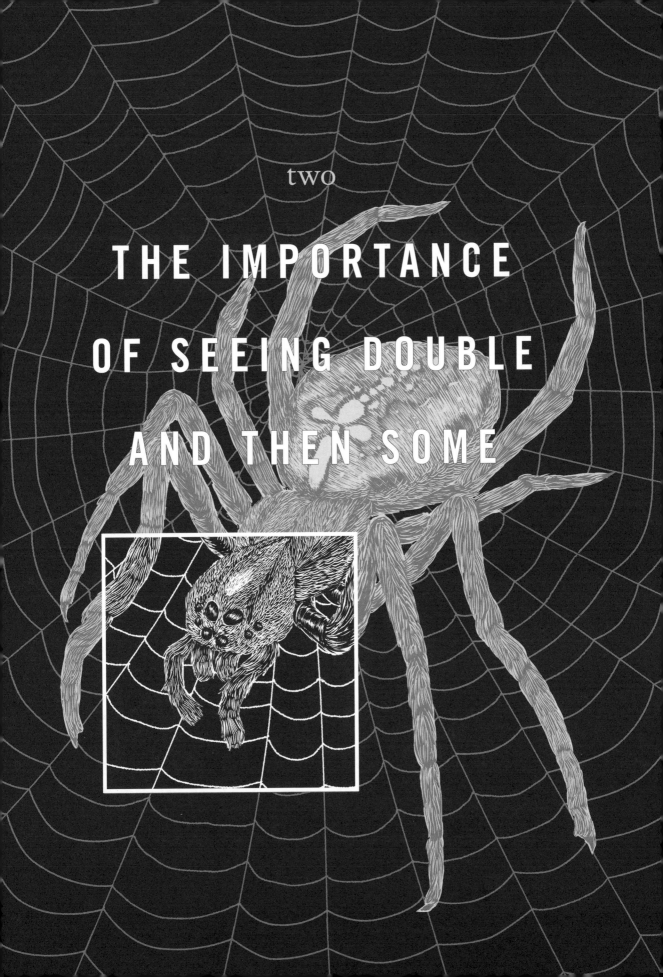

two

THE IMPORTANCE
OF SEEING DOUBLE
AND THEN SOME

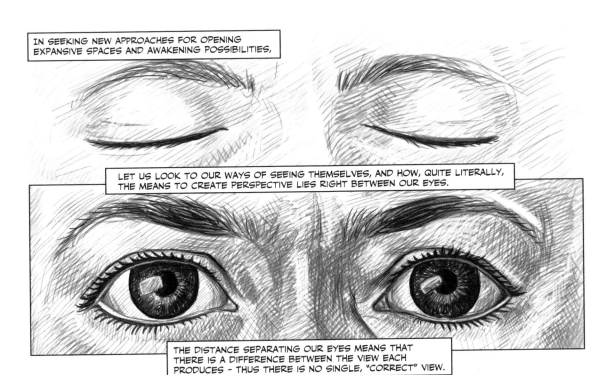

IN SEEKING NEW APPROACHES FOR OPENING EXPANSIVE SPACES AND AWAKENING POSSIBILITIES,

LET US LOOK TO OUR WAYS OF SEEING THEMSELVES, AND HOW, QUITE LITERALLY, THE MEANS TO CREATE PERSPECTIVE LIES RIGHT BETWEEN OUR EYES.

THE DISTANCE SEPARATING OUR EYES MEANS THAT THERE IS A DIFFERENCE BETWEEN THE VIEW EACH PRODUCES – THUS THERE IS NO SINGLE, "CORRECT" VIEW.

THIS BECOMES EVIDENT BY LOOKING ALTERNATELY THROUGH ONLY ONE EYE AT A TIME...

AND IT IS THIS DISPLACEMENT – PARALLAX – WHICH ENABLES US TO PERCEIVE DEPTH.

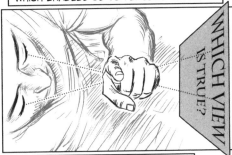

OUR STEREOSCOPIC VISION IS THE CREATION AND INTEGRATION OF TWO VIEWS. SEEING, MUCH LIKE WALKING ON TWO FEET, IS A CONSTANT NEGOTIATION BETWEEN TWO DISTINCT SOURCES.

BY MAKING A TRIP HALFWAY AROUND THE SUN, WE ESSENTIALLY CREATE TWO EYES A GREAT DISTANCE APART. THE DISPLACEMENT OF THE OBSERVATIONS FROM EACH AGAINST A DISTANT COSMIC BACKDROP ALLOWS US TO CALCULATE DISTANCES TO THE STARS,

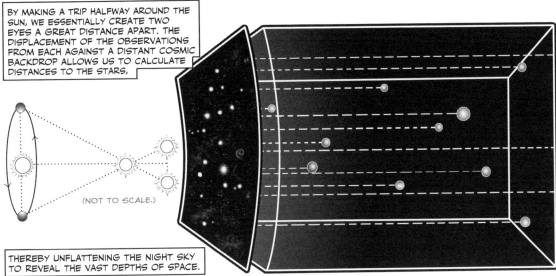

(NOT TO SCALE.)

THEREBY UNFLATTENING THE NIGHT SKY TO REVEAL THE VAST DEPTHS OF SPACE.

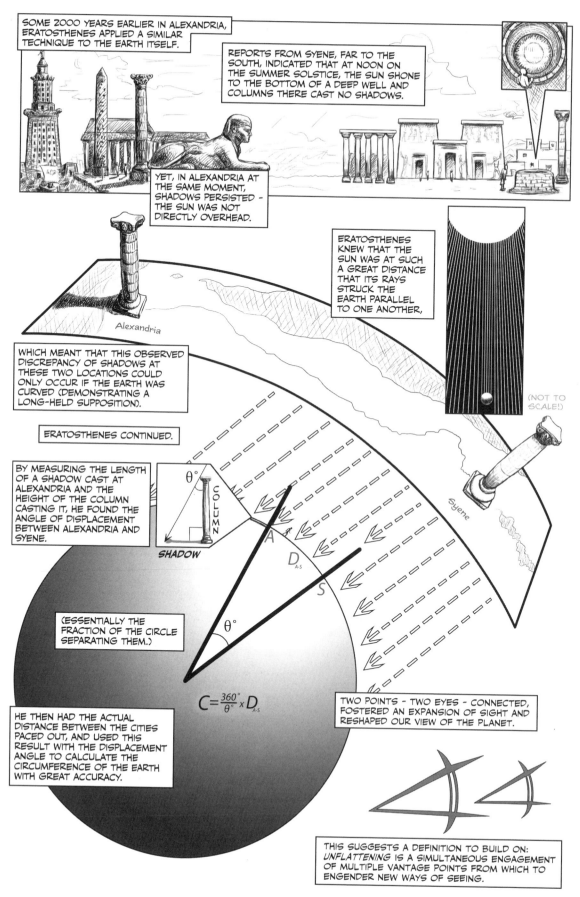

SOME 2000 YEARS EARLIER IN ALEXANDRIA, ERATOSTHENES APPLIED A SIMILAR TECHNIQUE TO THE EARTH ITSELF.

REPORTS FROM SYENE, FAR TO THE SOUTH, INDICATED THAT AT NOON ON THE SUMMER SOLSTICE, THE SUN SHONE TO THE BOTTOM OF A DEEP WELL AND COLUMNS THERE CAST NO SHADOWS.

YET, IN ALEXANDRIA AT THE SAME MOMENT, SHADOWS PERSISTED – THE SUN WAS NOT DIRECTLY OVERHEAD.

Alexandria

ERATOSTHENES KNEW THAT THE SUN WAS AT SUCH A GREAT DISTANCE THAT ITS RAYS STRUCK THE EARTH PARALLEL TO ONE ANOTHER,

(NOT TO SCALE!)

WHICH MEANT THAT THIS OBSERVED DISCREPANCY OF SHADOWS AT THESE TWO LOCATIONS COULD ONLY OCCUR IF THE EARTH WAS CURVED (DEMONSTRATING A LONG-HELD SUPPOSITION).

ERATOSTHENES CONTINUED.

BY MEASURING THE LENGTH OF A SHADOW CAST AT ALEXANDRIA AND THE HEIGHT OF THE COLUMN CASTING IT, HE FOUND THE ANGLE OF DISPLACEMENT BETWEEN ALEXANDRIA AND SYENE.

θ°

COLUMN

SHADOW

Syene

A

D_{A-S}

S

(ESSENTIALLY THE FRACTION OF THE CIRCLE SEPARATING THEM.)

θ°

$$C = \frac{360°}{θ°} \times D_{A-S}$$

HE THEN HAD THE ACTUAL DISTANCE BETWEEN THE CITIES PACED OUT, AND USED THIS RESULT WITH THE DISPLACEMENT ANGLE TO CALCULATE THE CIRCUMFERENCE OF THE EARTH WITH GREAT ACCURACY.

TWO POINTS – TWO EYES – CONNECTED, FOSTERED AN EXPANSION OF SIGHT AND RESHAPED OUR VIEW OF THE PLANET.

THIS SUGGESTS A DEFINITION TO BUILD ON: *UNFLATTENING* IS A SIMULTANEOUS ENGAGEMENT OF MULTIPLE VANTAGE POINTS FROM WHICH TO ENGENDER NEW WAYS OF SEEING.

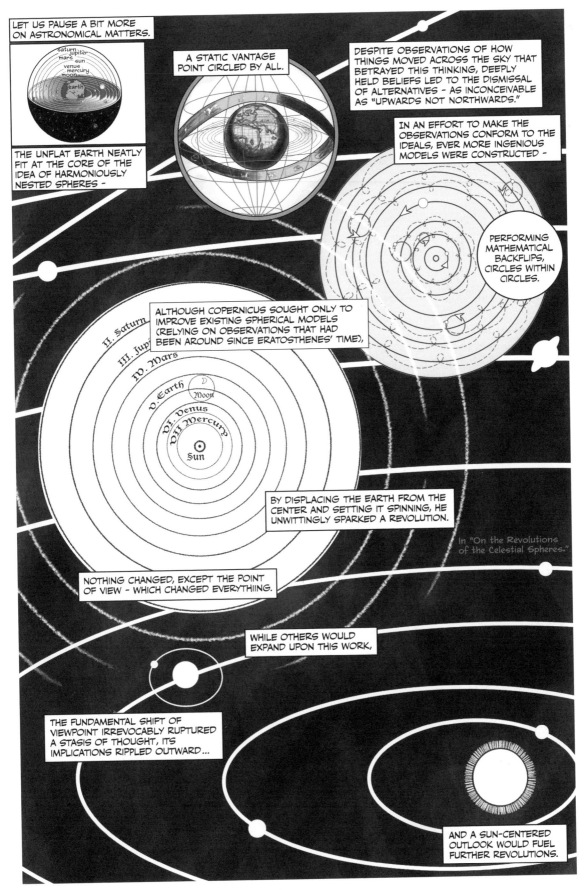

LET US PAUSE A BIT MORE ON ASTRONOMICAL MATTERS.

A STATIC VANTAGE POINT CIRCLED BY ALL.

DESPITE OBSERVATIONS OF HOW THINGS MOVED ACROSS THE SKY THAT BETRAYED THIS THINKING, DEEPLY HELD BELIEFS LED TO THE DISMISSAL OF ALTERNATIVES – AS INCONCEIVABLE AS "UPWARDS NOT NORTHWARDS."

THE UNFLAT EARTH NEATLY FIT AT THE CORE OF THE IDEA OF HARMONIOUSLY NESTED SPHERES –

IN AN EFFORT TO MAKE THE OBSERVATIONS CONFORM TO THE IDEALS, EVER MORE INGENIOUS MODELS WERE CONSTRUCTED –

PERFORMING MATHEMATICAL BACKFLIPS, CIRCLES WITHIN CIRCLES.

ALTHOUGH COPERNICUS SOUGHT ONLY TO IMPROVE EXISTING SPHERICAL MODELS (RELYING ON OBSERVATIONS THAT HAD BEEN AROUND SINCE ERATOSTHENES' TIME),

BY DISPLACING THE EARTH FROM THE CENTER AND SETTING IT SPINNING, HE UNWITTINGLY SPARKED A REVOLUTION.

In "On the Revolutions of the Celestial Spheres."

NOTHING CHANGED, EXCEPT THE POINT OF VIEW – WHICH CHANGED EVERYTHIING.

WHILE OTHERS WOULD EXPAND UPON THIS WORK,

THE FUNDAMENTAL SHIFT OF VIEWPOINT IRREVOCABLY RUPTURED A STASIS OF THOUGHT, ITS IMPLICATIONS RIPPLED OUTWARD...

AND A SUN-CENTERED OUTLOOK WOULD FUEL FURTHER REVOLUTIONS.

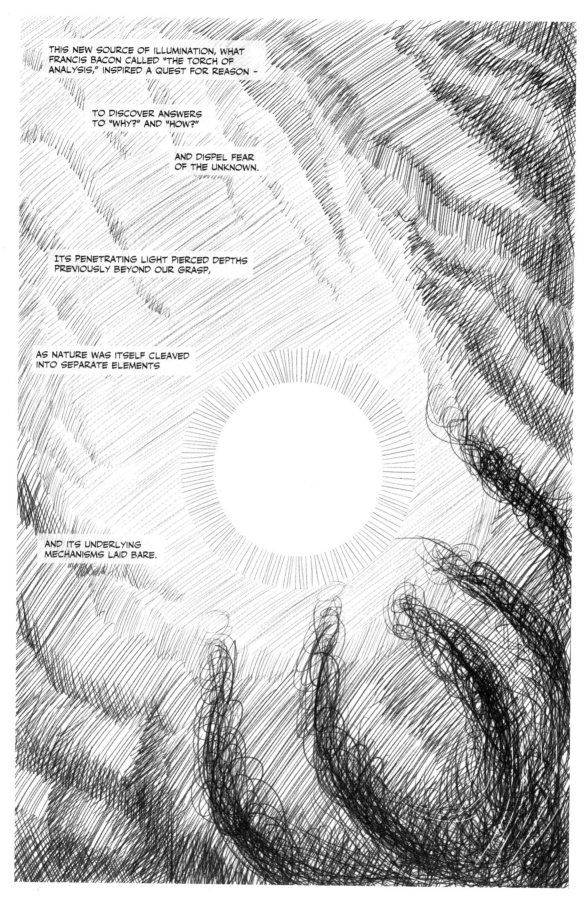

THIS NEW SOURCE OF ILLUMINATION, WHAT FRANCIS BACON CALLED "THE TORCH OF ANALYSIS," INSPIRED A QUEST FOR REASON –

TO DISCOVER ANSWERS TO "WHY?" AND "HOW?"

AND DISPEL FEAR OF THE UNKNOWN.

ITS PENETRATING LIGHT PIERCED DEPTHS PREVIOUSLY BEYOND OUR GRASP,

AS NATURE WAS ITSELF CLEAVED INTO SEPARATE ELEMENTS

AND ITS UNDERLYING MECHANISMS LAID BARE.

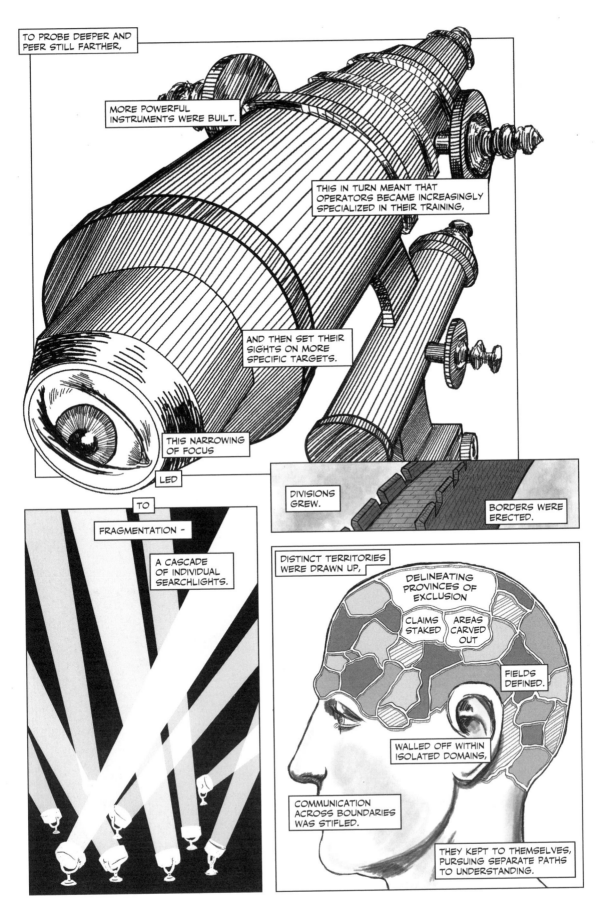

TO PROBE DEEPER AND PEER STILL FARTHER,

MORE POWERFUL INSTRUMENTS WERE BUILT.

THIS IN TURN MEANT THAT OPERATORS BECAME INCREASINGLY SPECIALIZED IN THEIR TRAINING,

AND THEN SET THEIR SIGHTS ON MORE SPECIFIC TARGETS.

THIS NARROWING OF FOCUS

LED

TO

FRAGMENTATION –

A CASCADE OF INDIVIDUAL SEARCHLIGHTS.

DIVISIONS GREW.

BORDERS WERE ERECTED.

DISTINCT TERRITORIES WERE DRAWN UP,

DELINEATING PROVINCES OF EXCLUSION

CLAIMS STAKED

AREAS CARVED OUT

FIELDS DEFINED.

WALLED OFF WITHIN ISOLATED DOMAINS,

COMMUNICATION ACROSS BOUNDARIES WAS STIFLED.

THEY KEPT TO THEMSELVES, PURSUING SEPARATE PATHS TO UNDERSTANDING.

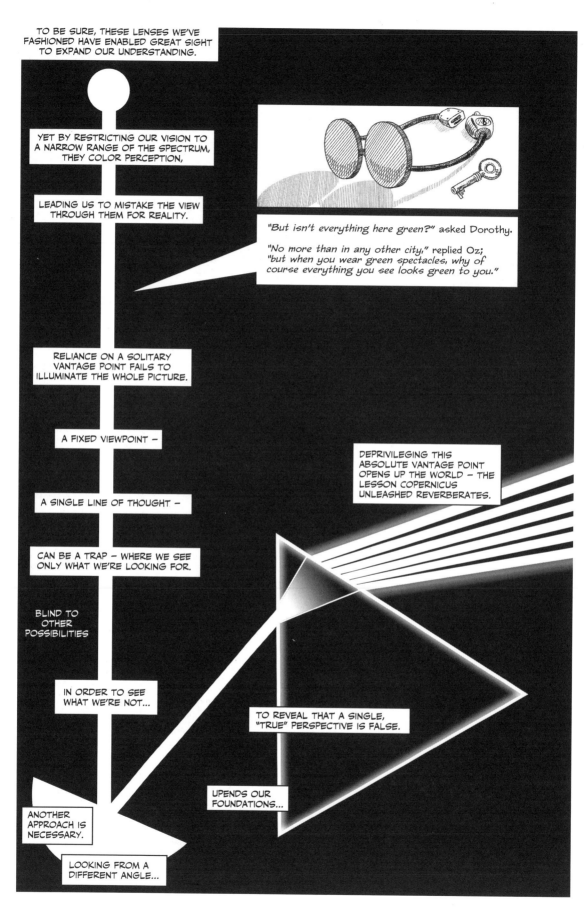

TO BE SURE, THESE LENSES WE'VE FASHIONED HAVE ENABLED GREAT SIGHT TO EXPAND OUR UNDERSTANDING.

YET BY RESTRICTING OUR VISION TO A NARROW RANGE OF THE SPECTRUM, THEY COLOR PERCEPTION,

LEADING US TO MISTAKE THE VIEW THROUGH THEM FOR REALITY.

"But isn't everything here green?" asked Dorothy.

"No more than in any other city," replied Oz; "but when you wear green spectacles, why of course everything you see looks green to you."

RELIANCE ON A SOLITARY VANTAGE POINT FAILS TO ILLUMINATE THE WHOLE PICTURE.

A FIXED VIEWPOINT –

DEPRIVILEGING THIS ABSOLUTE VANTAGE POINT OPENS UP THE WORLD – THE LESSON COPERNICUS UNLEASHED REVERBERATES.

A SINGLE LINE OF THOUGHT –

CAN BE A TRAP – WHERE WE SEE ONLY WHAT WE'RE LOOKING FOR.

BLIND TO OTHER POSSIBILITIES

IN ORDER TO SEE WHAT WE'RE NOT...

TO REVEAL THAT A SINGLE, "TRUE" PERSPECTIVE IS FALSE.

UPENDS OUR FOUNDATIONS...

ANOTHER APPROACH IS NECESSARY.

LOOKING FROM A DIFFERENT ANGLE...

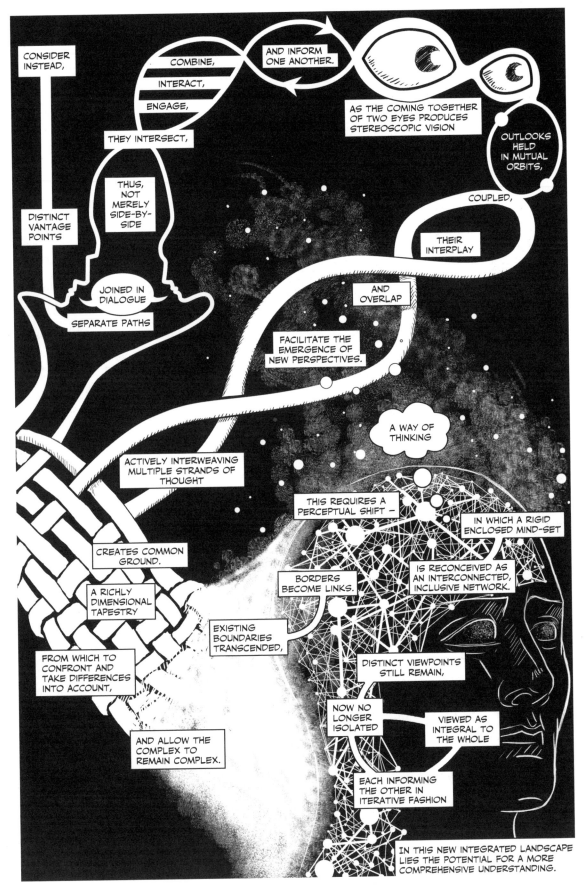

CONSIDER INSTEAD,

COMBINE,

INTERACT,

ENGAGE,

AND INFORM ONE ANOTHER.

THEY INTERSECT,

AS THE COMING TOGETHER OF TWO EYES PRODUCES STEREOSCOPIC VISION

OUTLOOKS HELD IN MUTUAL ORBITS,

DISTINCT VANTAGE POINTS

THUS, NOT MERELY SIDE-BY-SIDE

COUPLED,

THEIR INTERPLAY

JOINED IN DIALOGUE

SEPARATE PATHS

AND OVERLAP

FACILITATE THE EMERGENCE OF NEW PERSPECTIVES.

A WAY OF THINKING

ACTIVELY INTERWEAVING MULTIPLE STRANDS OF THOUGHT

THIS REQUIRES A PERCEPTUAL SHIFT —

IN WHICH A RIGID ENCLOSED MIND-SET

IS RECONCEIVED AS AN INTERCONNECTED, INCLUSIVE NETWORK.

CREATES COMMON GROUND.

BORDERS BECOME LINKS.

A RICHLY DIMENSIONAL TAPESTRY

EXISTING BOUNDARIES TRANSCENDED,

DISTINCT VIEWPOINTS STILL REMAIN,

FROM WHICH TO CONFRONT AND TAKE DIFFERENCES INTO ACCOUNT,

NOW NO LONGER ISOLATED

VIEWED AS INTEGRAL TO THE WHOLE

AND ALLOW THE COMPLEX TO REMAIN COMPLEX.

EACH INFORMING THE OTHER IN ITERATIVE FASHION

IN THIS NEW INTEGRATED LANDSCAPE LIES THE POTENTIAL FOR A MORE COMPREHENSIVE UNDERSTANDING.

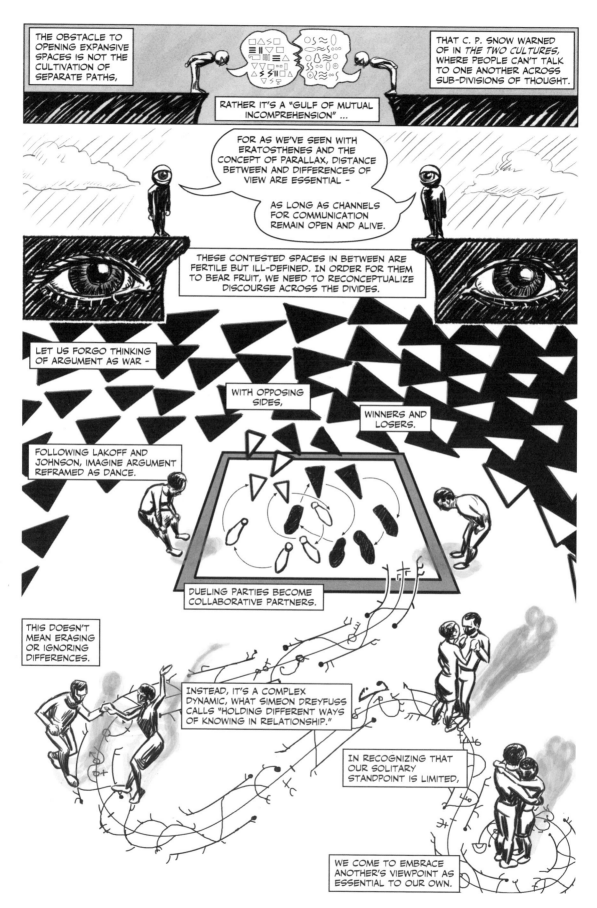

THE OBSTACLE TO OPENING EXPANSIVE SPACES IS NOT THE CULTIVATION OF SEPARATE PATHS,

THAT C. P. SNOW WARNED OF IN *THE TWO CULTURES*, WHERE PEOPLE CAN'T TALK TO ONE ANOTHER ACROSS SUB-DIVISIONS OF THOUGHT.

RATHER IT'S A "GULF OF MUTUAL INCOMPREHENSION" ...

FOR AS WE'VE SEEN WITH ERATOSTHENES AND THE CONCEPT OF PARALLAX, DISTANCE BETWEEN AND DIFFERENCES OF VIEW ARE ESSENTIAL –

AS LONG AS CHANNELS FOR COMMUNICATION REMAIN OPEN AND ALIVE.

THESE CONTESTED SPACES IN BETWEEN ARE FERTILE BUT ILL-DEFINED. IN ORDER FOR THEM TO BEAR FRUIT, WE NEED TO RECONCEPTUALIZE DISCOURSE ACROSS THE DIVIDES.

LET US FORGO THINKING OF ARGUMENT AS WAR –

WITH OPPOSING SIDES,

WINNERS AND LOSERS.

FOLLOWING LAKOFF AND JOHNSON, IMAGINE ARGUMENT REFRAMED AS DANCE.

DUELING PARTIES BECOME COLLABORATIVE PARTNERS.

THIS DOESN'T MEAN ERASING OR IGNORING DIFFERENCES.

INSTEAD, IT'S A COMPLEX DYNAMIC, WHAT SIMEON DREYFUSS CALLS "HOLDING DIFFERENT WAYS OF KNOWING IN RELATIONSHIP."

IN RECOGNIZING THAT OUR SOLITARY STANDPOINT IS LIMITED,

WE COME TO EMBRACE ANOTHER'S VIEWPOINT AS ESSENTIAL TO OUR OWN.

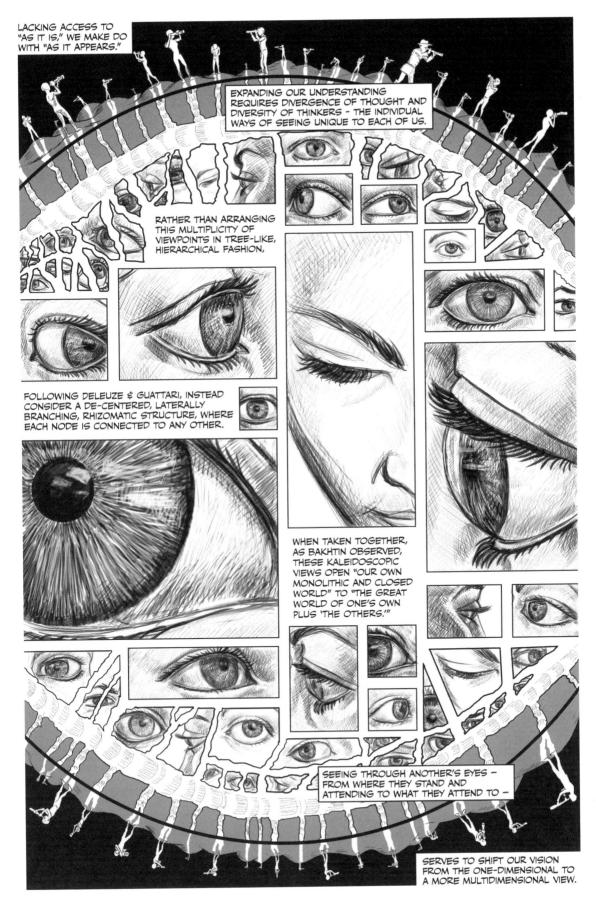

LACKING ACCESS TO "AS IT IS," WE MAKE DO WITH "AS IT APPEARS."

EXPANDING OUR UNDERSTANDING REQUIRES DIVERGENCE OF THOUGHT AND DIVERSITY OF THINKERS — THE INDIVIDUAL WAYS OF SEEING UNIQUE TO EACH OF US.

RATHER THAN ARRANGING THIS MULTIPLICITY OF VIEWPOINTS IN TREE-LIKE, HIERARCHICAL FASHION,

FOLLOWING DELEUZE & GUATTARI, INSTEAD CONSIDER A DE-CENTERED, LATERALLY BRANCHING, RHIZOMATIC STRUCTURE, WHERE EACH NODE IS CONNECTED TO ANY OTHER.

WHEN TAKEN TOGETHER, AS BAKHTIN OBSERVED, THESE KALEIDOSCOPIC VIEWS OPEN "OUR OWN MONOLITHIC AND CLOSED WORLD" TO "THE GREAT WORLD OF ONE'S OWN PLUS 'THE OTHERS.'"

SEEING THROUGH ANOTHER'S EYES — FROM WHERE THEY STAND AND ATTENDING TO WHAT THEY ATTEND TO —

SERVES TO SHIFT OUR VISION FROM THE ONE-DIMENSIONAL TO A MORE MULTIDIMENSIONAL VIEW.

PERMIT ME TO PAUSE BRIEFLY HERE TO NOTE THAT WHILE THIS DISCUSSION HAS BEEN RESTRICTED TO THE VISUAL, THIS IS NOT MEANT TO EXCLUDE OTHER MODES OF PERCEPTION. RATHER IT IS INTENDED THAT OUR LITERAL WAYS OF SEEING METAPHORICALLY SERVE TO ENCOMPASS OTHER WAYS OF MAKING MEANING AND EXPERIENCING THE WORLD.

TO THIS END, I'M REMINDED OF LESSONS LEARNED FROM MY DOG, NAVIGATING DEEP WOODS IN DARKNESS,

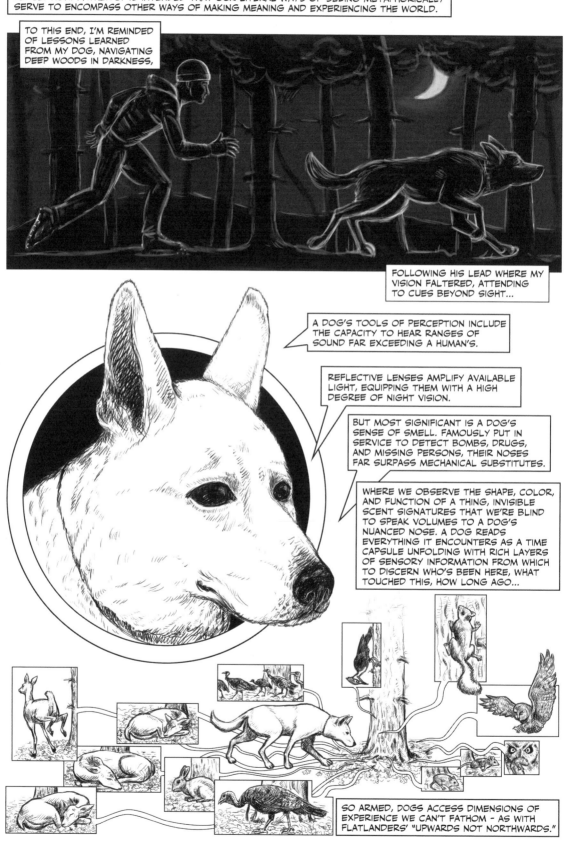

FOLLOWING HIS LEAD WHERE MY VISION FALTERED, ATTENDING TO CUES BEYOND SIGHT...

A DOG'S TOOLS OF PERCEPTION INCLUDE THE CAPACITY TO HEAR RANGES OF SOUND FAR EXCEEDING A HUMAN'S.

REFLECTIVE LENSES AMPLIFY AVAILABLE LIGHT, EQUIPPING THEM WITH A HIGH DEGREE OF NIGHT VISION.

BUT MOST SIGNIFICANT IS A DOG'S SENSE OF SMELL. FAMOUSLY PUT IN SERVICE TO DETECT BOMBS, DRUGS, AND MISSING PERSONS, THEIR NOSES FAR SURPASS MECHANICAL SUBSTITUTES.

WHERE WE OBSERVE THE SHAPE, COLOR, AND FUNCTION OF A THING, INVISIBLE SCENT SIGNATURES THAT WE'RE BLIND TO SPEAK VOLUMES TO A DOG'S NUANCED NOSE. A DOG READS EVERYTHING IT ENCOUNTERS AS A TIME CAPSULE UNFOLDING WITH RICH LAYERS OF SENSORY INFORMATION FROM WHICH TO DISCERN WHO'S BEEN HERE, WHAT TOUCHED THIS, HOW LONG AGO...

SO ARMED, DOGS ACCESS DIMENSIONS OF EXPERIENCE WE CAN'T FATHOM – AS WITH FLATLANDERS' "UPWARDS NOT NORTHWARDS."

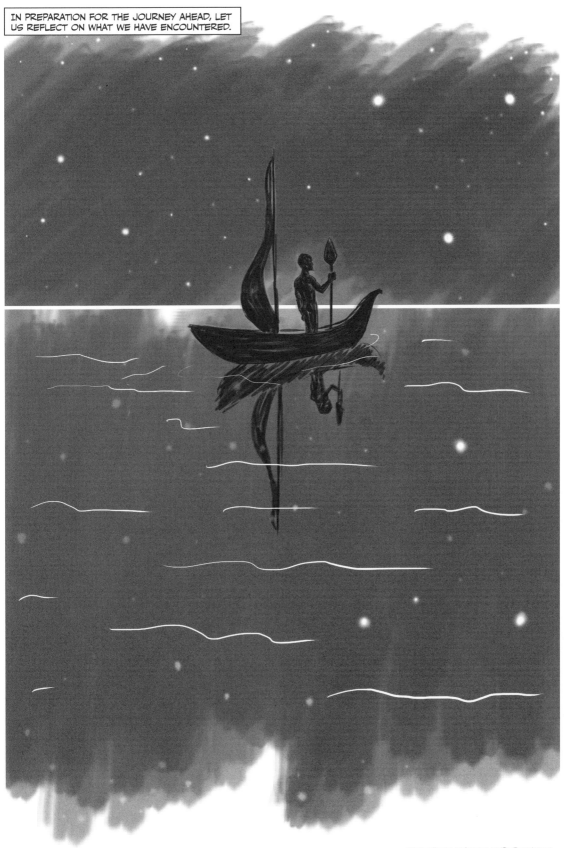

IN PREPARATION FOR THE JOURNEY AHEAD, LET US REFLECT ON WHAT WE HAVE ENCOUNTERED.

AND FROM THOSE EXPERIENCES, DERIVE TOOLS FOR NAVIGATION.

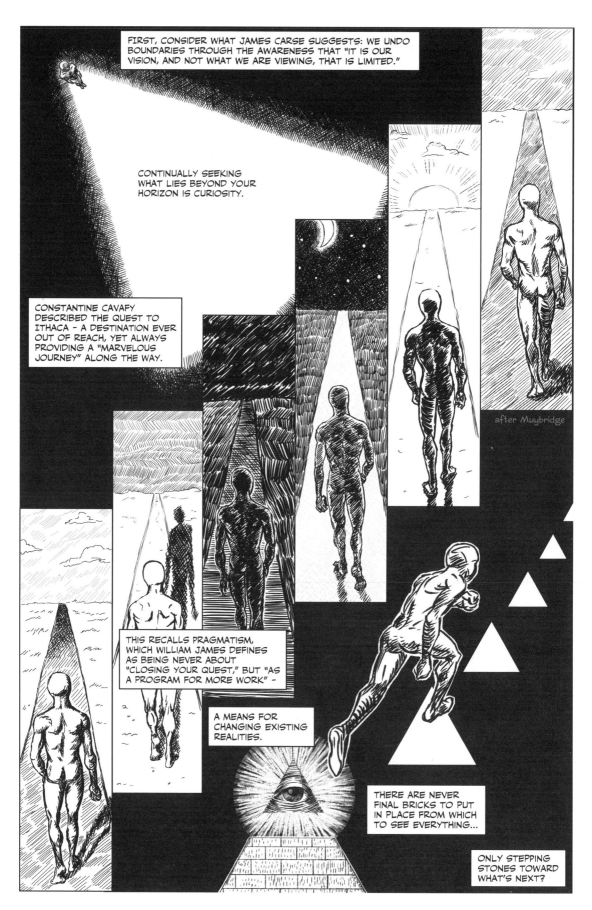

FIRST, CONSIDER WHAT JAMES CARSE SUGGESTS: WE UNDO BOUNDARIES THROUGH THE AWARENESS THAT "IT IS OUR VISION, AND NOT WHAT WE ARE VIEWING, THAT IS LIMITED."

CONTINUALLY SEEKING WHAT LIES BEYOND YOUR HORIZON IS CURIOSITY.

CONSTANTINE CAVAFY DESCRIBED THE QUEST TO ITHACA – A DESTINATION EVER OUT OF REACH, YET ALWAYS PROVIDING A "MARVELOUS JOURNEY" ALONG THE WAY.

after Muybridge

THIS RECALLS PRAGMATISM, WHICH WILLIAM JAMES DEFINES AS BEING NEVER ABOUT "CLOSING YOUR QUEST," BUT "AS A PROGRAM FOR MORE WORK" –

A MEANS FOR CHANGING EXISTING REALITIES.

THERE ARE NEVER FINAL BRICKS TO PUT IN PLACE FROM WHICH TO SEE EVERYTHING...

ONLY STEPPING STONES TOWARD WHAT'S NEXT?

42

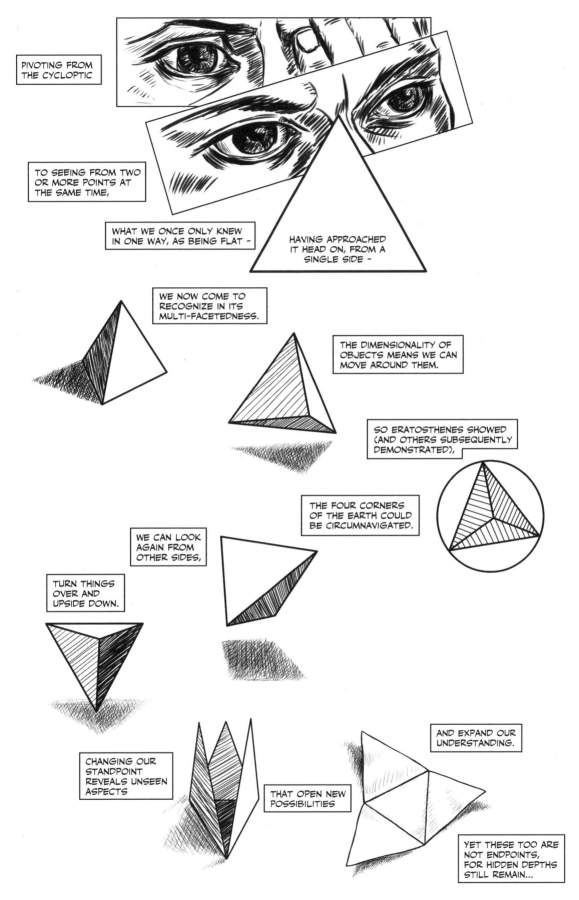

PIVOTING FROM THE CYCLOPTIC

TO SEEING FROM TWO OR MORE POINTS AT THE SAME TIME,

WHAT WE ONCE ONLY KNEW IN ONE WAY, AS BEING FLAT –

HAVING APPROACHED IT HEAD ON, FROM A SINGLE SIDE –

WE NOW COME TO RECOGNIZE IN ITS MULTI-FACETEDNESS.

THE DIMENSIONALITY OF OBJECTS MEANS WE CAN MOVE AROUND THEM.

SO ERATOSTHENES SHOWED (AND OTHERS SUBSEQUENTLY DEMONSTRATED),

THE FOUR CORNERS OF THE EARTH COULD BE CIRCUMNAVIGATED.

WE CAN LOOK AGAIN FROM OTHER SIDES,

TURN THINGS OVER AND UPSIDE DOWN.

CHANGING OUR STANDPOINT REVEALS UNSEEN ASPECTS

THAT OPEN NEW POSSIBILITIES

AND EXPAND OUR UNDERSTANDING.

YET THESE TOO ARE NOT ENDPOINTS, FOR HIDDEN DEPTHS STILL REMAIN...

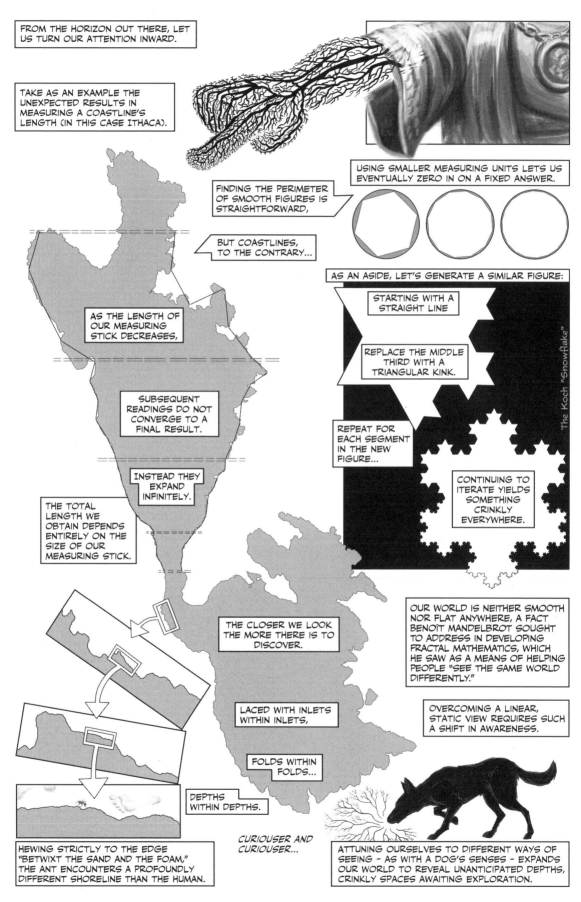

FROM THE HORIZON OUT THERE, LET US TURN OUR ATTENTION INWARD.

TAKE AS AN EXAMPLE THE UNEXPECTED RESULTS IN MEASURING A COASTLINE'S LENGTH (IN THIS CASE ITHACA).

FINDING THE PERIMETER OF SMOOTH FIGURES IS STRAIGHTFORWARD,

BUT COASTLINES, TO THE CONTRARY...

USING SMALLER MEASURING UNITS LETS US EVENTUALLY ZERO IN ON A FIXED ANSWER.

AS THE LENGTH OF OUR MEASURING STICK DECREASES,

SUBSEQUENT READINGS DO NOT CONVERGE TO A FINAL RESULT.

INSTEAD THEY EXPAND INFINITELY.

THE TOTAL LENGTH WE OBTAIN DEPENDS ENTIRELY ON THE SIZE OF OUR MEASURING STICK.

AS AN ASIDE, LET'S GENERATE A SIMILAR FIGURE:

STARTING WITH A STRAIGHT LINE

REPLACE THE MIDDLE THIRD WITH A TRIANGULAR KINK.

REPEAT FOR EACH SEGMENT IN THE NEW FIGURE...

CONTINUING TO ITERATE YIELDS SOMETHING CRINKLY EVERYWHERE.

The Koch "Snowflake"

THE CLOSER WE LOOK THE MORE THERE IS TO DISCOVER.

OUR WORLD IS NEITHER SMOOTH NOR FLAT ANYWHERE, A FACT BENOÎT MANDELBROT SOUGHT TO ADDRESS IN DEVELOPING FRACTAL MATHEMATICS, WHICH HE SAW AS A MEANS OF HELPING PEOPLE "SEE THE SAME WORLD DIFFERENTLY."

OVERCOMING A LINEAR, STATIC VIEW REQUIRES SUCH A SHIFT IN AWARENESS.

LACED WITH INLETS WITHIN INLETS,

FOLDS WITHIN FOLDS...

DEPTHS WITHIN DEPTHS.

CURIOUSER AND CURIOUSER...

HEWING STRICTLY TO THE EDGE "BETWIXT THE SAND AND THE FOAM," THE ANT ENCOUNTERS A PROFOUNDLY DIFFERENT SHORELINE THAN THE HUMAN.

ATTUNING OURSELVES TO DIFFERENT WAYS OF SEEING — AS WITH A DOG'S SENSES — EXPANDS OUR WORLD TO REVEAL UNANTICIPATED DEPTHS, CRINKLY SPACES AWAITING EXPLORATION.

A FURTHER CRENULATION: IN *ULYSSES* JAMES JOYCE UTILIZED DIVERSE NARRATIVE PERSPECTIVES TO CREATE LITERARY PARALLAX.

ANSWERING: "DID IT FLOW?"

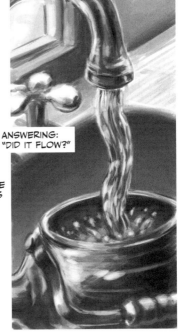

BY SEEING THROUGH MULTIPLE EYES, WE CAN TRACE OTHERWISE INVISIBLE CONNECTIONS ACROSS LAYERS OF TIME AND SPACE,

THEREBY TRANSFORMING THE SEEMINGLY MUNDANE ACT OF TURNING ON A FAUCET INTO AN ODYSSEY IN ITS OWN RIGHT.

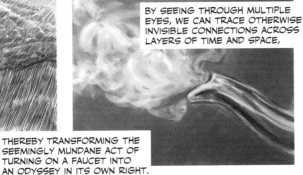

THIS EXPANSIVE WAY OF SEEING CORRESPONDS TO AN UNDERSTANDING OF ECOSYSTEMS...

WHICH, DESPITE VISUAL BOUNDARIES, REMAIN RHIZOMATICALLY BOUND.

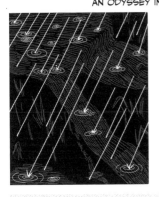

Roundwood

Vartry Reservoir

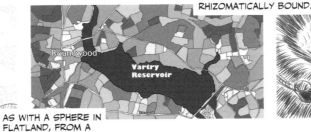

AS WITH A SPHERE IN FLATLAND, FROM A HIGHER DIMENSION –

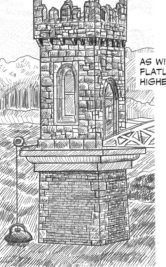

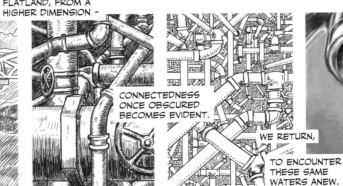

CONNECTEDNESS ONCE OBSCURED BECOMES EVIDENT.

WE RETURN, TO ENCOUNTER THESE SAME WATERS ANEW.

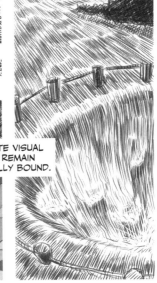

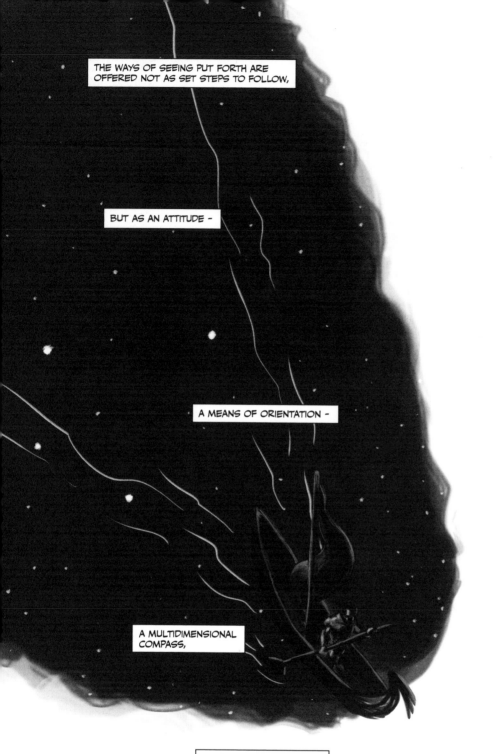

THE WAYS OF SEEING PUT FORTH ARE OFFERED NOT AS SET STEPS TO FOLLOW,

BUT AS AN ATTITUDE –

A MEANS OF ORIENTATION –

A MULTIDIMENSIONAL COMPASS,

TO HELP US FIND OUR WAY BEYOND THE CONFINES OF "HOW IT IS,"

AND SEEK OUT NEW WAYS OF BEING IN DIRECTIONS NOT ONLY NORTHWARDS AND UPWARDS,

BUT OUTWARDS, INWARDS, AND IN DIMENSIONS NOT YET WITHIN OUR IMAGINATION...

three

THE SHAPE OF
OUR THOUGHTS

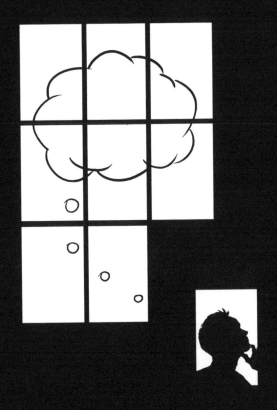

THE MEANS BY WHICH WE ORDER
EXPERIENCE AND GIVE STRUCTURE
TO OUR THOUGHTS –

OUR LANGUAGES –

ARE THE STUFF WE BREATHE
IN AND A SEA WE SWIM IN.

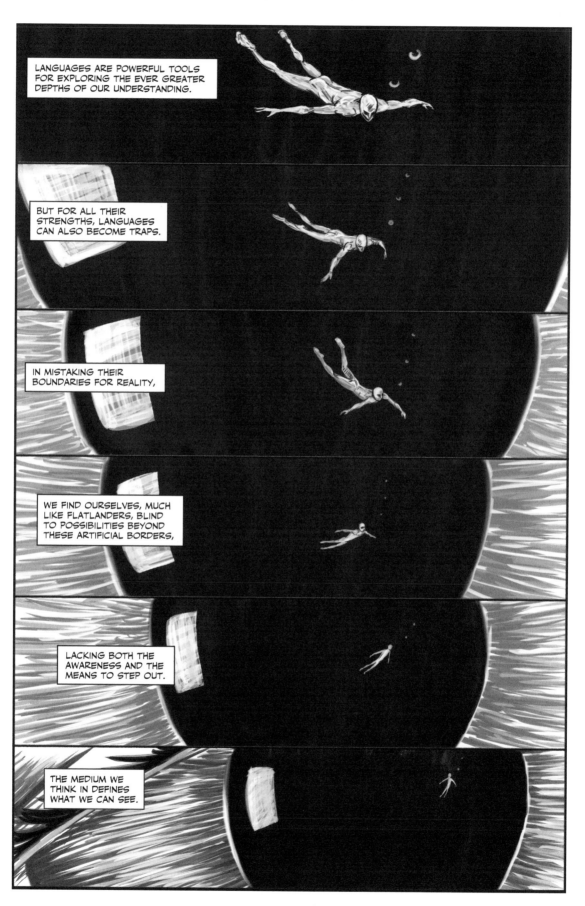

LANGUAGES ARE POWERFUL TOOLS FOR EXPLORING THE EVER GREATER DEPTHS OF OUR UNDERSTANDING.

BUT FOR ALL THEIR STRENGTHS, LANGUAGES CAN ALSO BECOME TRAPS.

IN MISTAKING THEIR BOUNDARIES FOR REALITY,

WE FIND OURSELVES, MUCH LIKE FLATLANDERS, BLIND TO POSSIBILITIES BEYOND THESE ARTIFICIAL BORDERS,

LACKING BOTH THE AWARENESS AND THE MEANS TO STEP OUT.

THE MEDIUM WE THINK IN DEFINES WHAT WE CAN SEE.

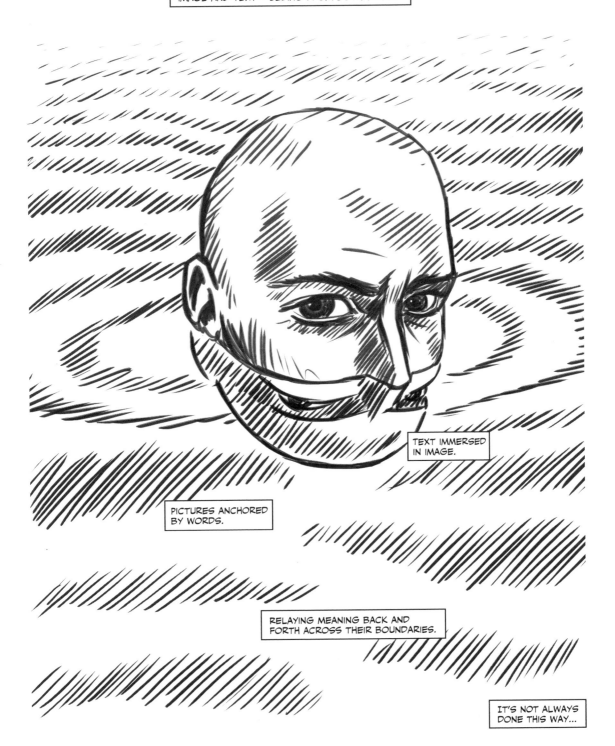

AS S. I. HAYAKAWA DESCRIBED THE SITUATION: "WE ARE THE PRISONERS OF ANCIENT ORIENTATIONS IMBEDDED IN THE LANGUAGES WE HAVE INHERITED."

WE'VE BEEN CONDUCTING THIS DISCUSSION AMPHIBIOUSLY – BREATHING IN THE WORLDS OF IMAGE AND TEXT – SEEING FROM BOTH SIDES.

TEXT IMMERSED IN IMAGE.

PICTURES ANCHORED BY WORDS.

RELAYING MEANING BACK AND FORTH ACROSS THEIR BOUNDARIES.

IT'S NOT ALWAYS DONE THIS WAY...

Traditionally, words have been privileged as the proper mode of explanation, as *the* tool of thought. Images have, on the other hand, long been sequestered to the realm of spectacle and aesthetics, sidelined in serious discussions as mere illustration to support the text — never as

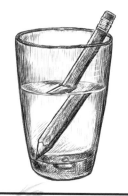

equal partner. The source of this historical bias can be traced to Plato, who professed a deep distrust of perception, citing its illusory nature: "The object which appears to bend as it enters water provokes a lively puzzlement about what is real" (Murdoch, 1977, p. 44). For Plato, human life was a pilgrimage (p. 2) from the world of appearance in the cave to the reality of pure forms — of

Fig 1: Object bent in water truth. He insisted that "we see *through* the eyes . . . not *with* them" (Jay, 1994, p. 27). If appearances were deceiving, images were far more treacherous, these "shadows of shadows," capable of obscuring the search for truth — mistaking fire for the sun. Plato considered thinking as a kind of "inner speech" (Murdoch, p. 31). Thus, despite a similar distrust of writing as an "inferior substitute for memory and live understanding" (p. 22), he tolerated the written word as a necessary evil to convey thought.

Descartes took this distrust of the senses a step further, as he considered the possibility that all he perceived might be a deception of a supremely powerful evil spirit. His observations of wax in the presence of flame betrayed the reality that the substance remained unchanged:

> But I need to realize that the perception of the wax is neither a seeing, nor a touching, nor an imagining. Nor has it ever been, even though it previously seemed so; rather it is an inspection on the part of the mind alone. This inspection can be imperfect and confused, as it was before, or clear and distinct, as it is now, depending on how closely I pay attention to the things in which the piece of wax consists. (1637/2002, p. 68)

This reasoning about wax raised questions as to how he could know anything, "all the things that had ever entered my mind were no more true than the illusions of my dreams" (p. 87). From there, Descartes proceeded with his program of radical doubt, setting out to discard and raze any "false opinions" he had come to accept in his life. By burning away all he'd come to believe, he could build up from what he knew with certainty.

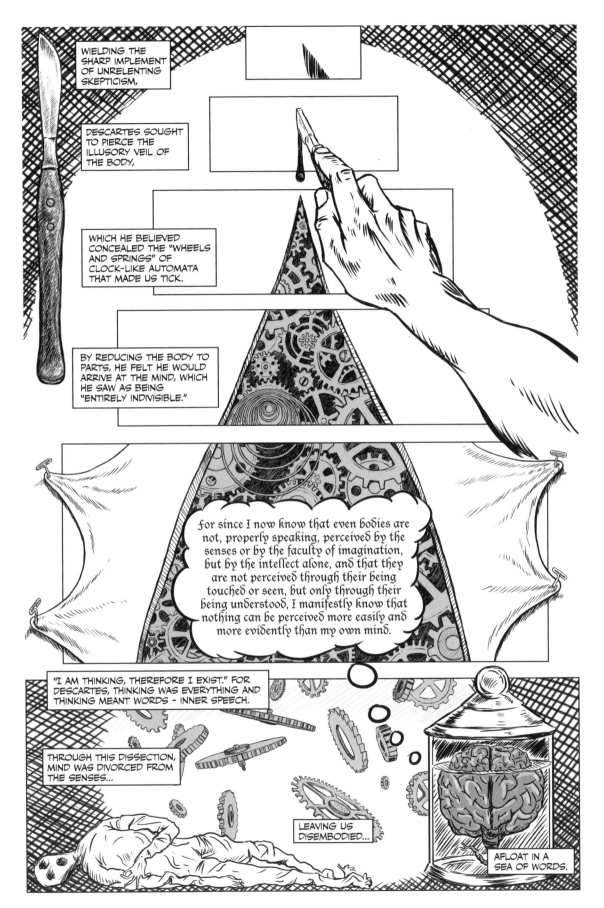

WIELDING THE SHARP IMPLEMENT OF UNRELENTING SKEPTICISM,

DESCARTES SOUGHT TO PIERCE THE ILLUSORY VEIL OF THE BODY,

WHICH HE BELIEVED CONCEALED THE "WHEELS AND SPRINGS" OF CLOCK-LIKE AUTOMATA THAT MADE US TICK.

BY REDUCING THE BODY TO PARTS, HE FELT HE WOULD ARRIVE AT THE MIND, WHICH HE SAW AS BEING "ENTIRELY INDIVISIBLE."

for since I now know that even bodies are not, properly speaking, perceived by the senses or by the faculty of imagination, but by the intellect alone, and that they are not perceived through their being touched or seen, but only through their being understood, I manifestly know that nothing can be perceived more easily and more evidently than my own mind.

"I AM THINKING, THEREFORE I EXIST." FOR DESCARTES, THINKING WAS EVERYTHING AND THINKING MEANT WORDS - INNER SPEECH.

THROUGH THIS DISSECTION, MIND WAS DIVORCED FROM THE SENSES...

LEAVING US DISEMBODIED...

AFLOAT IN A SEA OF WORDS.

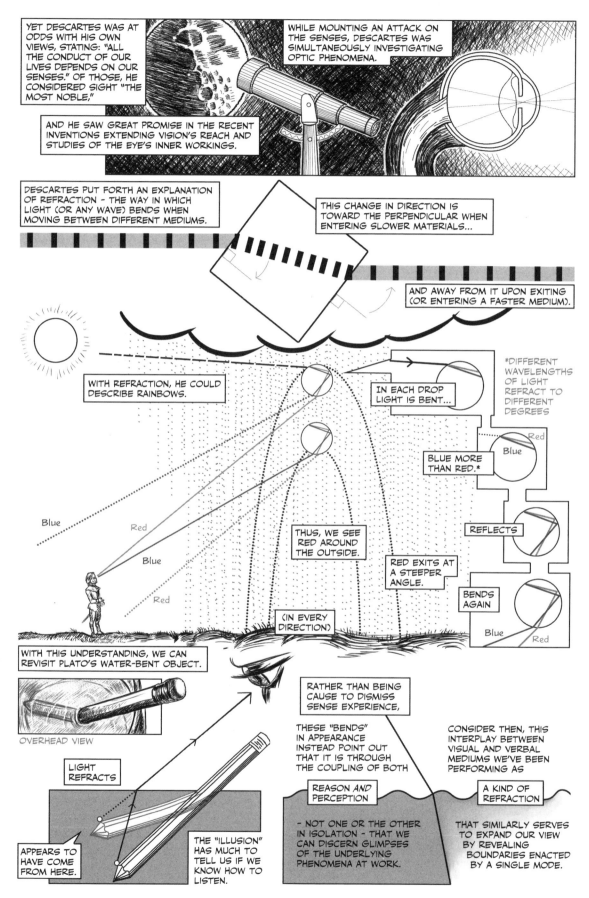

YET DESCARTES WAS AT ODDS WITH HIS OWN VIEWS, STATING: "ALL THE CONDUCT OF OUR LIVES DEPENDS ON OUR SENSES." OF THOSE, HE CONSIDERED SIGHT "THE MOST NOBLE,"

AND HE SAW GREAT PROMISE IN THE RECENT INVENTIONS EXTENDING VISION'S REACH AND STUDIES OF THE EYE'S INNER WORKINGS.

WHILE MOUNTING AN ATTACK ON THE SENSES, DESCARTES WAS SIMULTANEOUSLY INVESTIGATING OPTIC PHENOMENA.

DESCARTES PUT FORTH AN EXPLANATION OF REFRACTION – THE WAY IN WHICH LIGHT (OR ANY WAVE) BENDS WHEN MOVING BETWEEN DIFFERENT MEDIUMS.

THIS CHANGE IN DIRECTION IS TOWARD THE PERPENDICULAR WHEN ENTERING SLOWER MATERIALS...

AND AWAY FROM IT UPON EXITING (OR ENTERING A FASTER MEDIUM).

WITH REFRACTION, HE COULD DESCRIBE RAINBOWS.

IN EACH DROP LIGHT IS BENT...

*DIFFERENT WAVELENGTHS OF LIGHT REFRACT TO DIFFERENT DEGREES

Red

Blue

BLUE MORE THAN RED.*

REFLECTS

RED EXITS AT A STEEPER ANGLE.

BENDS AGAIN

Blue Red

Blue

Red

Blue

Red

THUS, WE SEE RED AROUND THE OUTSIDE.

(IN EVERY DIRECTION)

WITH THIS UNDERSTANDING, WE CAN REVISIT PLATO'S WATER-BENT OBJECT.

OVERHEAD VIEW

LIGHT REFRACTS

APPEARS TO HAVE COME FROM HERE.

THE "ILLUSION" HAS MUCH TO TELL US IF WE KNOW HOW TO LISTEN.

RATHER THAN BEING CAUSE TO DISMISS SENSE EXPERIENCE,

THESE "BENDS" IN APPEARANCE INSTEAD POINT OUT THAT IT IS THROUGH THE COUPLING OF BOTH

REASON *AND* PERCEPTION

– NOT ONE OR THE OTHER IN ISOLATION – THAT WE CAN DISCERN GLIMPSES OF THE UNDERLYING PHENOMENA AT WORK.

CONSIDER THEN, THIS INTERPLAY BETWEEN VISUAL AND VERBAL MEDIUMS WE'VE BEEN PERFORMING AS

A KIND OF REFRACTION

THAT SIMILARLY SERVES TO EXPAND OUR VIEW BY REVEALING BOUNDARIES ENACTED BY A SINGLE MODE.

WHEN REPRESENTED THROUGH ANY SINGLE MODE,

THIS WORLD OF OUR EXPERIENCE,

OF ENDLESS HORIZONS,

IS NECESSARILY FLATTENED.

A SHADOW CAST FROM A HIGHER DIMENSION.

DISTORTIONS HAPPEN.

CONNECTIONS SEVERED.

INFORMATION LOST.

ITS WHOLENESS CONCEALS ITS LIMITATIONS AND OFFERS THE IMPRESSION THAT IT'S COMPLETE, BUT THIS IS ONLY ONE WAY OF LOOKING.

CHANGING ORIENTATION PUTS FORTH A DECIDEDLY DIFFERENT WORLD VIEW.

(BUCKMINSTER FULLER'S "DYMAXION MAP" PROJECTS THE GLOBE ONTO AN ICOSAHEDRON BEFORE UNFOLDING IT.)

THUS RECAST, CONNECTIONS ARE EMPHASIZED IN PLACE OF OPPOSITIONS.

IN SELECTING FOR WHAT IT PRESENTS, EACH MODE EXCLUDES WHAT IT DOES NOT.

NOT EVEN THE MOST EXPANSIVE MAPPING CAN CONVEY EVERYTHING. JUST AS THE THERMOMETER PROVIDES BUT A PARTIAL VIEW OF THE WEATHER,

EVERY LANGUAGE, HAYAKAWA SUGGESTS, "LEAVES WORK UNDONE FOR OTHER LANGUAGES TO DO."

CIRCUMNAVICA

F° C°

0 0 0 0 0 0

CHANGE

millimeters

0.1 mm

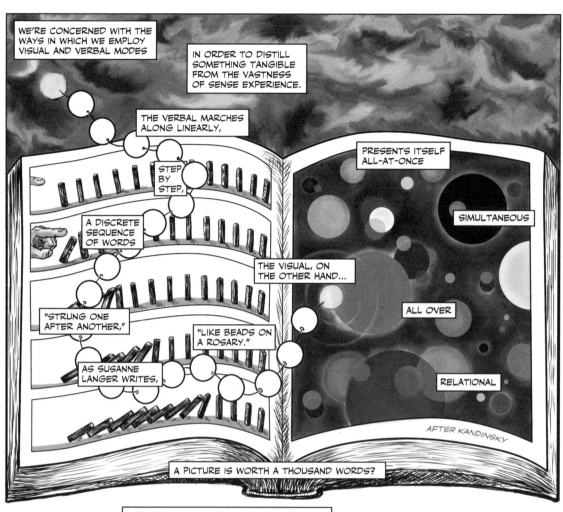

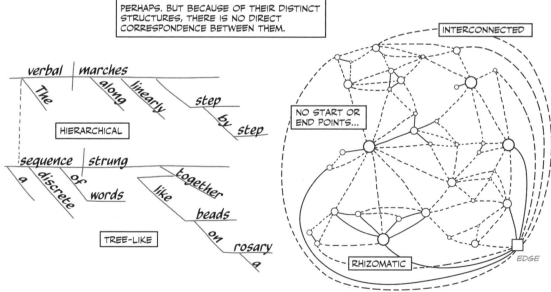

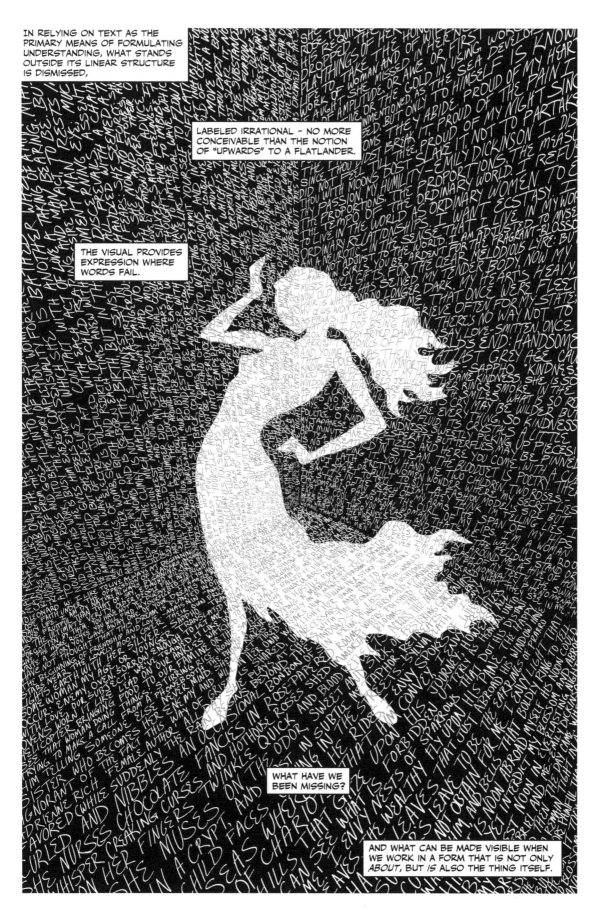

IN RELYING ON TEXT AS THE PRIMARY MEANS OF FORMULATING UNDERSTANDING, WHAT STANDS OUTSIDE ITS LINEAR STRUCTURE IS DISMISSED,

LABELED IRRATIONAL – NO MORE CONCEIVABLE THAN THE NOTION OF "UPWARDS" TO A FLATLANDER.

THE VISUAL PROVIDES EXPRESSION WHERE WORDS FAIL.

WHAT HAVE WE BEEN MISSING?

AND WHAT CAN BE MADE VISIBLE WHEN WE WORK IN A FORM THAT IS NOT ONLY ABOUT, BUT IS ALSO THE THING ITSELF.

AT THIS JUNCTURE, IT'S TIME TO...

ATTEND TO THE INTRICACIES...

PEEL AWAY AND...

DELVE INTO THE INNER WORKINGS...

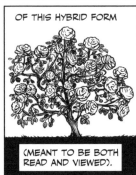

OF THIS HYBRID FORM

(MEANT TO BE BOTH READ AND VIEWED).

FIRST, ITS NAME –

EVER A PRICKLY TOPIC.

THE ONE IT CAME WITH CONCEALS ITS POTENTIAL.

comic books

comics

HENCE, A QUEST FOR RESPECTABILITY:

after Renoir

GRANDER VARIETIES PUT FORTH;

GRAPHIC

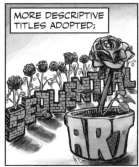

MORE DESCRIPTIVE TITLES ADOPTED;

SEQUENTIAL ART

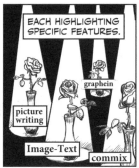

EACH HIGHLIGHTING SPECIFIC FEATURES.

graphein

picture writing

Image-Text

commix

FROM DIFFERENT CLIMATES,

DISTINCT OFFSHOOTS AROSE.

manga

bandes dessinées

fumetti

WHILE OFTEN SEEN AS A BUDDING FORM,

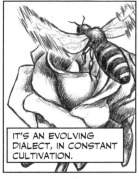

IT'S AN EVOLVING DIALECT, IN CONSTANT CULTIVATION.

ITS LINEAGE RUNS DEEP.

ITS HISTORY OUR OWN.

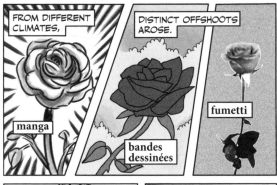

A MEANS OF GRAPPLING WITH EXPERIENCE BEFORE WE HAD NAMES FOR IT.

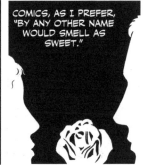

COMICS, AS I PREFER, "BY ANY OTHER NAME WOULD SMELL AS SWEET."

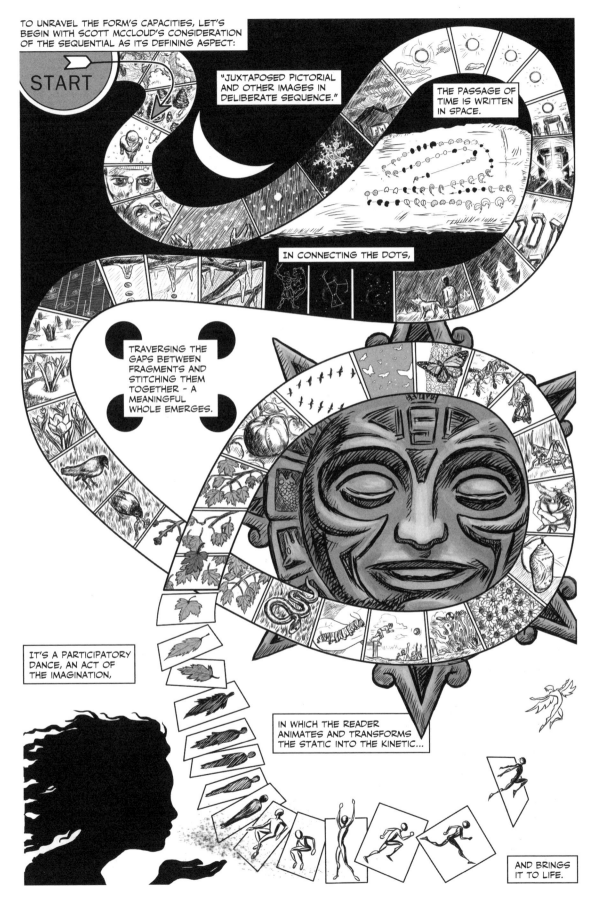

TO UNRAVEL THE FORM'S CAPACITIES, LET'S BEGIN WITH SCOTT MCCLOUD'S CONSIDERATION OF THE SEQUENTIAL AS ITS DEFINING ASPECT:

START

"JUXTAPOSED PICTORIAL AND OTHER IMAGES IN DELIBERATE SEQUENCE."

THE PASSAGE OF TIME IS WRITTEN IN SPACE.

IN CONNECTING THE DOTS,

TRAVERSING THE GAPS BETWEEN FRAGMENTS AND STITCHING THEM TOGETHER – A MEANINGFUL WHOLE EMERGES.

IT'S A PARTICIPATORY DANCE, AN ACT OF THE IMAGINATION,

IN WHICH THE READER ANIMATES AND TRANSFORMS THE STATIC INTO THE KINETIC...

AND BRINGS IT TO LIFE.

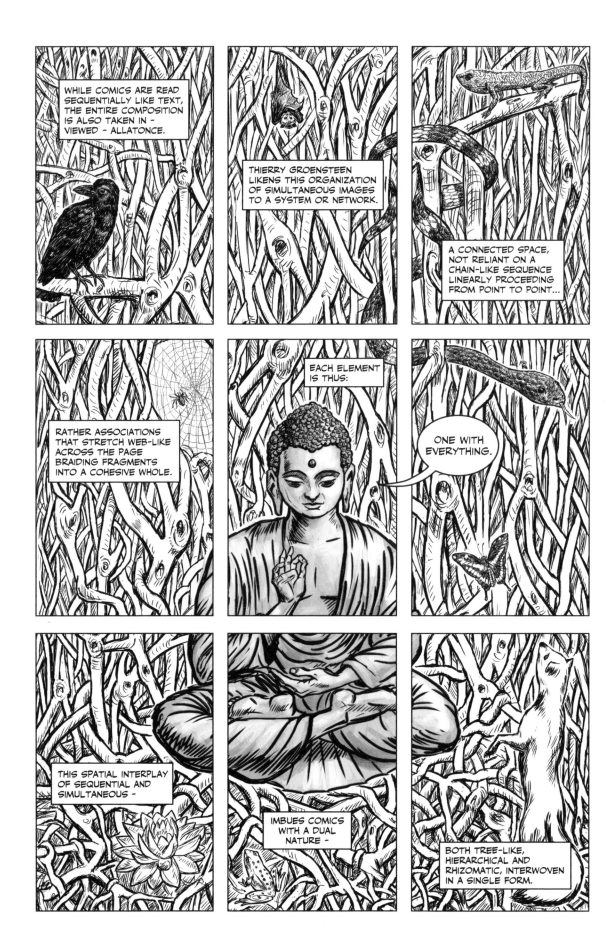

WHILE COMICS ARE READ SEQUENTIALLY LIKE TEXT, THE ENTIRE COMPOSITION IS ALSO TAKEN IN - VIEWED - ALLATONCE.

THIERRY GROENSTEEN LIKENS THIS ORGANIZATION OF SIMULTANEOUS IMAGES TO A SYSTEM OR NETWORK.

A CONNECTED SPACE, NOT RELIANT ON A CHAIN-LIKE SEQUENCE LINEARLY PROCEEDING FROM POINT TO POINT...

RATHER ASSOCIATIONS THAT STRETCH WEB-LIKE ACROSS THE PAGE BRAIDING FRAGMENTS INTO A COHESIVE WHOLE.

EACH ELEMENT IS THUS:

ONE WITH EVERYTHING.

THIS SPATIAL INTERPLAY OF SEQUENTIAL AND SIMULTANEOUS -

IMBUES COMICS WITH A DUAL NATURE -

BOTH TREE-LIKE, HIERARCHICAL AND RHIZOMATIC, INTERWOVEN IN A SINGLE FORM.

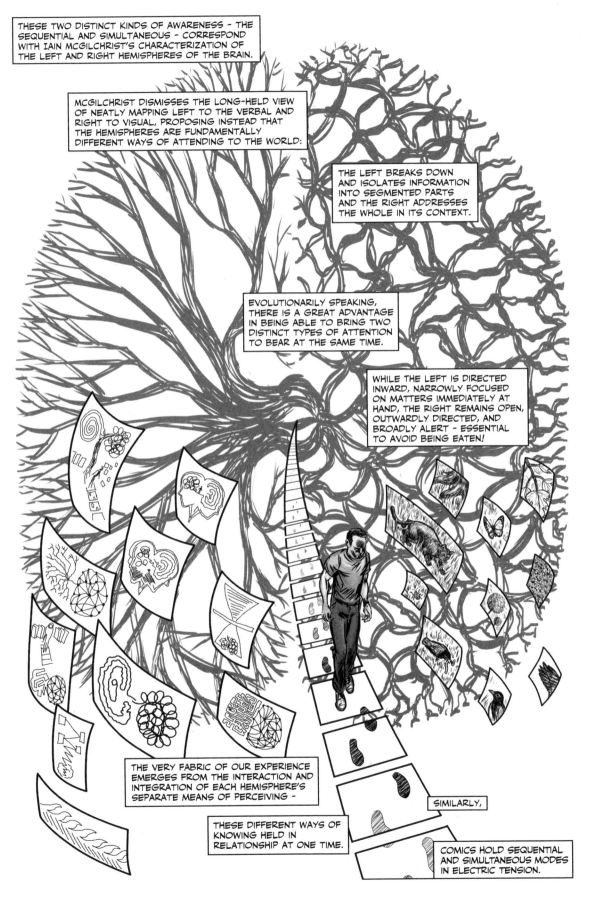

THESE TWO DISTINCT KINDS OF AWARENESS - THE SEQUENTIAL AND SIMULTANEOUS - CORRESPOND WITH IAIN MCGILCHRIST'S CHARACTERIZATION OF THE LEFT AND RIGHT HEMISPHERES OF THE BRAIN.

MCGILCHRIST DISMISSES THE LONG-HELD VIEW OF NEATLY MAPPING LEFT TO THE VERBAL AND RIGHT TO VISUAL, PROPOSING INSTEAD THAT THE HEMISPHERES ARE FUNDAMENTALLY DIFFERENT WAYS OF ATTENDING TO THE WORLD:

THE LEFT BREAKS DOWN AND ISOLATES INFORMATION INTO SEGMENTED PARTS AND THE RIGHT ADDRESSES THE WHOLE IN ITS CONTEXT.

EVOLUTIONARILY SPEAKING, THERE IS A GREAT ADVANTAGE IN BEING ABLE TO BRING TWO DISTINCT TYPES OF ATTENTION TO BEAR AT THE SAME TIME.

WHILE THE LEFT IS DIRECTED INWARD, NARROWLY FOCUSED ON MATTERS IMMEDIATELY AT HAND, THE RIGHT REMAINS OPEN, OUTWARDLY DIRECTED, AND BROADLY ALERT - ESSENTIAL TO AVOID BEING EATEN!

THE VERY FABRIC OF OUR EXPERIENCE EMERGES FROM THE INTERACTION AND INTEGRATION OF EACH HEMISPHERE'S SEPARATE MEANS OF PERCEIVING -

THESE DIFFERENT WAYS OF KNOWING HELD IN RELATIONSHIP AT ONE TIME.

SIMILARLY,

COMICS HOLD SEQUENTIAL AND SIMULTANEOUS MODES IN ELECTRIC TENSION.

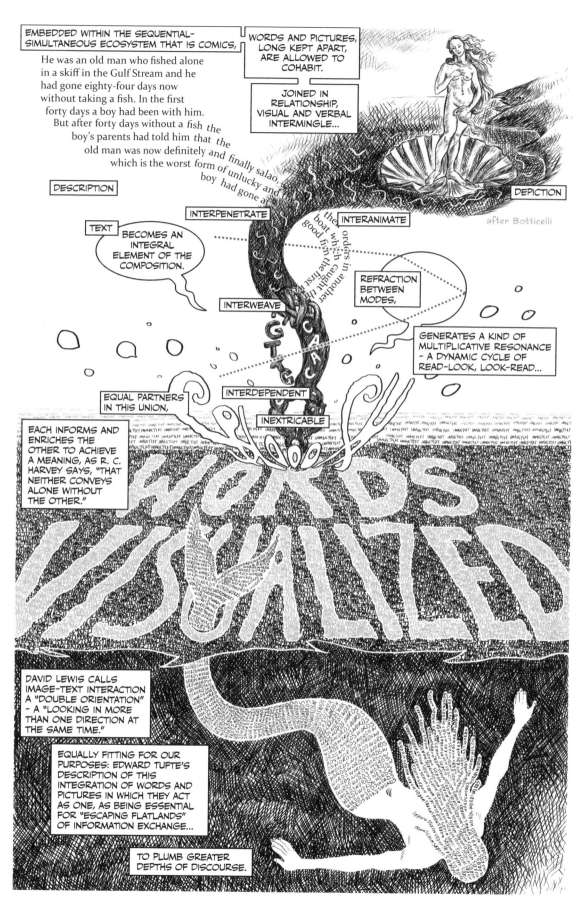

EMBEDDED WITHIN THE SEQUENTIAL-SIMULTANEOUS ECOSYSTEM THAT IS COMICS,

He was an old man who fished alone in a skiff in the Gulf Stream and he had gone eighty-four days now without taking a fish. In the first forty days a boy had been with him. But after forty days without a fish the boy's parents had told him that the old man was now definitely and finally salao, which is the worst form of unlucky and boy had gone at

WORDS AND PICTURES, LONG KEPT APART, ARE ALLOWED TO COHABIT.

JOINED IN RELATIONSHIP, VISUAL AND VERBAL INTERMINGLE...

DESCRIPTION

DEPICTION

after Botticelli

INTERPENETRATE

INTERANIMATE

TEXT BECOMES AN INTEGRAL ELEMENT OF THE COMPOSITION.

the orders in another boat which caught three good fish the first week

REFRACTION BETWEEN MODES,

INTERWEAVE

GENERATES A KIND OF MULTIPLICATIVE RESONANCE - A DYNAMIC CYCLE OF READ-LOOK, LOOK-READ...

EQUAL PARTNERS IN THIS UNION,

INTERDEPENDENT

INEXTRICABLE

EACH INFORMS AND ENRICHES THE OTHER TO ACHIEVE A MEANING, AS R. C. HARVEY SAYS, "THAT NEITHER CONVEYS ALONE WITHOUT THE OTHER."

WORDS VISUALIZED

DAVID LEWIS CALLS IMAGE-TEXT INTERACTION A "DOUBLE ORIENTATION" - A "LOOKING IN MORE THAN ONE DIRECTION AT THE SAME TIME."

EQUALLY FITTING FOR OUR PURPOSES: EDWARD TUFTE'S DESCRIPTION OF THIS INTEGRATION OF WORDS AND PICTURES IN WHICH THEY ACT AS ONE, AS BEING ESSENTIAL FOR "ESCAPING FLATLANDS" OF INFORMATION EXCHANGE...

TO PLUMB GREATER DEPTHS OF DISCOURSE.

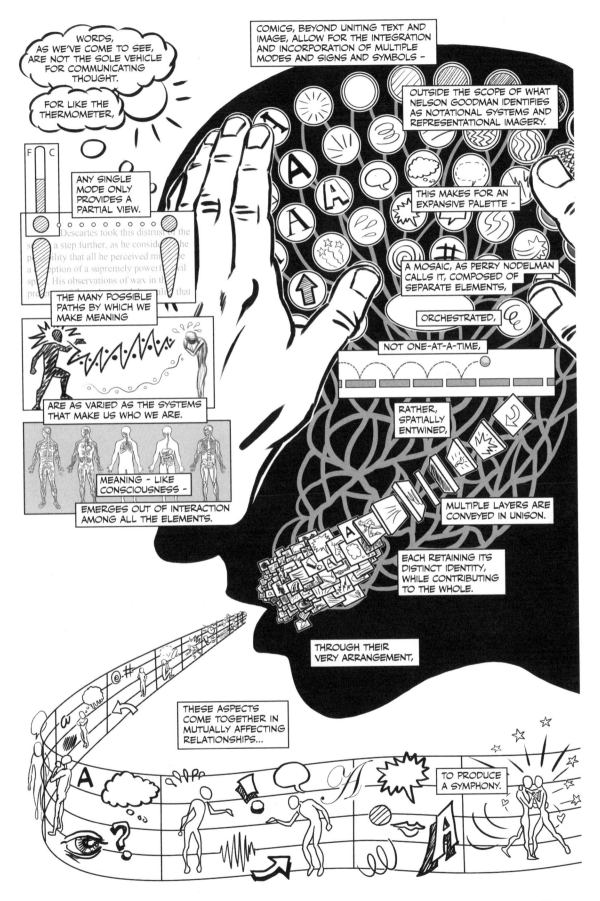

WORDS, AS WE'VE COME TO SEE, ARE NOT THE SOLE VEHICLE FOR COMMUNICATING THOUGHT.

FOR LIKE THE THERMOMETER,

COMICS, BEYOND UNITING TEXT AND IMAGE, ALLOW FOR THE INTEGRATION AND INCORPORATION OF MULTIPLE MODES AND SIGNS AND SYMBOLS –

OUTSIDE THE SCOPE OF WHAT NELSON GOODMAN IDENTIFIES AS NOTATIONAL SYSTEMS AND REPRESENTATIONAL IMAGERY.

THIS MAKES FOR AN EXPANSIVE PALETTE –

A MOSAIC, AS PERRY NODELMAN CALLS IT, COMPOSED OF SEPARATE ELEMENTS,

ORCHESTRATED,

NOT ONE-AT-A-TIME,

RATHER, SPATIALLY ENTWINED,

MULTIPLE LAYERS ARE CONVEYED IN UNISON.

EACH RETAINING ITS DISTINCT IDENTITY, WHILE CONTRIBUTING TO THE WHOLE.

THROUGH THEIR VERY ARRANGEMENT,

ANY SINGLE MODE ONLY PROVIDES A PARTIAL VIEW.

THE MANY POSSIBLE PATHS BY WHICH WE MAKE MEANING

ARE AS VARIED AS THE SYSTEMS THAT MAKE US WHO WE ARE.

MEANING – LIKE CONSCIOUSNESS –

EMERGES OUT OF INTERACTION AMONG ALL THE ELEMENTS.

THESE ASPECTS COME TOGETHER IN MUTUALLY AFFECTING RELATIONSHIPS...

TO PRODUCE A SYMPHONY.

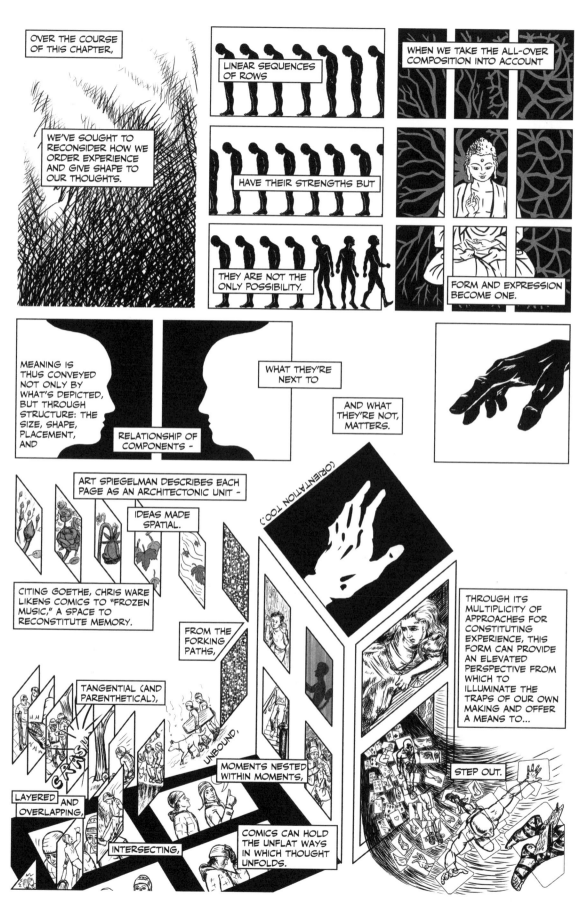

OVER THE COURSE OF THIS CHAPTER,

WE'VE SOUGHT TO RECONSIDER HOW WE ORDER EXPERIENCE AND GIVE SHAPE TO OUR THOUGHTS.

LINEAR SEQUENCES OF ROWS

HAVE THEIR STRENGTHS BUT

THEY ARE NOT THE ONLY POSSIBILITY.

WHEN WE TAKE THE ALL-OVER COMPOSITION INTO ACCOUNT

FORM AND EXPRESSION BECOME ONE.

MEANING IS THUS CONVEYED NOT ONLY BY WHAT'S DEPICTED, BUT THROUGH STRUCTURE: THE SIZE, SHAPE, PLACEMENT, AND RELATIONSHIP OF COMPONENTS –

WHAT THEY'RE NEXT TO

AND WHAT THEY'RE NOT, MATTERS.

ART SPIEGELMAN DESCRIBES EACH PAGE AS AN ARCHITECTONIC UNIT –

IDEAS MADE SPATIAL.

CITING GOETHE, CHRIS WARE LIKENS COMICS TO "FROZEN MUSIC," A SPACE TO RECONSTITUTE MEMORY.

FROM THE FORKING PATHS,

TANGENTIAL (AND PARENTHETICAL),

LAYERED AND OVERLAPPING,

INTERSECTING,

UNBOUND,

MOMENTS NESTED WITHIN MOMENTS,

COMICS CAN HOLD THE UNFLAT WAYS IN WHICH THOUGHT UNFOLDS.

(ORIENTATION TOO.)

THROUGH ITS MULTIPLICITY OF APPROACHES FOR CONSTITUTING EXPERIENCE, THIS FORM CAN PROVIDE AN ELEVATED PERSPECTIVE FROM WHICH TO ILLUMINATE THE TRAPS OF OUR OWN MAKING AND OFFER A MEANS TO...

STEP OUT.

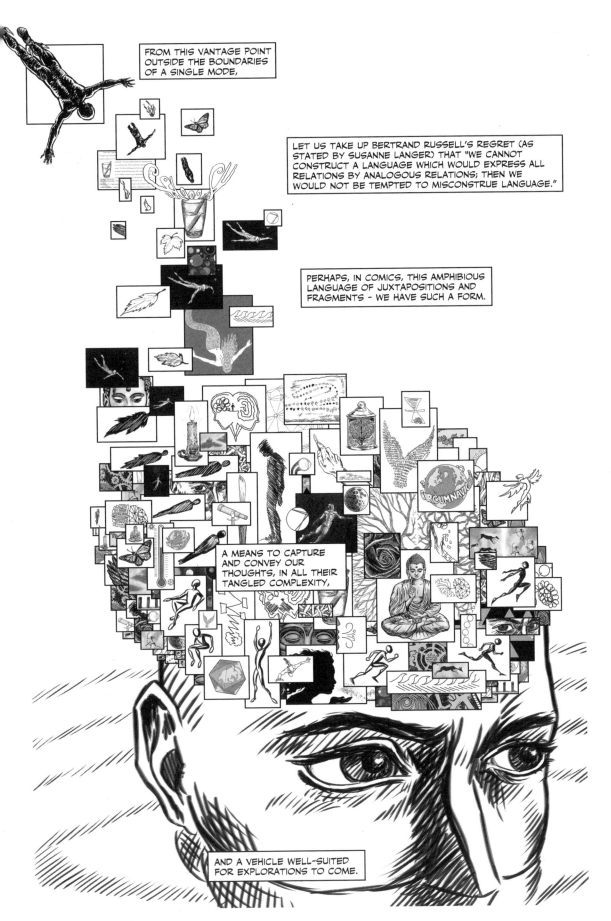

FROM THIS VANTAGE POINT OUTSIDE THE BOUNDARIES OF A SINGLE MODE,

LET US TAKE UP BERTRAND RUSSELL'S REGRET (AS STATED BY SUSANNE LANGER) THAT "WE CANNOT CONSTRUCT A LANGUAGE WHICH WOULD EXPRESS ALL RELATIONS BY ANALOGOUS RELATIONS; THEN WE WOULD NOT BE TEMPTED TO MISCONSTRUE LANGUAGE."

PERHAPS, IN COMICS, THIS AMPHIBIOUS LANGUAGE OF JUXTAPOSITIONS AND FRAGMENTS – WE HAVE SUCH A FORM.

A MEANS TO CAPTURE AND CONVEY OUR THOUGHTS, IN ALL THEIR TANGLED COMPLEXITY,

AND A VEHICLE WELL-SUITED FOR EXPLORATIONS TO COME.

four

OUR BODIES IN MOTION

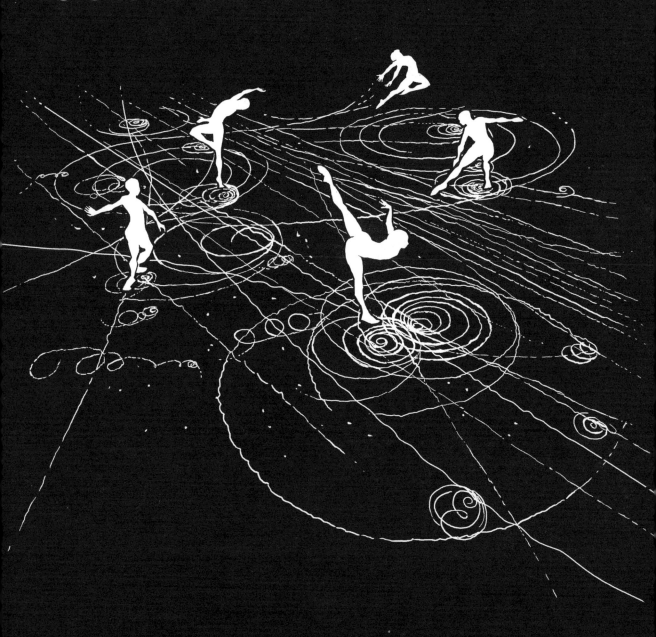

THE IMAGE-TEXT DIVIDE...

BREACHED,

WE NOW INTRODUCE ANOTHER
DIMENSION TO OUR THINKING...

AND SET FORTH OVER
AN EXPANSIVE HORIZON,

COMPLETE WITH ITS OWN
FORMS FOR EXPRESSION
AND MEANS OF DISCOVERY.

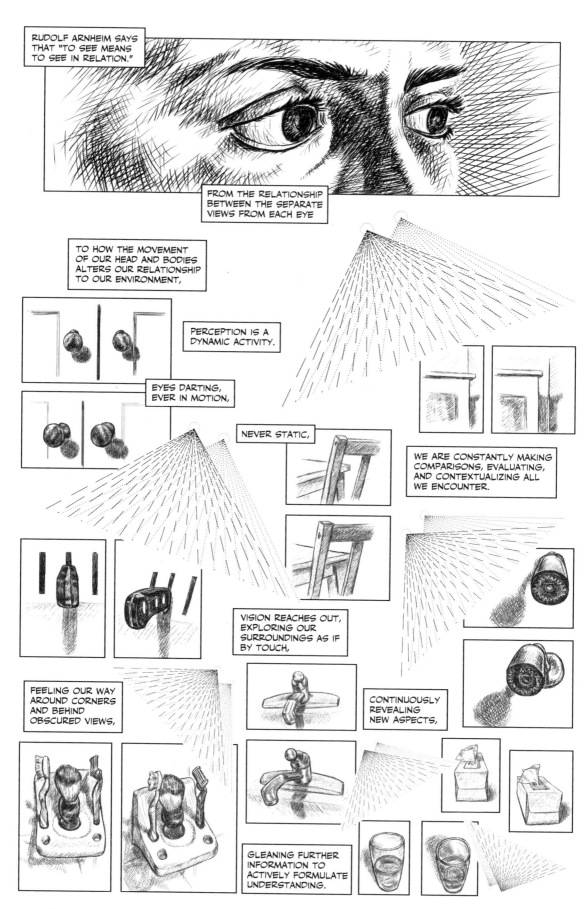

RUDOLF ARNHEIM SAYS THAT "TO SEE MEANS TO SEE IN RELATION."

FROM THE RELATIONSHIP BETWEEN THE SEPARATE VIEWS FROM EACH EYE

TO HOW THE MOVEMENT OF OUR HEAD AND BODIES ALTERS OUR RELATIONSHIP TO OUR ENVIRONMENT,

PERCEPTION IS A DYNAMIC ACTIVITY.

EYES DARTING, EVER IN MOTION,

NEVER STATIC,

WE ARE CONSTANTLY MAKING COMPARISONS, EVALUATING, AND CONTEXTUALIZING ALL WE ENCOUNTER.

VISION REACHES OUT, EXPLORING OUR SURROUNDINGS AS IF BY TOUCH,

FEELING OUR WAY AROUND CORNERS AND BEHIND OBSCURED VIEWS,

CONTINUOUSLY REVEALING NEW ASPECTS,

GLEANING FURTHER INFORMATION TO ACTIVELY FORMULATE UNDERSTANDING.

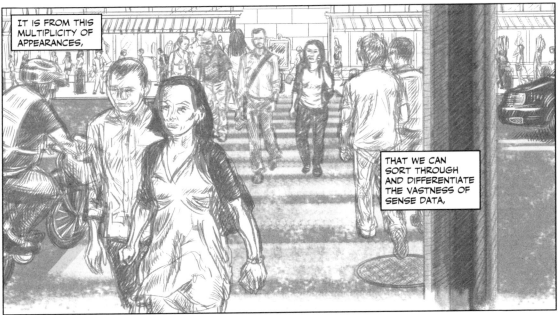

IT IS FROM THIS MULTIPLICITY OF APPEARANCES,

THAT WE CAN SORT THROUGH AND DIFFERENTIATE THE VASTNESS OF SENSE DATA,

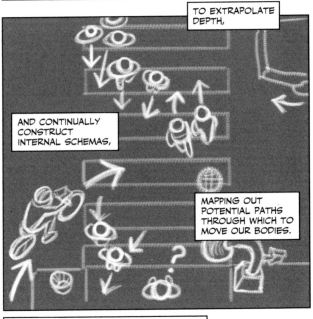

TO EXTRAPOLATE DEPTH,

AND CONTINUALLY CONSTRUCT INTERNAL SCHEMAS,

MAPPING OUT POTENTIAL PATHS THROUGH WHICH TO MOVE OUR BODIES.

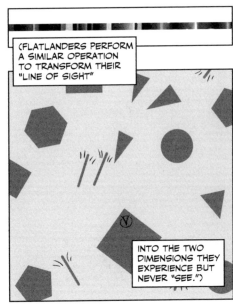

(FLATLANDERS PERFORM A SIMILAR OPERATION TO TRANSFORM THEIR "LINE OF SIGHT"

INTO THE TWO DIMENSIONS THEY EXPERIENCE BUT NEVER "SEE.")

ALVA NOË SUGGESTS THAT "PERCEPTUAL EXPERIENCE IS A WAY OF ENCOUNTERING HOW THINGS ARE BY MAKING CONTACT WITH HOW THEY APPEAR TO BE."

EVEN AS THE PLATE APPEARS ELLIPTICAL, WE ALSO RECOGNIZE IT AS BEING CIRCULAR IN ITS ELLIPTICAL APPEARANCE.

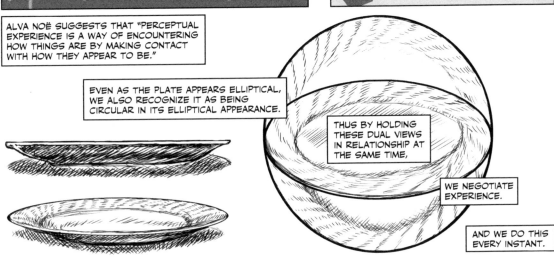

THUS BY HOLDING THESE DUAL VIEWS IN RELATIONSHIP AT THE SAME TIME,

WE NEGOTIATE EXPERIENCE.

AND WE DO THIS EVERY INSTANT.

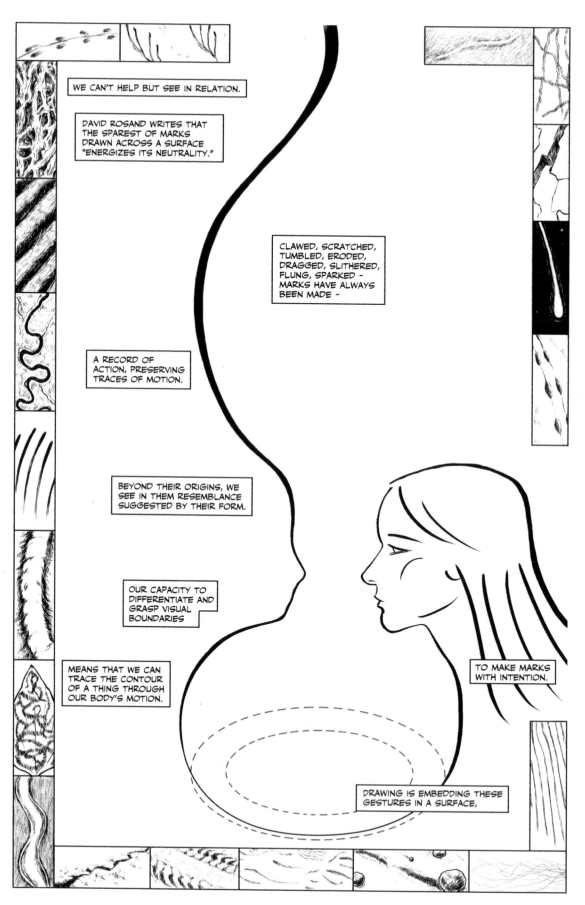

WE CAN'T HELP BUT SEE IN RELATION.

DAVID ROSAND WRITES THAT THE SPAREST OF MARKS DRAWN ACROSS A SURFACE "ENERGIZES ITS NEUTRALITY."

CLAWED, SCRATCHED, TUMBLED, ERODED, DRAGGED, SLITHERED, FLUNG, SPARKED – MARKS HAVE ALWAYS BEEN MADE –

A RECORD OF ACTION, PRESERVING TRACES OF MOTION.

BEYOND THEIR ORIGINS, WE SEE IN THEM RESEMBLANCE SUGGESTED BY THEIR FORM.

OUR CAPACITY TO DIFFERENTIATE AND GRASP VISUAL BOUNDARIES

MEANS THAT WE CAN TRACE THE CONTOUR OF A THING THROUGH OUR BODY'S MOTION.

TO MAKE MARKS WITH INTENTION.

DRAWING IS EMBEDDING THESE GESTURES IN A SURFACE,

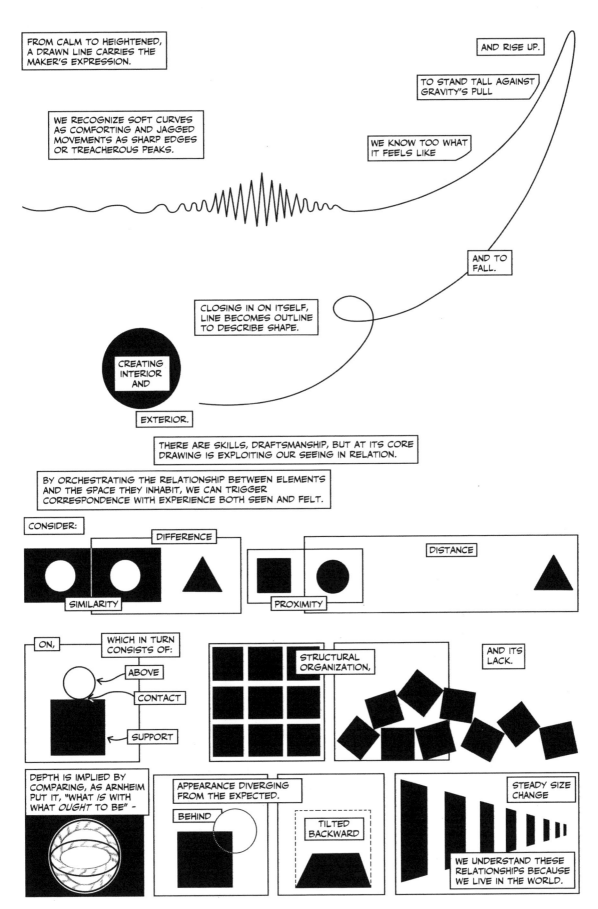

FROM CALM TO HEIGHTENED, A DRAWN LINE CARRIES THE MAKER'S EXPRESSION.

AND RISE UP.

TO STAND TALL AGAINST GRAVITY'S PULL

WE RECOGNIZE SOFT CURVES AS COMFORTING AND JAGGED MOVEMENTS AS SHARP EDGES OR TREACHEROUS PEAKS.

WE KNOW TOO WHAT IT FEELS LIKE

AND TO FALL.

CLOSING IN ON ITSELF, LINE BECOMES OUTLINE TO DESCRIBE SHAPE.

CREATING INTERIOR AND

EXTERIOR.

THERE ARE SKILLS, DRAFTSMANSHIP, BUT AT ITS CORE DRAWING IS EXPLOITING OUR SEEING IN RELATION.

BY ORCHESTRATING THE RELATIONSHIP BETWEEN ELEMENTS AND THE SPACE THEY INHABIT, WE CAN TRIGGER CORRESPONDENCE WITH EXPERIENCE BOTH SEEN AND FELT.

CONSIDER:

DIFFERENCE

DISTANCE

SIMILARITY

PROXIMITY

ON,

WHICH IN TURN CONSISTS OF:

ABOVE

CONTACT

SUPPORT

STRUCTURAL ORGANIZATION,

AND ITS LACK.

DEPTH IS IMPLIED BY COMPARING, AS ARNHEIM PUT IT, "WHAT *IS* WITH WHAT *OUGHT TO BE*" –

APPEARANCE DIVERGING FROM THE EXPECTED.

BEHIND

TILTED BACKWARD

STEADY SIZE CHANGE

WE UNDERSTAND THESE RELATIONSHIPS BECAUSE WE LIVE IN THE WORLD.

LAKOFF AND JOHNSON AND NÚÑEZ SAY THAT OUR FUNDAMENTAL CONCEPTS DO NOT SPRING FROM THE REALM OF PURE, DISEMBODIED REASON, BUT ARE GROUNDED IN OUR SEEING AND BEING IN THE WORLD.

THAT IS, THROUGH OUR EVERYDAY PERCEPTUAL AND BODILY ACTIVITIES, WE FORM DYNAMIC IMAGE-LIKE STRUCTURES THAT ENABLE US TO ORGANIZE AND MAKE SENSE OF OUR EXPERIENCE.

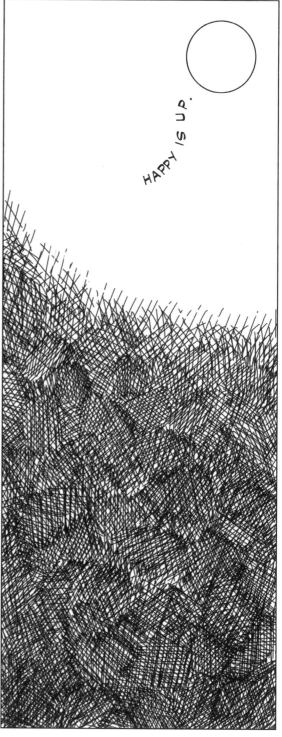

HAPPY IS UP.

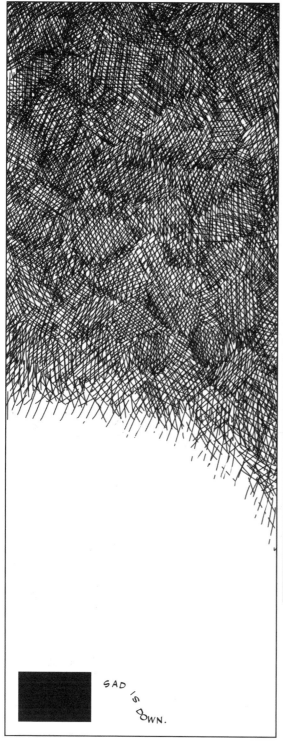

SAD IS DOWN.

THESE STRUCTURES OPERATE BELOW OUR CONSCIOUS AWARENESS AND SHAPE OUR THINKING AND BEHAVIOR.

CONCRETE EXPERIENCES SERVE AS THE PRIMARY BUILDING BLOCKS FROM WHICH WE EXTEND OUR CAPACITY FOR THOUGHT AND GIVE RISE TO MORE ABSTRACTED CONCEPTS.

WE UNDERSTAND THE NEW IN TERMS OF THE KNOWN.

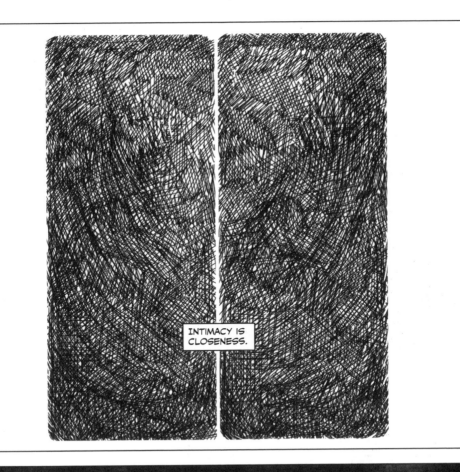

INTIMACY IS
CLOSENESS.

ISOLATION
IS APART

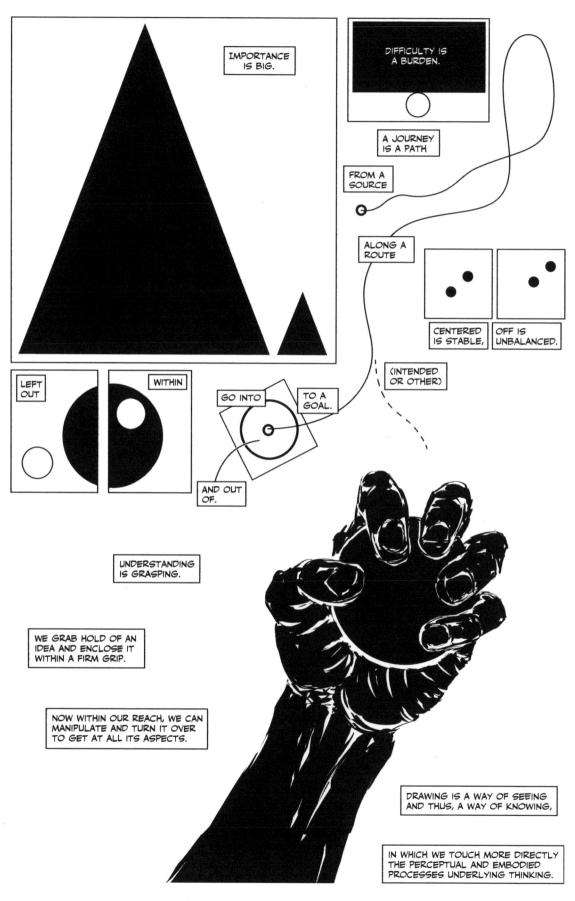

IMPORTANCE IS BIG.

DIFFICULTY IS A BURDEN.

A JOURNEY IS A PATH

FROM A SOURCE

ALONG A ROUTE

CENTERED IS STABLE,

OFF IS UNBALANCED.

LEFT OUT

WITHIN

GO INTO

TO A GOAL.

(INTENDED OR OTHER)

AND OUT OF.

UNDERSTANDING IS GRASPING.

WE GRAB HOLD OF AN IDEA AND ENCLOSE IT WITHIN A FIRM GRIP.

NOW WITHIN OUR REACH, WE CAN MANIPULATE AND TURN IT OVER TO GET AT ALL ITS ASPECTS.

DRAWING IS A WAY OF SEEING AND THUS, A WAY OF KNOWING,

IN WHICH WE TOUCH MORE DIRECTLY THE PERCEPTUAL AND EMBODIED PROCESSES UNDERLYING THINKING.

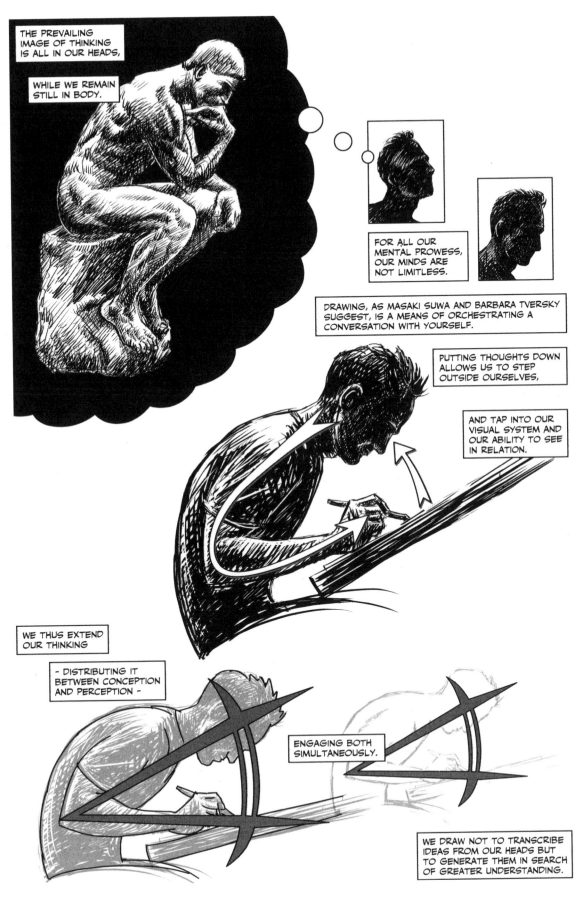

THE PREVAILING IMAGE OF THINKING IS ALL IN OUR HEADS,

WHILE WE REMAIN STILL IN BODY.

FOR ALL OUR MENTAL PROWESS, OUR MINDS ARE NOT LIMITLESS.

DRAWING, AS MASAKI SUWA AND BARBARA TVERSKY SUGGEST, IS A MEANS OF ORCHESTRATING A CONVERSATION WITH YOURSELF.

PUTTING THOUGHTS DOWN ALLOWS US TO STEP OUTSIDE OURSELVES,

AND TAP INTO OUR VISUAL SYSTEM AND OUR ABILITY TO SEE IN RELATION.

WE THUS EXTEND OUR THINKING

- DISTRIBUTING IT BETWEEN CONCEPTION AND PERCEPTION -

ENGAGING BOTH SIMULTANEOUSLY.

WE DRAW NOT TO TRANSCRIBE IDEAS FROM OUR HEADS BUT TO GENERATE THEM IN SEARCH OF GREATER UNDERSTANDING.

CHRIS MOFFETT WRITES THAT MOVING IS THE PROPER MODE OF THOUGHT: "THE WAY WE FIND OUR WAY." THE PHYSICAL ACTIVITY OF DRAWING OCCURS IN DYNAMIC RELATIONSHIP WITH THE ARTIST'S VISUAL RESPONSE TO WHAT'S PUT DOWN.

DRAWER AND DRAWING JOURNEY FORTH INTO THE UNKNOWN TOGETHER.

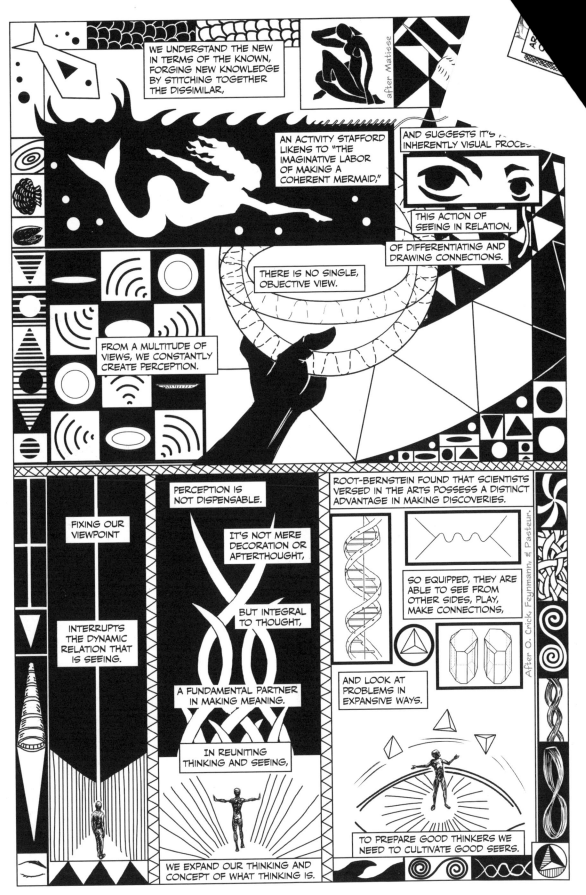

WE UNDERSTAND THE NEW IN TERMS OF THE KNOWN, FORGING NEW KNOWLEDGE BY STITCHING TOGETHER THE DISSIMILAR,

after Matisse

AN ACTIVITY STAFFORD LIKENS TO "THE IMAGINATIVE LABOR OF MAKING A COHERENT MERMAID,"

AND SUGGESTS IT'S ... INHERENTLY VISUAL PROCESS.

THIS ACTION OF SEEING IN RELATION,

OF DIFFERENTIATING AND DRAWING CONNECTIONS.

THERE IS NO SINGLE, OBJECTIVE VIEW.

FROM A MULTITUDE OF VIEWS, WE CONSTANTLY CREATE PERCEPTION.

PERCEPTION IS NOT DISPENSABLE.

FIXING OUR VIEWPOINT

IT'S NOT MERE DECORATION OR AFTERTHOUGHT,

ROOT-BERNSTEIN FOUND THAT SCIENTISTS VERSED IN THE ARTS POSSESS A DISTINCT ADVANTAGE IN MAKING DISCOVERIES.

After O. Crick, Feynmann, & Pasteur.

SO EQUIPPED, THEY ARE ABLE TO SEE FROM OTHER SIDES, PLAY, MAKE CONNECTIONS,

BUT INTEGRAL TO THOUGHT,

INTERRUPTS THE DYNAMIC RELATION THAT IS SEEING.

AND LOOK AT PROBLEMS IN EXPANSIVE WAYS.

A FUNDAMENTAL PARTNER IN MAKING MEANING.

IN REUNITING THINKING AND SEEING,

TO PREPARE GOOD THINKERS WE NEED TO CULTIVATE GOOD SEERS.

WE EXPAND OUR THINKING AND CONCEPT OF WHAT THINKING IS.

81

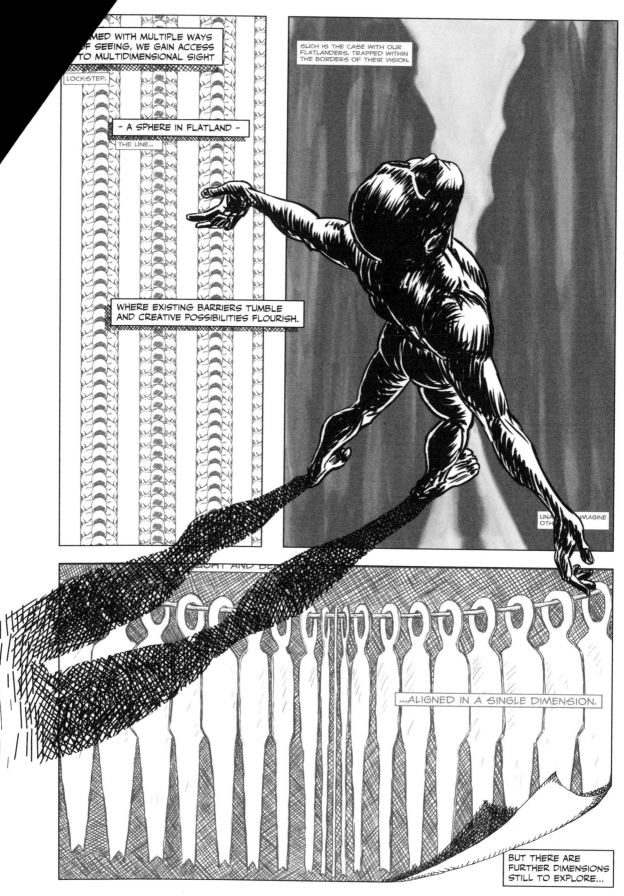

...MED WITH MULTIPLE WAYS
...F SEEING, WE GAIN ACCESS
...TO MULTIDIMENSIONAL SIGHT

LOCKSTEP,

- A SPHERE IN FLATLAND -

THE LINE...

WHERE EXISTING BARRIERS TUMBLE
AND CREATIVE POSSIBILITIES FLOURISH.

SUCH IS THE CASE WITH OUR
FLATLANDERS, TRAPPED WITHIN
THE BORDERS OF THEIR VISION.

...ALIGNED IN A SINGLE DIMENSION.

BUT THERE ARE
FURTHER DIMENSIONS
STILL TO EXPLORE...

82

five

THE FIFTH DIMENSION

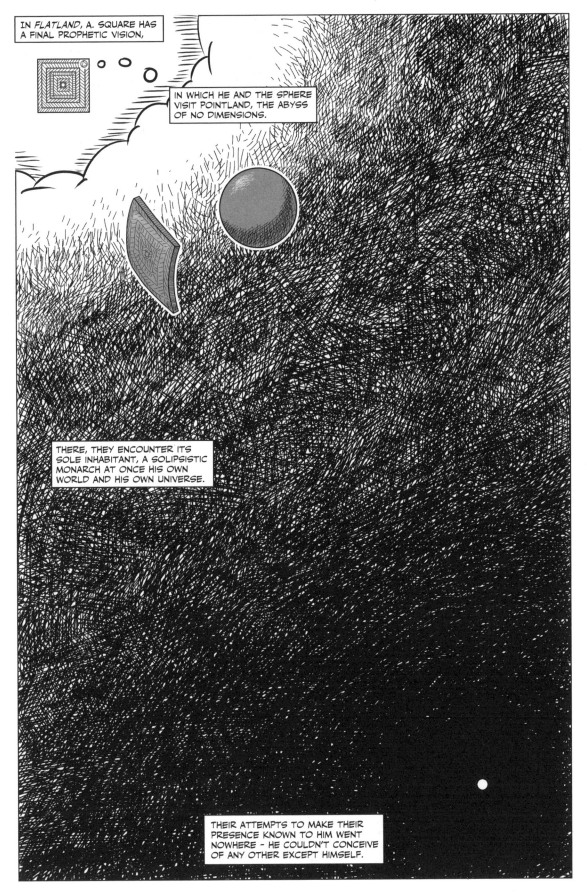

IN *FLATLAND*, A. SQUARE HAS A FINAL PROPHETIC VISION,

IN WHICH HE AND THE SPHERE VISIT POINTLAND, THE ABYSS OF NO DIMENSIONS.

THERE, THEY ENCOUNTER ITS SOLE INHABITANT, A SOLIPSISTIC MONARCH AT ONCE HIS OWN WORLD AND HIS OWN UNIVERSE.

THEIR ATTEMPTS TO MAKE THEIR PRESENCE KNOWN TO HIM WENT NOWHERE – HE COULDN'T CONCEIVE OF ANY OTHER EXCEPT HIMSELF.

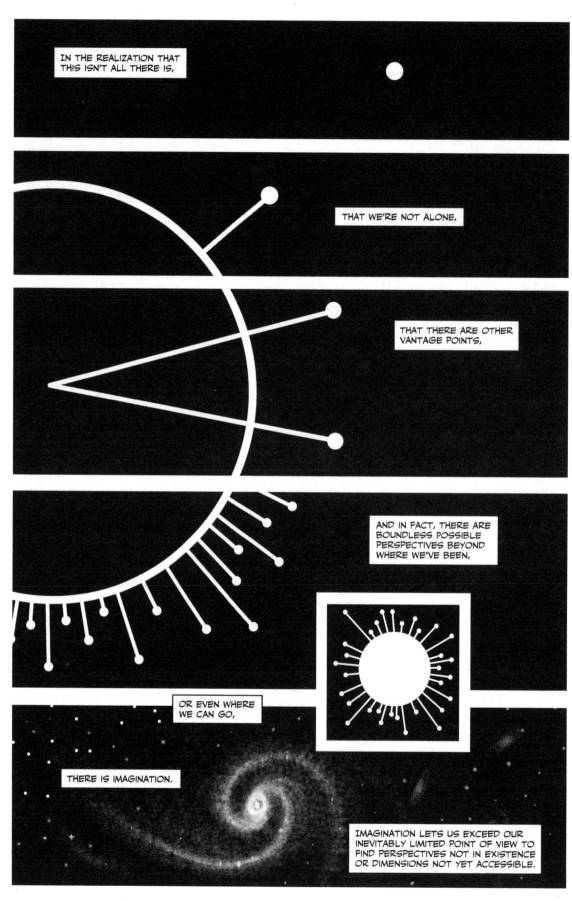

IN THE REALIZATION THAT THIS ISN'T ALL THERE IS,

THAT WE'RE NOT ALONE,

THAT THERE ARE OTHER VANTAGE POINTS,

AND IN FACT, THERE ARE BOUNDLESS POSSIBLE PERSPECTIVES BEYOND WHERE WE'VE BEEN,

OR EVEN WHERE WE CAN GO,

THERE IS IMAGINATION.

IMAGINATION LETS US EXCEED OUR INEVITABLY LIMITED POINT OF VIEW TO FIND PERSPECTIVES NOT IN EXISTENCE OR DIMENSIONS NOT YET ACCESSIBLE.

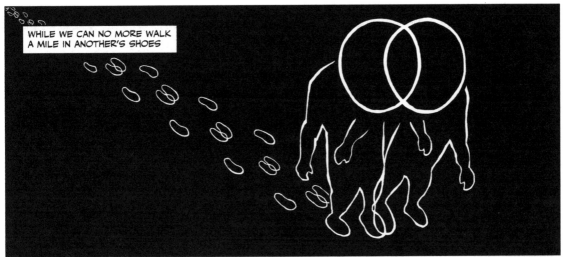

WHILE WE CAN NO MORE WALK A MILE IN ANOTHER'S SHOES

THAN SEE THROUGH THEIR EYES,

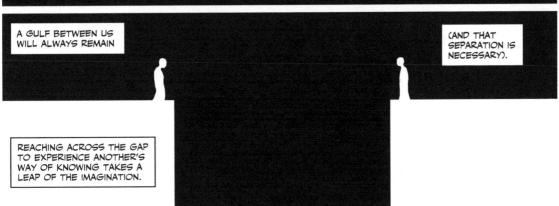

A GULF BETWEEN US WILL ALWAYS REMAIN

(AND THAT SEPARATION IS NECESSARY).

REACHING ACROSS THE GAP TO EXPERIENCE ANOTHER'S WAY OF KNOWING TAKES A LEAP OF THE IMAGINATION.

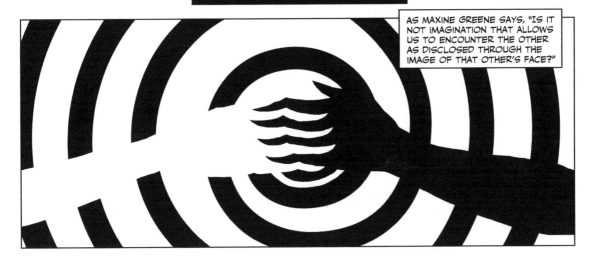

AS MAXINE GREENE SAYS, "IS IT NOT IMAGINATION THAT ALLOWS US TO ENCOUNTER THE OTHER AS DISCLOSED THROUGH THE IMAGE OF THAT OTHER'S FACE?"

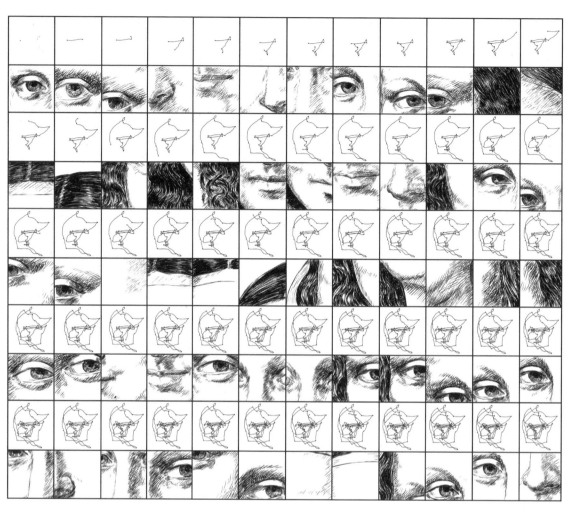

"TO ENCOUNTER" THE WORLD OUTSIDE OURSELVES,

DANCING AND DARTING, OUR EYES GO TO WORK, A FLURRY OF MOTION PUNCTUATED BY BRIEF PAUSES A FEW TIMES A SECOND IN WHICH THEY FIX ON A TARGET – BEFORE DASHING OFF TO SEEK ANOTHER OF INTEREST.

OUR VISION CAPTURES DISCONNECTED STATIC SNAPSHOTS, AN INCOMPLETE PICTURE RIDDLED WITH GAPS.

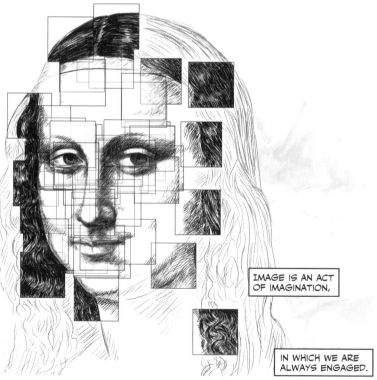

IT IS THE IMAGINATION, ETIENNE PELAPRAT AND MICHAEL COLE ASSERT, THAT FILLS IN THE GAPS AND LINKS FRAGMENTS TO CREATE STABLE AND SINGLE IMAGES THAT MAKE IT POSSIBLE FOR US TO THINK AND TO ACT.

IMAGE IS AN ACT OF IMAGINATION,

IN WHICH WE ARE ALWAYS ENGAGED.

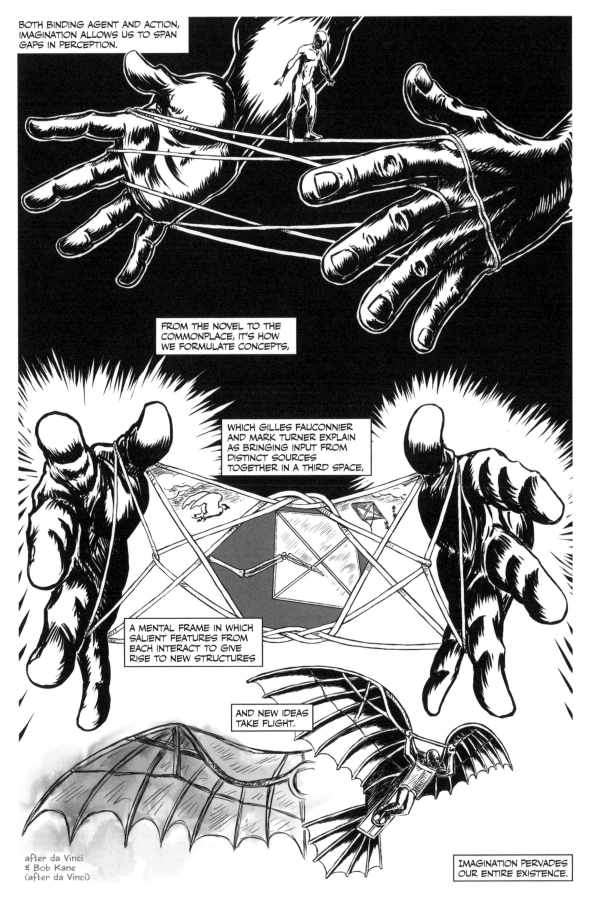

BOTH BINDING AGENT AND ACTION, IMAGINATION ALLOWS US TO SPAN GAPS IN PERCEPTION.

FROM THE NOVEL TO THE COMMONPLACE, IT'S HOW WE FORMULATE CONCEPTS,

WHICH GILLES FAUCONNIER AND MARK TURNER EXPLAIN AS BRINGING INPUT FROM DISTINCT SOURCES TOGETHER IN A THIRD SPACE,

A MENTAL FRAME IN WHICH SALIENT FEATURES FROM EACH INTERACT TO GIVE RISE TO NEW STRUCTURES

AND NEW IDEAS TAKE FLIGHT.

after da Vinci & Bob Kane (after da Vinci)

IMAGINATION PERVADES OUR ENTIRE EXISTENCE.

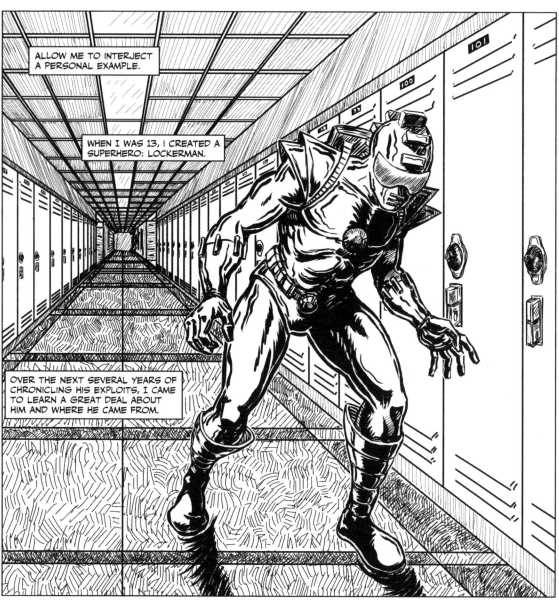

ALLOW ME TO INTERJECT A PERSONAL EXAMPLE.

WHEN I WAS 13, I CREATED A SUPERHERO: LOCKERMAN.

OVER THE NEXT SEVERAL YEARS OF CHRONICLING HIS EXPLOITS, I CAME TO LEARN A GREAT DEAL ABOUT HIM AND WHERE HE CAME FROM.

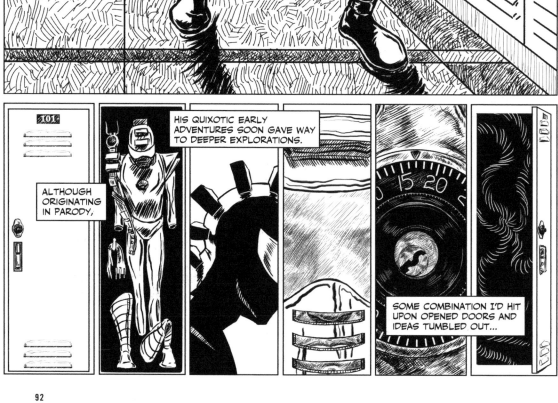

HIS QUIXOTIC EARLY ADVENTURES SOON GAVE WAY TO DEEPER EXPLORATIONS.

ALTHOUGH ORIGINATING IN PARODY,

SOME COMBINATION I'D HIT UPON OPENED DOORS AND IDEAS TUMBLED OUT...

92

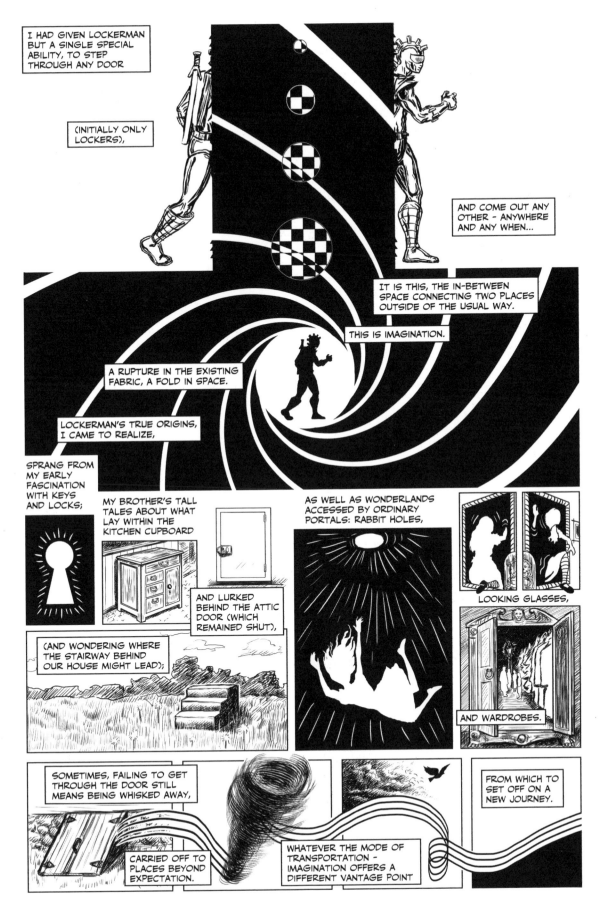

I HAD GIVEN LOCKERMAN BUT A SINGLE SPECIAL ABILITY, TO STEP THROUGH ANY DOOR

(INITIALLY ONLY LOCKERS),

AND COME OUT ANY OTHER – ANYWHERE AND ANY WHEN...

IT IS THIS, THE IN-BETWEEN SPACE CONNECTING TWO PLACES OUTSIDE OF THE USUAL WAY.

THIS IS IMAGINATION.

A RUPTURE IN THE EXISTING FABRIC, A FOLD IN SPACE.

LOCKERMAN'S TRUE ORIGINS, I CAME TO REALIZE,

SPRANG FROM MY EARLY FASCINATION WITH KEYS AND LOCKS;

MY BROTHER'S TALL TALES ABOUT WHAT LAY WITHIN THE KITCHEN CUPBOARD

AND LURKED BEHIND THE ATTIC DOOR (WHICH REMAINED SHUT),

(AND WONDERING WHERE THE STAIRWAY BEHIND OUR HOUSE MIGHT LEAD);

AS WELL AS WONDERLANDS ACCESSED BY ORDINARY PORTALS: RABBIT HOLES,

LOOKING GLASSES,

AND WARDROBES.

SOMETIMES, FAILING TO GET THROUGH THE DOOR STILL MEANS BEING WHISKED AWAY,

CARRIED OFF TO PLACES BEYOND EXPECTATION.

WHATEVER THE MODE OF TRANSPORTATION – IMAGINATION OFFERS A DIFFERENT VANTAGE POINT

FROM WHICH TO SET OFF ON A NEW JOURNEY.

REFLECTING UPON THIS NOW
BRINGS TO MIND SWIFT HERMES,
THE MESSENGER, GUIDE AND
GUARDIAN TO TRAVELERS

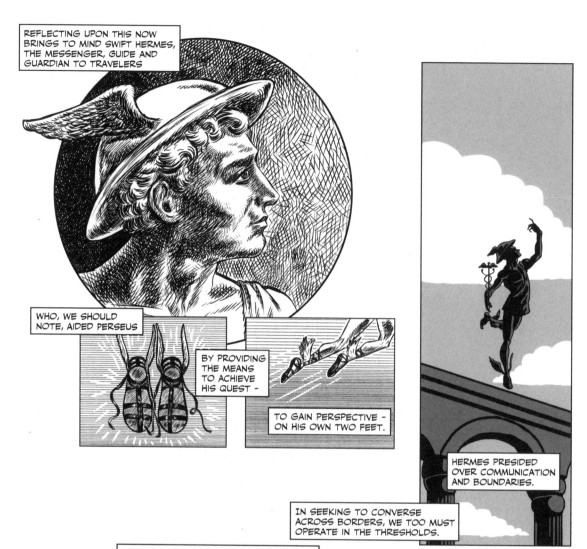

WHO, WE SHOULD
NOTE, AIDED PERSEUS

BY PROVIDING
THE MEANS
TO ACHIEVE
HIS QUEST –

TO GAIN PERSPECTIVE –
ON HIS OWN TWO FEET.

HERMES PRESIDED
OVER COMMUNICATION
AND BOUNDARIES.

IN SEEKING TO CONVERSE
ACROSS BORDERS, WE TOO MUST
OPERATE IN THE THRESHOLDS.

CONSIDER A DOOR'S DUAL NATURE,
SIMULTANEOUSLY BARRIER AND BRIDGE

INTENDED TO
KEEP OUT,

WHILE ALSO SERVING AS
AN INVITATION TO ENTER.

FROM ABOVE,

A DOOR CAN BE BOTH FLAT

AND NOT.

ITS HINGE ALLOWS
FOR THE POSSIBILITY
OF AN OPENING,

THROUGH WHICH TO PASS AND DISPLACE
ONE'S EXISTING FRAME OF REFERENCE.

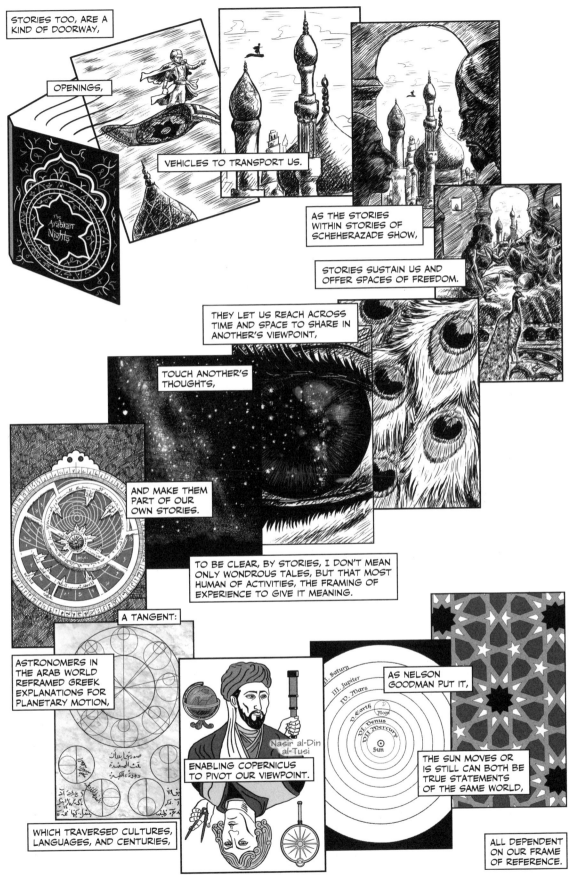

STORIES TOO, ARE A KIND OF DOORWAY,

OPENINGS,

VEHICLES TO TRANSPORT US.

AS THE STORIES WITHIN STORIES OF SCHEHERAZADE SHOW,

STORIES SUSTAIN US AND OFFER SPACES OF FREEDOM.

THEY LET US REACH ACROSS TIME AND SPACE TO SHARE IN ANOTHER'S VIEWPOINT,

TOUCH ANOTHER'S THOUGHTS,

AND MAKE THEM PART OF OUR OWN STORIES.

TO BE CLEAR, BY STORIES, I DON'T MEAN ONLY WONDROUS TALES, BUT THAT MOST HUMAN OF ACTIVITIES, THE FRAMING OF EXPERIENCE TO GIVE IT MEANING.

A TANGENT:

ASTRONOMERS IN THE ARAB WORLD REFRAMED GREEK EXPLANATIONS FOR PLANETARY MOTION,

Nasir al-Din al-Tusi

ENABLING COPERNICUS TO PIVOT OUR VIEWPOINT.

WHICH TRAVERSED CULTURES, LANGUAGES, AND CENTURIES,

AS NELSON GOODMAN PUT IT,

THE SUN MOVES OR IS STILL CAN BOTH BE TRUE STATEMENTS OF THE SAME WORLD,

ALL DEPENDENT ON OUR FRAME OF REFERENCE.

95

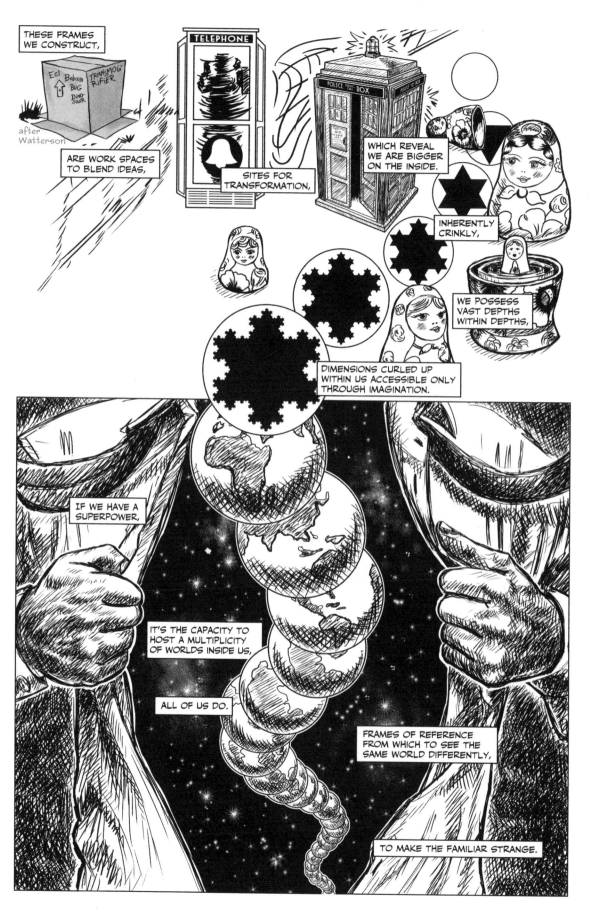

THESE FRAMES WE CONSTRUCT,

Ecl Baboon BUG Dino-saur TRANSMOGRIFIER

after Watterson

ARE WORK SPACES TO BLEND IDEAS,

TELEPHONE

POLICE BOX

SITES FOR TRANSFORMATION,

WHICH REVEAL WE ARE BIGGER ON THE INSIDE.

INHERENTLY CRINKLY,

WE POSSESS VAST DEPTHS WITHIN DEPTHS,

DIMENSIONS CURLED UP WITHIN US ACCESSIBLE ONLY THROUGH IMAGINATION.

IF WE HAVE A SUPERPOWER,

IT'S THE CAPACITY TO HOST A MULTIPLICITY OF WORLDS INSIDE US,

ALL OF US DO.

FRAMES OF REFERENCE FROM WHICH TO SEE THE SAME WORLD DIFFERENTLY,

TO MAKE THE FAMILIAR STRANGE.

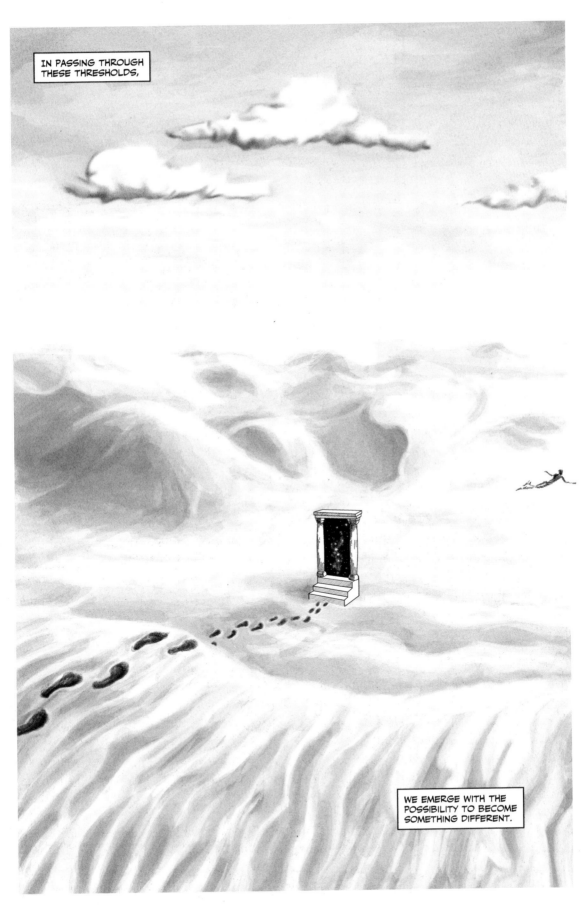

IN PASSING THROUGH THESE THRESHOLDS,

WE EMERGE WITH THE POSSIBILITY TO BECOME SOMETHING DIFFERENT.

six

RUTS

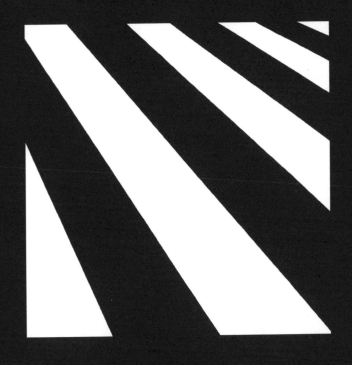

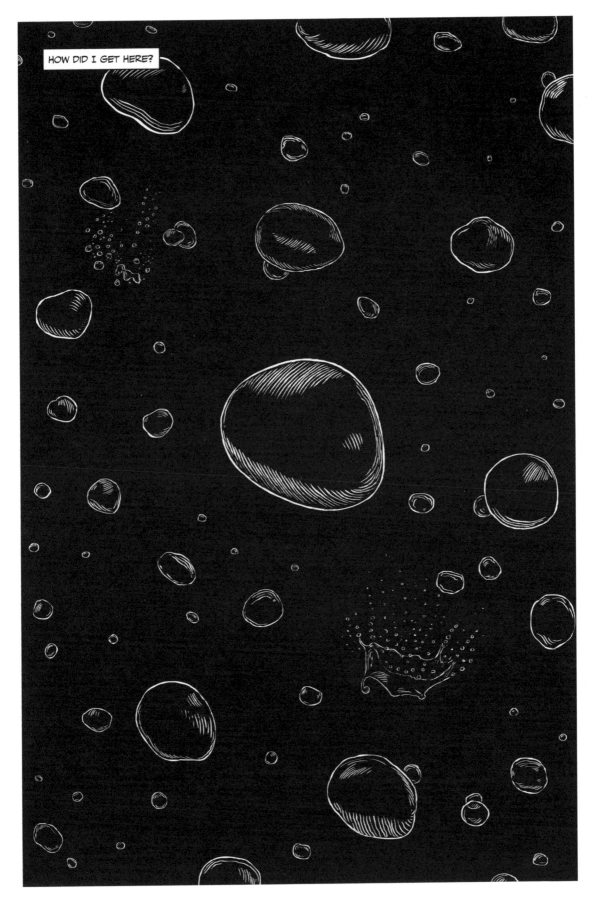

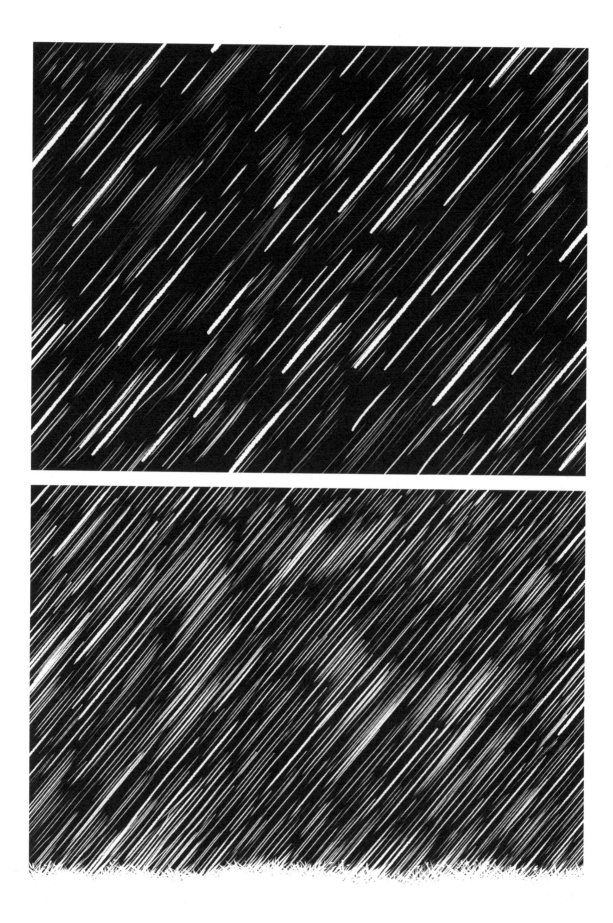

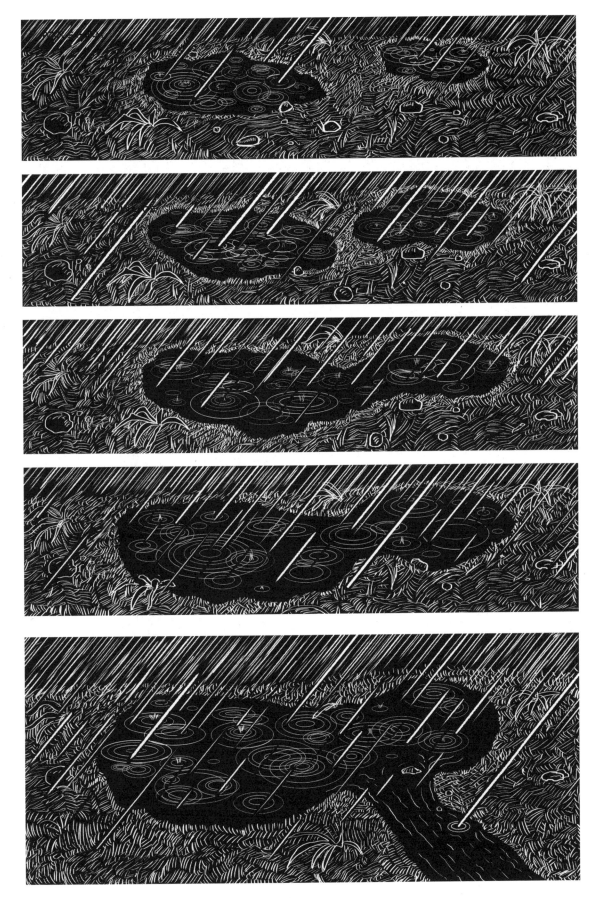

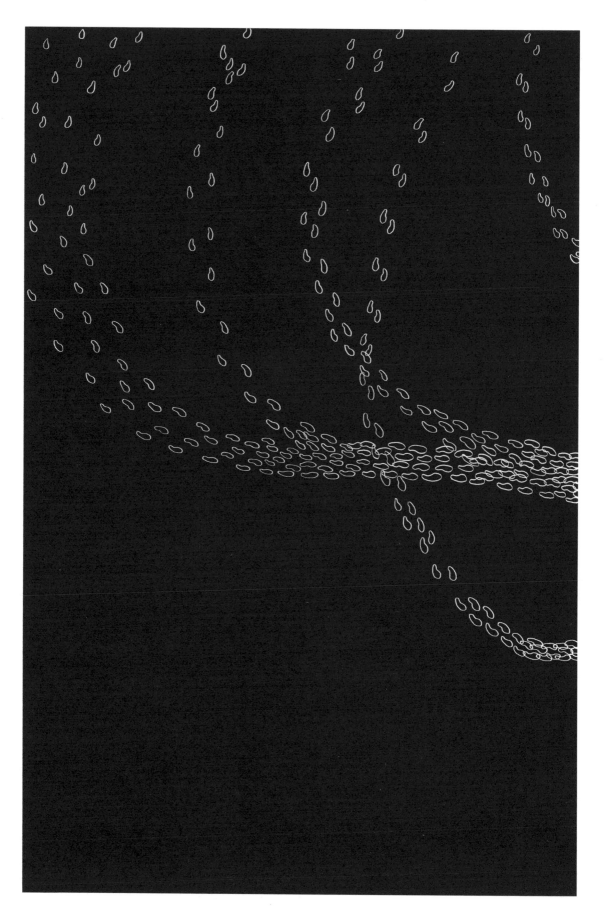

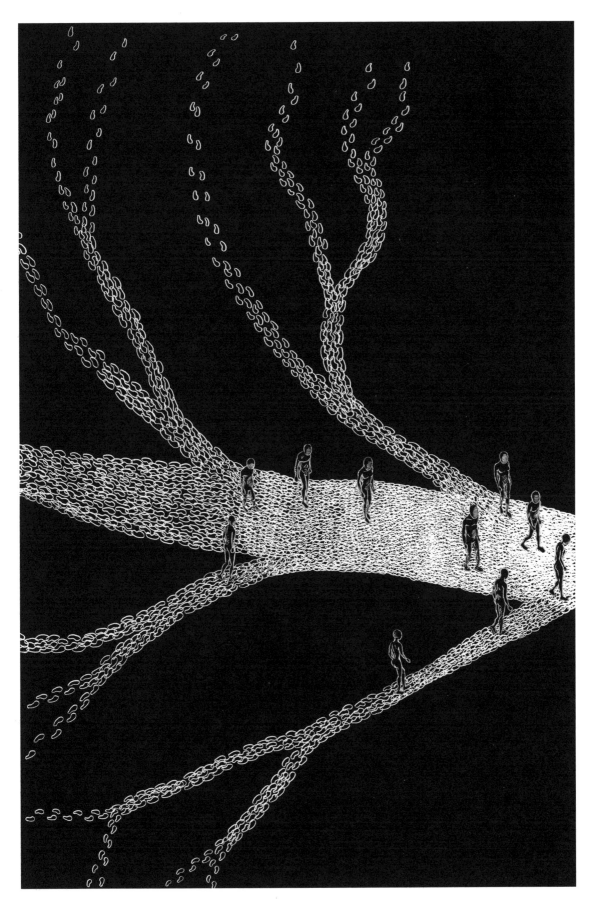

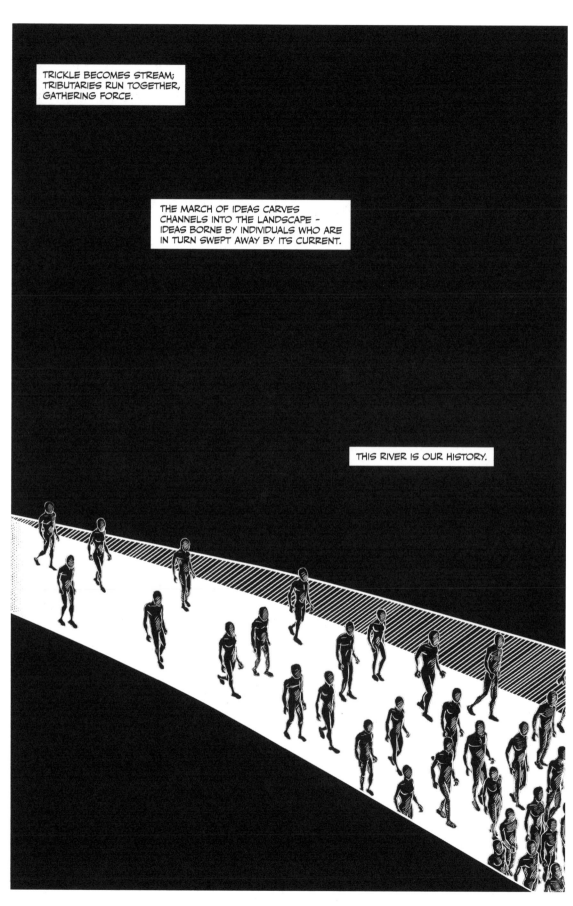

TRICKLE BECOMES STREAM; TRIBUTARIES RUN TOGETHER, GATHERING FORCE.

THE MARCH OF IDEAS CARVES CHANNELS INTO THE LANDSCAPE – IDEAS BORNE BY INDIVIDUALS WHO ARE IN TURN SWEPT AWAY BY ITS CURRENT.

THIS RIVER IS OUR HISTORY.

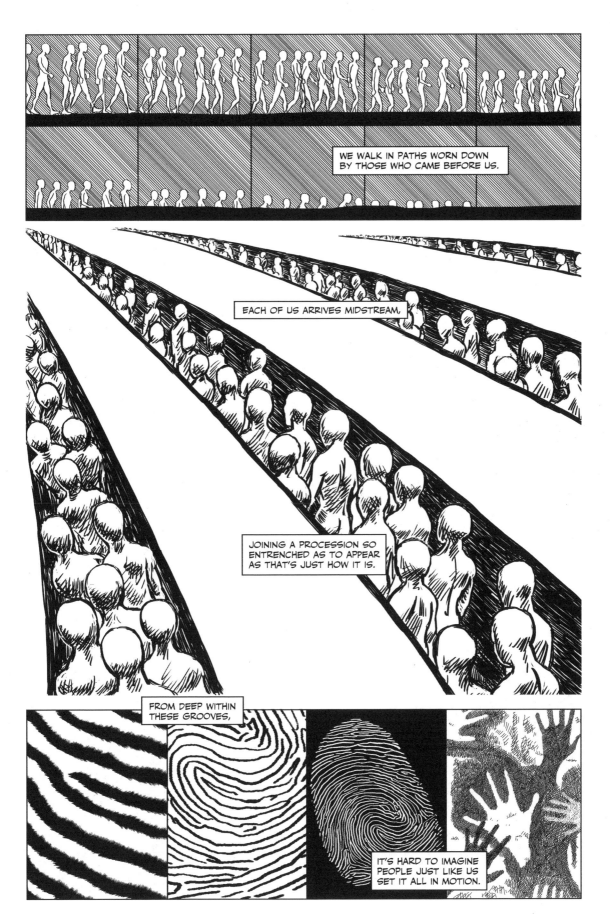

WE WALK IN PATHS WORN DOWN BY THOSE WHO CAME BEFORE US.

EACH OF US ARRIVES MIDSTREAM,

JOINING A PROCESSION SO ENTRENCHED AS TO APPEAR AS THAT'S JUST HOW IT IS.

FROM DEEP WITHIN THESE GROOVES,

IT'S HARD TO IMAGINE PEOPLE JUST LIKE US SET IT ALL IN MOTION.

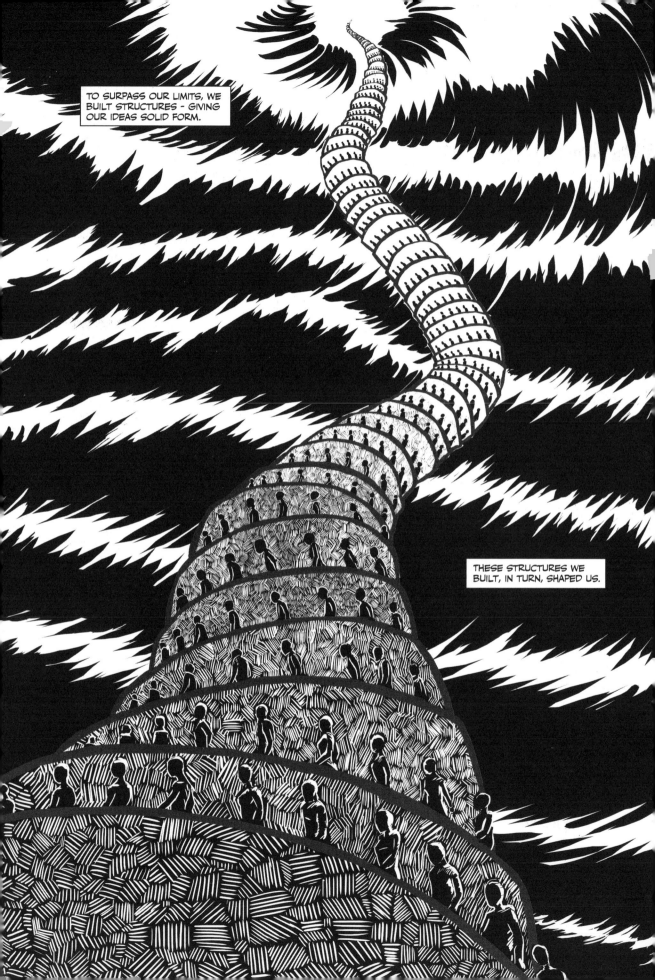

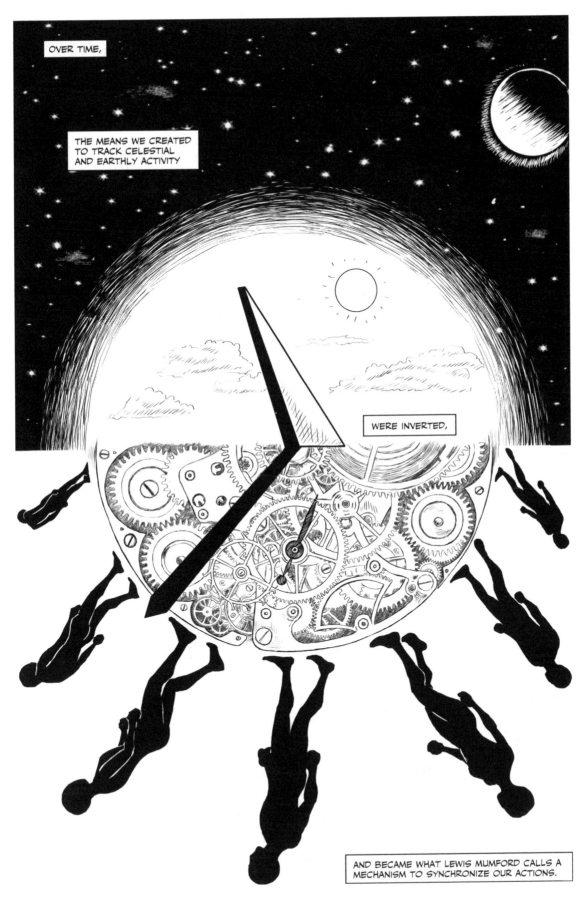

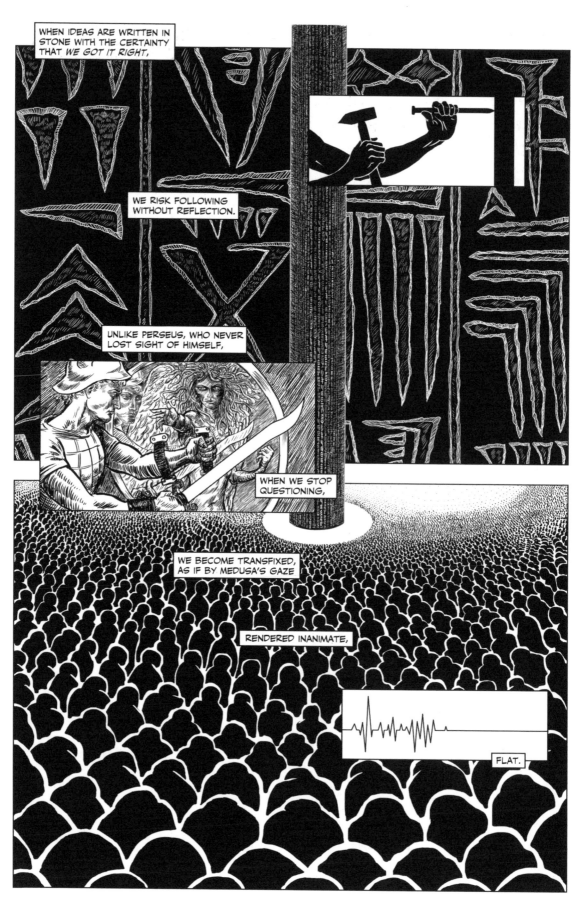

WHEN IDEAS ARE WRITTEN IN STONE WITH THE CERTAINTY THAT *WE GOT IT RIGHT*,

WE RISK FOLLOWING WITHOUT REFLECTION.

UNLIKE PERSEUS, WHO NEVER LOST SIGHT OF HIMSELF,

WHEN WE STOP QUESTIONING,

WE BECOME TRANSFIXED, AS IF BY MEDUSA'S GAZE

RENDERED INANIMATE,

FLAT.

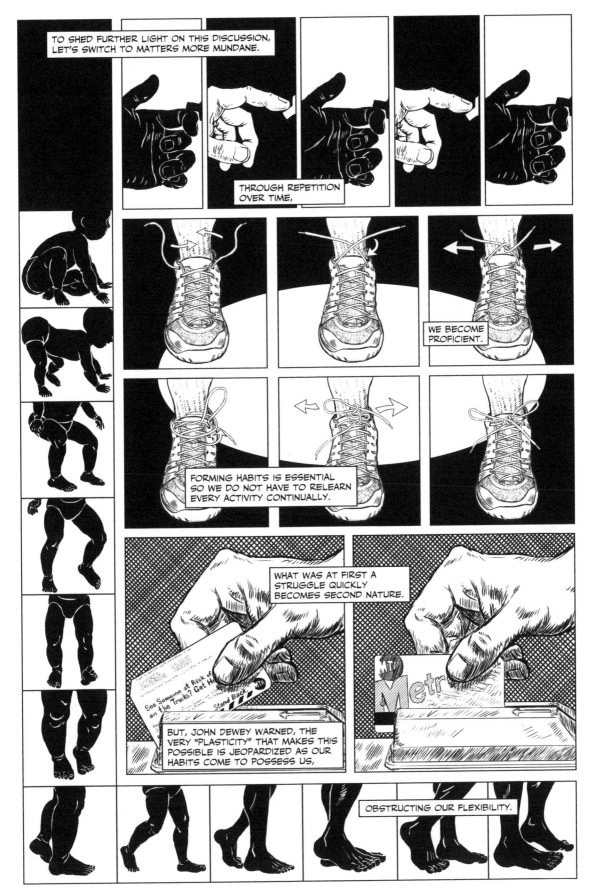

TO SHED FURTHER LIGHT ON THIS DISCUSSION, LET'S SWITCH TO MATTERS MORE MUNDANE.

THROUGH REPETITION OVER TIME,

WE BECOME PROFICIENT.

FORMING HABITS IS ESSENTIAL SO WE DO NOT HAVE TO RELEARN EVERY ACTIVITY CONTINUALLY.

WHAT WAS AT FIRST A STRUGGLE QUICKLY BECOMES SECOND NATURE.

BUT, JOHN DEWEY WARNED, THE VERY "PLASTICITY" THAT MAKES THIS POSSIBLE IS JEOPARDIZED AS OUR HABITS COME TO POSSESS US,

OBSTRUCTING OUR FLEXIBILITY.

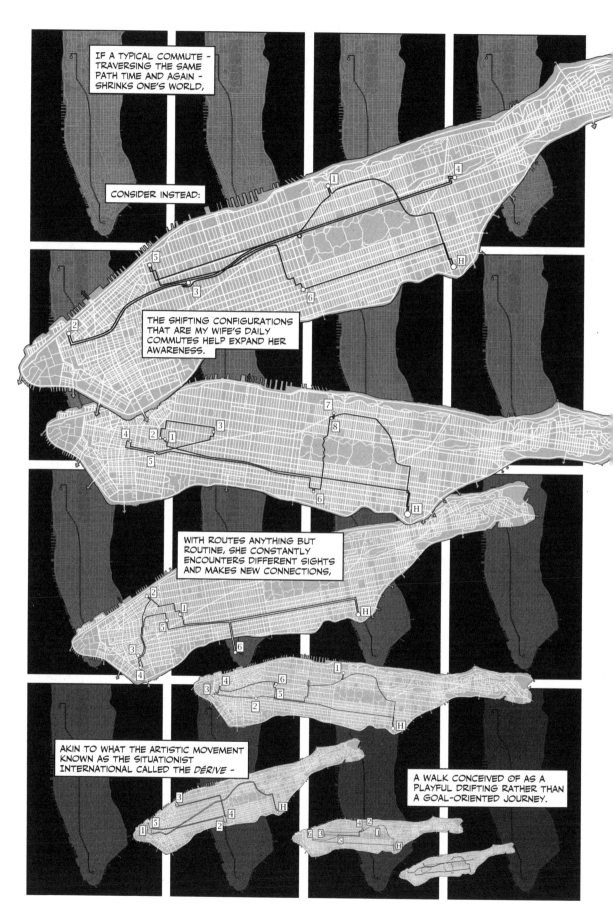

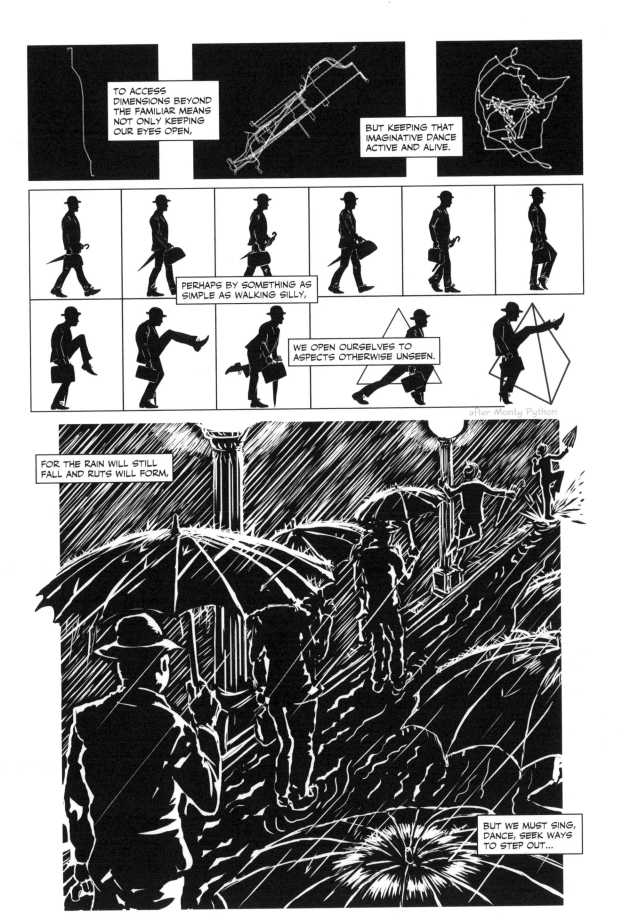

TO ACCESS DIMENSIONS BEYOND THE FAMILIAR MEANS NOT ONLY KEEPING OUR EYES OPEN,

BUT KEEPING THAT IMAGINATIVE DANCE ACTIVE AND ALIVE.

PERHAPS BY SOMETHING AS SIMPLE AS WALKING SILLY,

WE OPEN OURSELVES TO ASPECTS OTHERWISE UNSEEN.

after Monty Python

FOR THE RAIN WILL STILL FALL AND RUTS WILL FORM,

BUT WE MUST SING, DANCE, SEEK WAYS TO STEP OUT...

113

interlude

STRINGS ATTACHED

As you will recall, through the action of mentally binding and framing separate concepts, we generate new understandings.

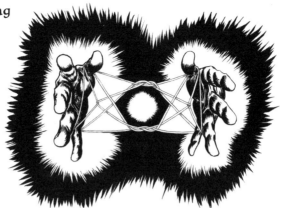

Stories provide us with such frames, openings through which to pass.

So then, imagine if you will,

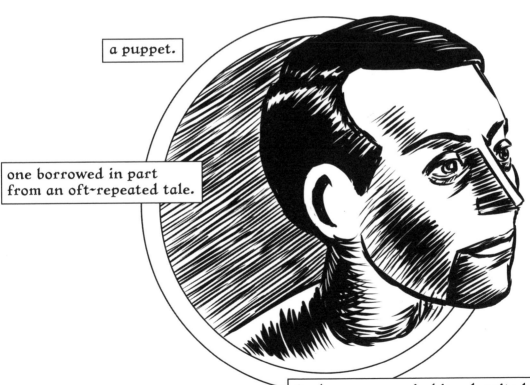

a puppet.

one borrowed in part from an oft~repeated tale.

And we may see in him, despite his physical dimensionality, something akin to our flatlanders...

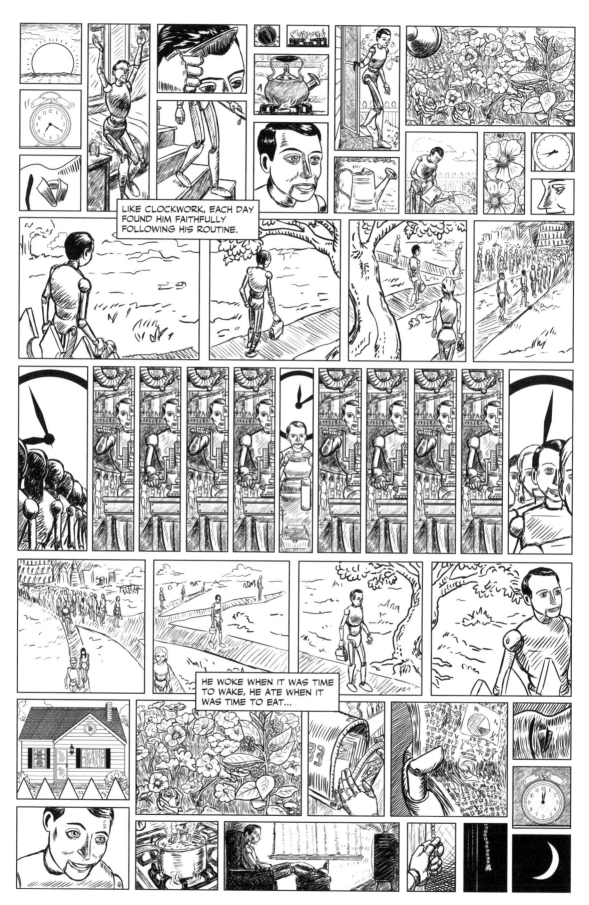

LIKE CLOCKWORK, EACH DAY FOUND HIM FAITHFULLY FOLLOWING HIS ROUTINE.

HE WOKE WHEN IT WAS TIME TO WAKE, HE ATE WHEN IT WAS TIME TO EAT...

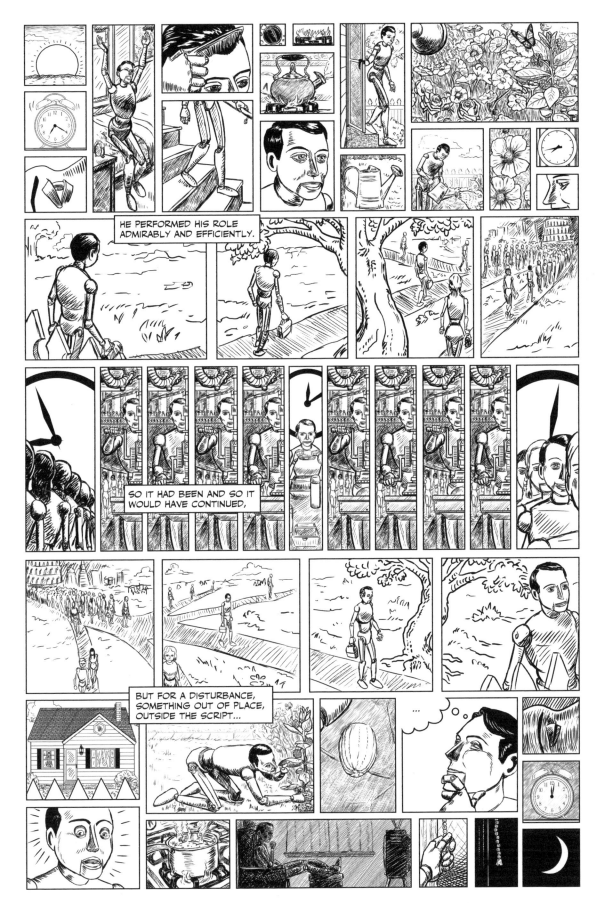

HE PERFORMED HIS ROLE ADMIRABLY AND EFFICIENTLY.

SO IT HAD BEEN AND SO IT WOULD HAVE CONTINUED,

BUT FOR A DISTURBANCE, SOMETHING OUT OF PLACE, OUTSIDE THE SCRIPT...

...

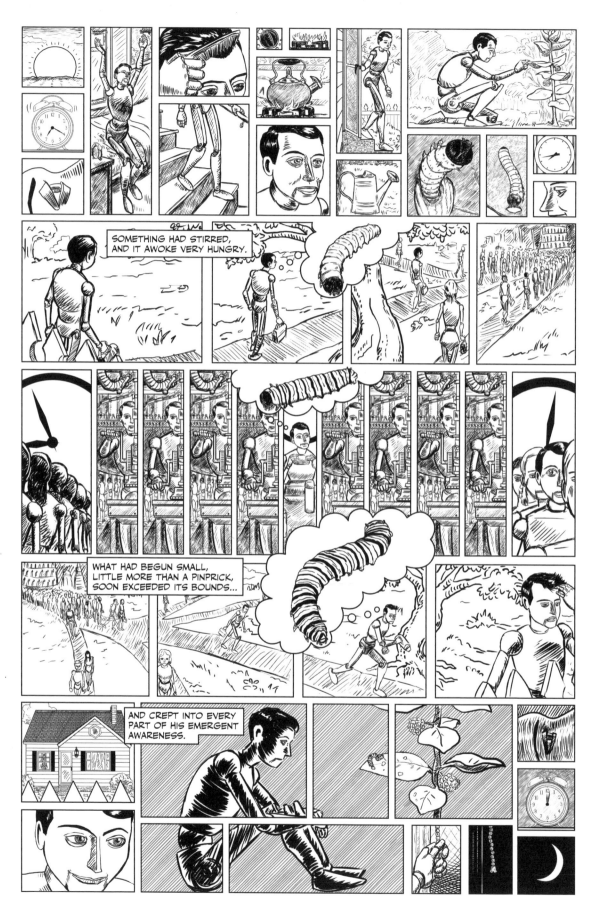

SOMETHING HAD STIRRED, AND IT AWOKE VERY HUNGRY.

WHAT HAD BEGUN SMALL, LITTLE MORE THAN A PINPRICK, SOON EXCEEDED ITS BOUNDS...

AND CREPT INTO EVERY PART OF HIS EMERGENT AWARENESS.

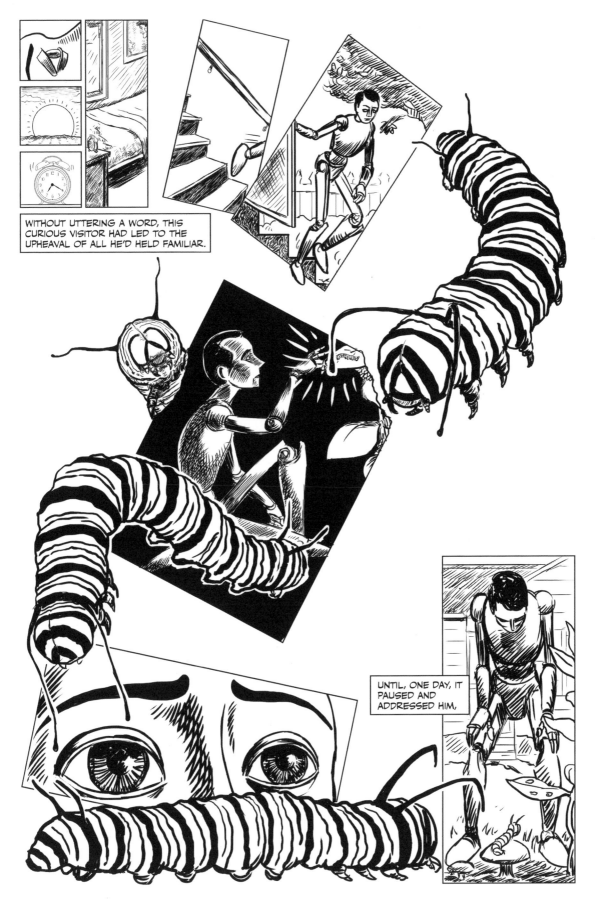

WITHOUT UTTERING A WORD, THIS CURIOUS VISITOR HAD LED TO THE UPHEAVAL OF ALL HE'D HELD FAMILIAR.

UNTIL, ONE DAY, IT PAUSED AND ADDRESSED HIM,

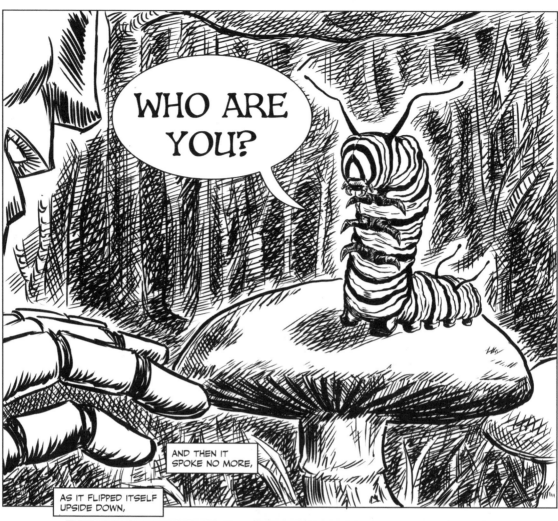

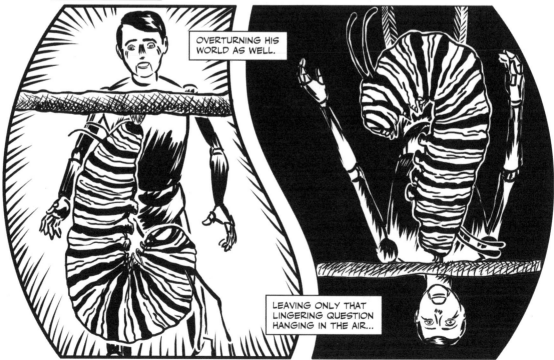

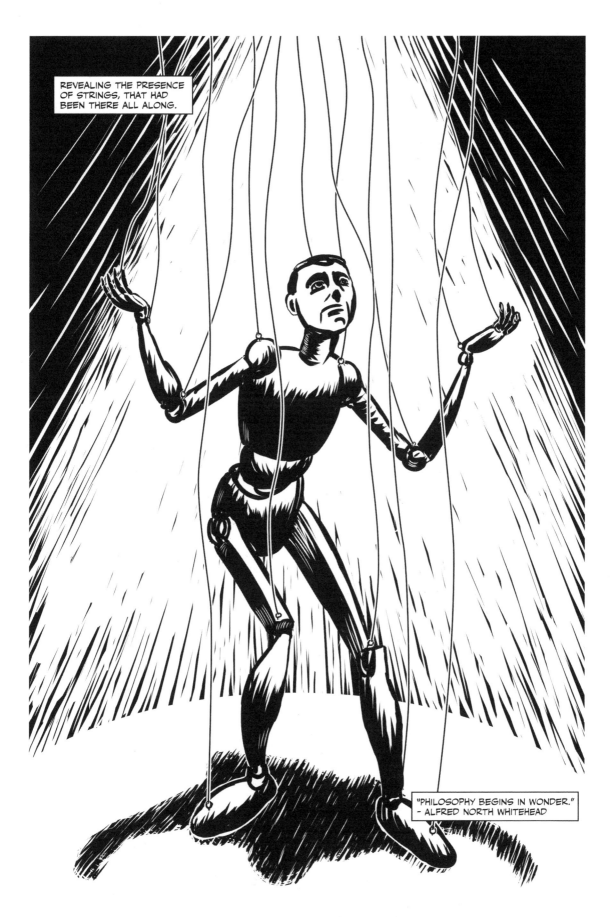

123

seven

VECTORS

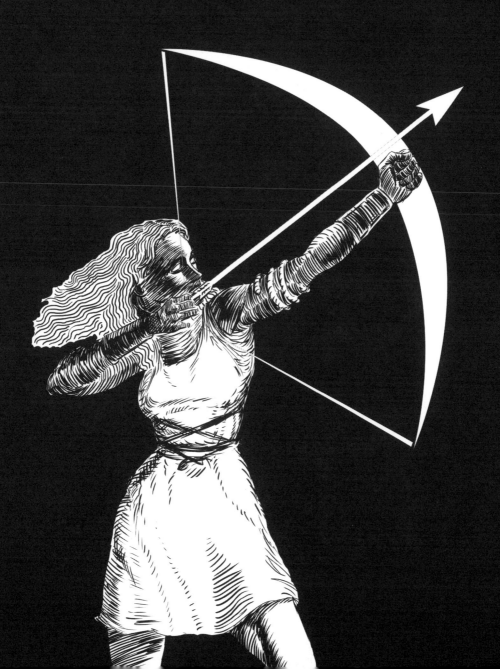

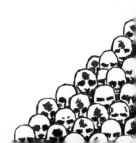

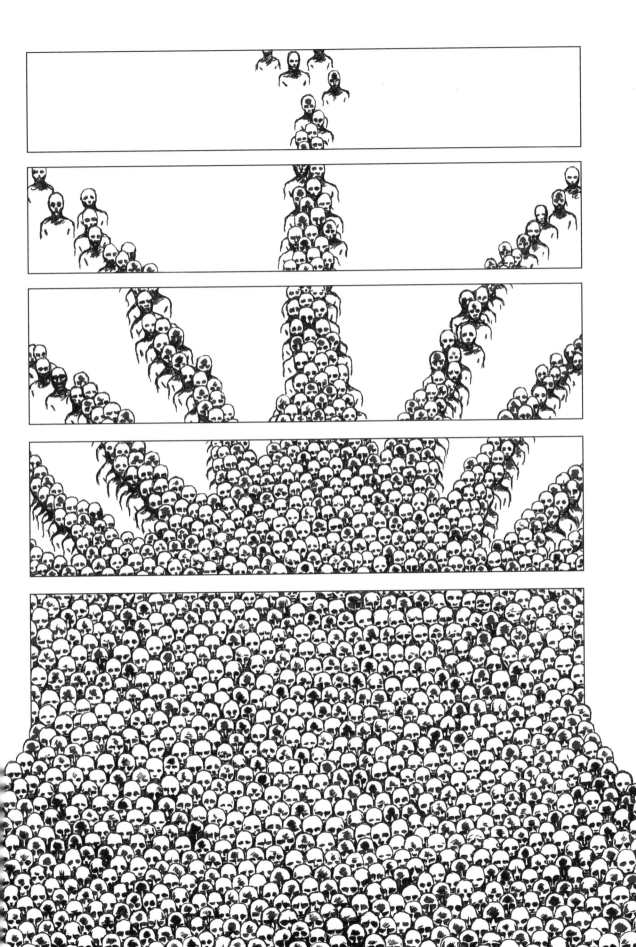

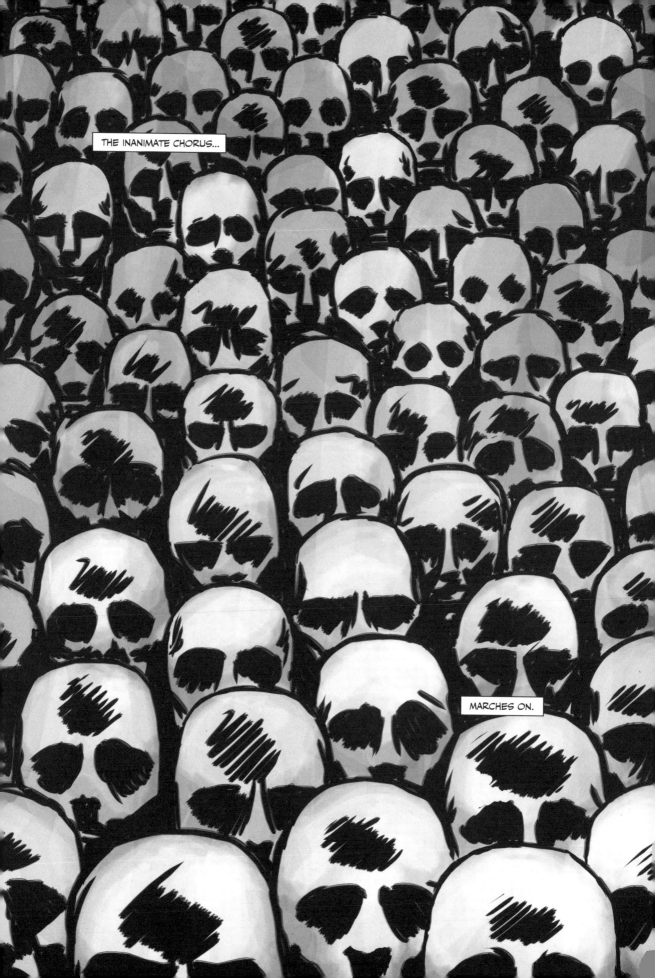

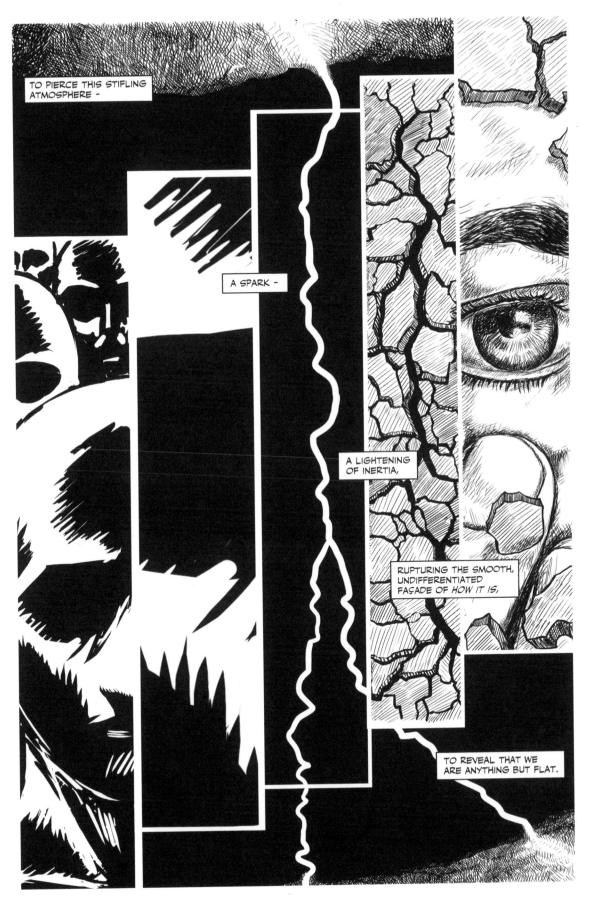

TO PIERCE THIS STIFLING ATMOSPHERE –

A SPARK –

A LIGHTENING OF INERTIA,

RUPTURING THE SMOOTH, UNDIFFERENTIATED FAÇADE OF *HOW IT IS,*

TO REVEAL THAT WE ARE ANYTHING BUT FLAT.

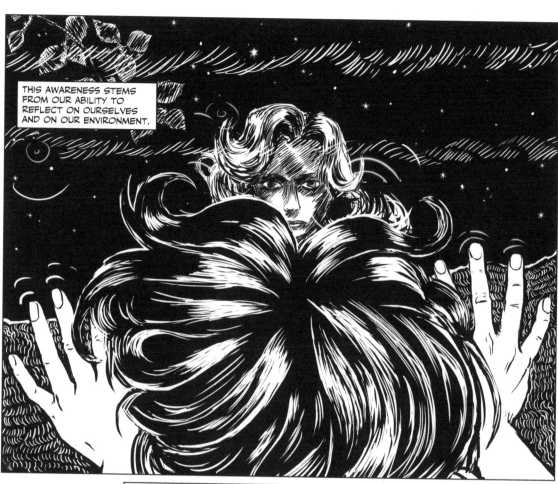

THIS AWARENESS STEMS
FROM OUR ABILITY TO
REFLECT ON OURSELVES
AND ON OUR ENVIRONMENT.

WE CAN BE BOTH PRESENT AND
AT THE SAME TIME REMOVED –

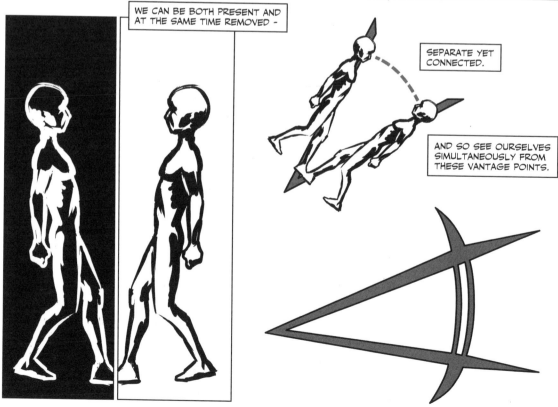

SEPARATE YET
CONNECTED.

AND SO SEE OURSELVES
SIMULTANEOUSLY FROM
THESE VANTAGE POINTS.

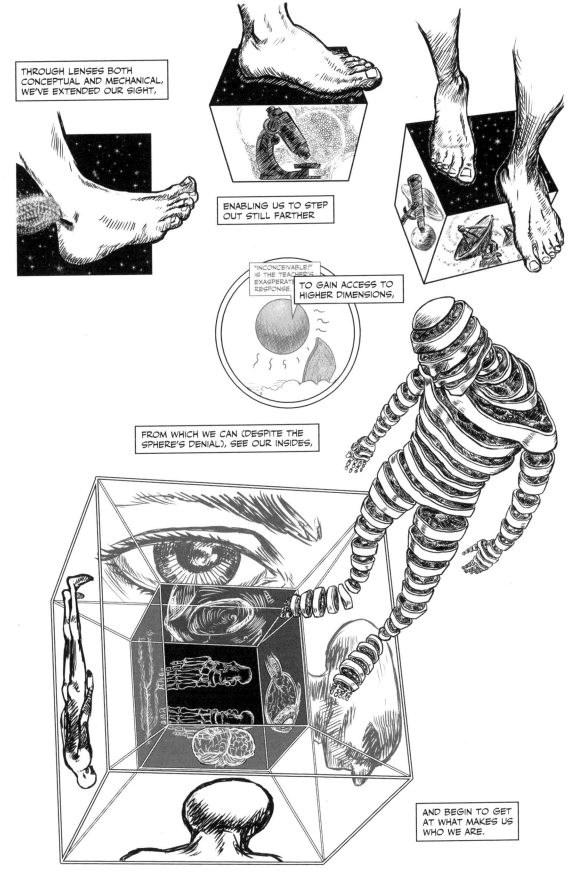

THROUGH LENSES BOTH CONCEPTUAL AND MECHANICAL, WE'VE EXTENDED OUR SIGHT,

ENABLING US TO STEP OUT STILL FARTHER

"INCONCEIVABLE!" IS THE TEACHER'S EXASPERATED RESPONSE.

TO GAIN ACCESS TO HIGHER DIMENSIONS,

FROM WHICH WE CAN (DESPITE THE SPHERE'S DENIAL), SEE OUR INSIDES,

AND BEGIN TO GET AT WHAT MAKES US WHO WE ARE.

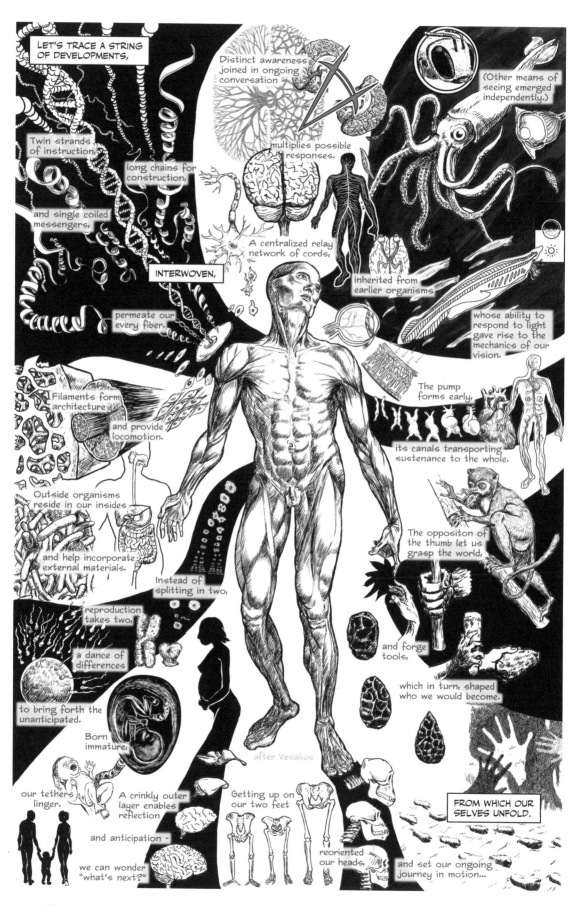

LET'S TRACE A STRING OF DEVELOPMENTS,

Distinct awareness joined in ongoing conversation

multiplies possible responses.

(Other means of seeing emerged independently.)

Twin strands of instruction,

long chains for construction,

and single coiled messengers,

A centralized relay network of cords,

INTERWOVEN,

inherited from earlier organisms

permeate our every fiber.

whose ability to respond to light gave rise to the mechanics of our vision.

Filaments form architecture

and provide locomotion.

The pump forms early,

its canals transporting sustenance to the whole.

Outside organisms reside in our insides

and help incorporate external materials.

The opposition of the thumb let us grasp the world,

Instead of splitting in two,

reproduction takes two,

a dance of differences

and forge tools,

which in turn, shaped who we would become.

to bring forth the unanticipated.

Born immature,

after Vesalius

our tethers linger.

A crinkly outer layer enables reflection

Getting up on our two feet

FROM WHICH OUR SELVES UNFOLD.

and anticipation -

we can wonder "what's next?"

reoriented our heads,

and set our ongoing journey in motion...

132

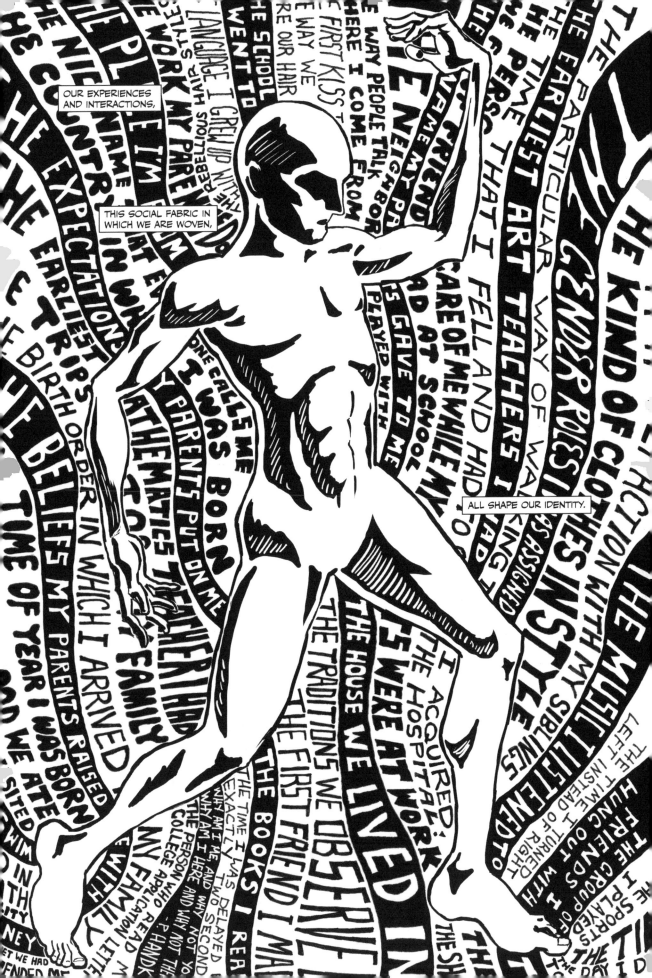

OUR EXPERIENCES AND INTERACTIONS,

THIS SOCIAL FABRIC IN WHICH WE ARE WOVEN,

ALL SHAPE OUR IDENTITY.

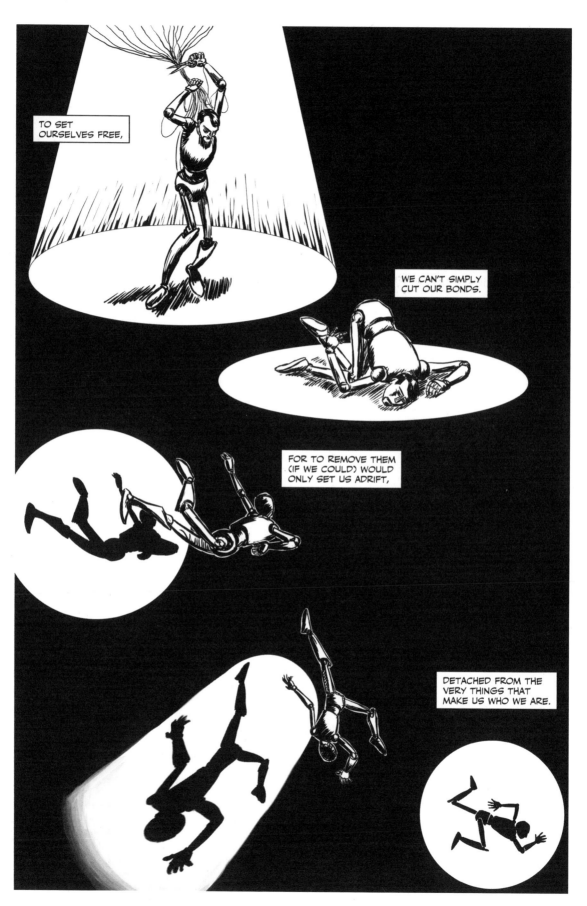

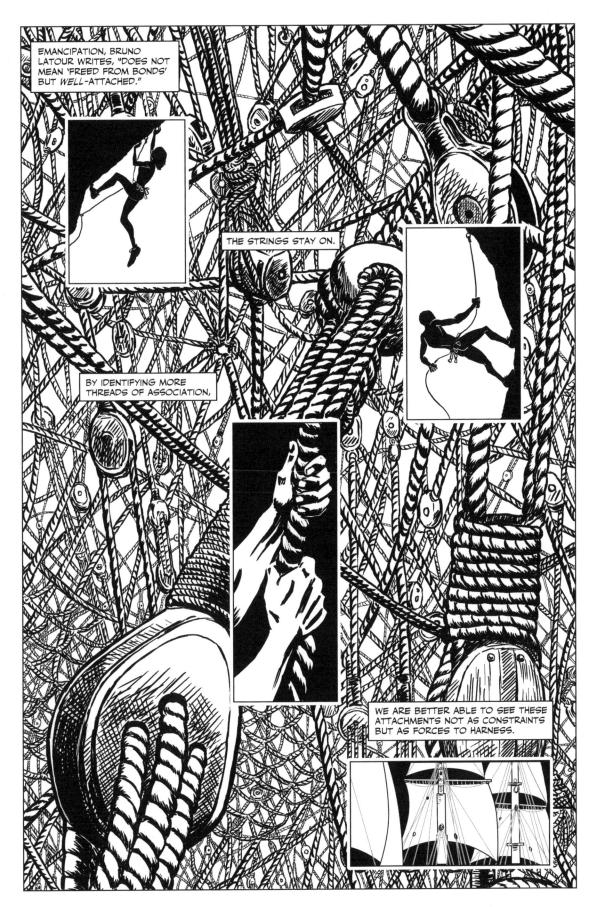

EMANCIPATION, BRUNO LATOUR WRITES, "DOES NOT MEAN 'FREED FROM BONDS' BUT *WELL*-ATTACHED."

THE STRINGS STAY ON.

BY IDENTIFYING MORE THREADS OF ASSOCIATION,

WE ARE BETTER ABLE TO SEE THESE ATTACHMENTS NOT AS CONSTRAINTS BUT AS FORCES TO HARNESS.

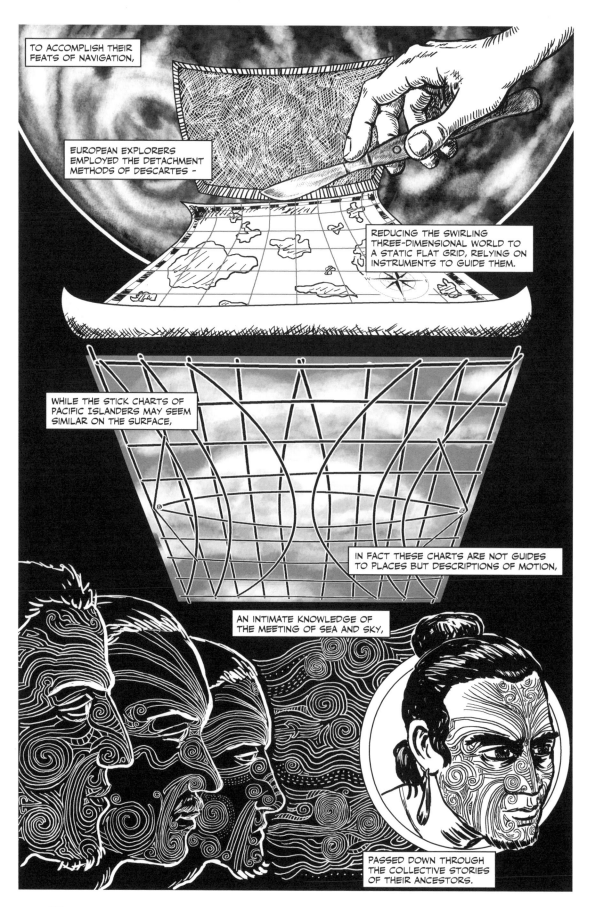

TO ACCOMPLISH THEIR FEATS OF NAVIGATION,

EUROPEAN EXPLORERS EMPLOYED THE DETACHMENT METHODS OF DESCARTES –

REDUCING THE SWIRLING THREE-DIMENSIONAL WORLD TO A STATIC FLAT GRID, RELYING ON INSTRUMENTS TO GUIDE THEM.

WHILE THE STICK CHARTS OF PACIFIC ISLANDERS MAY SEEM SIMILAR ON THE SURFACE,

IN FACT THESE CHARTS ARE NOT GUIDES TO PLACES BUT DESCRIPTIONS OF MOTION,

AN INTIMATE KNOWLEDGE OF THE MEETING OF SEA AND SKY,

PASSED DOWN THROUGH THE COLLECTIVE STORIES OF THEIR ANCESTORS.

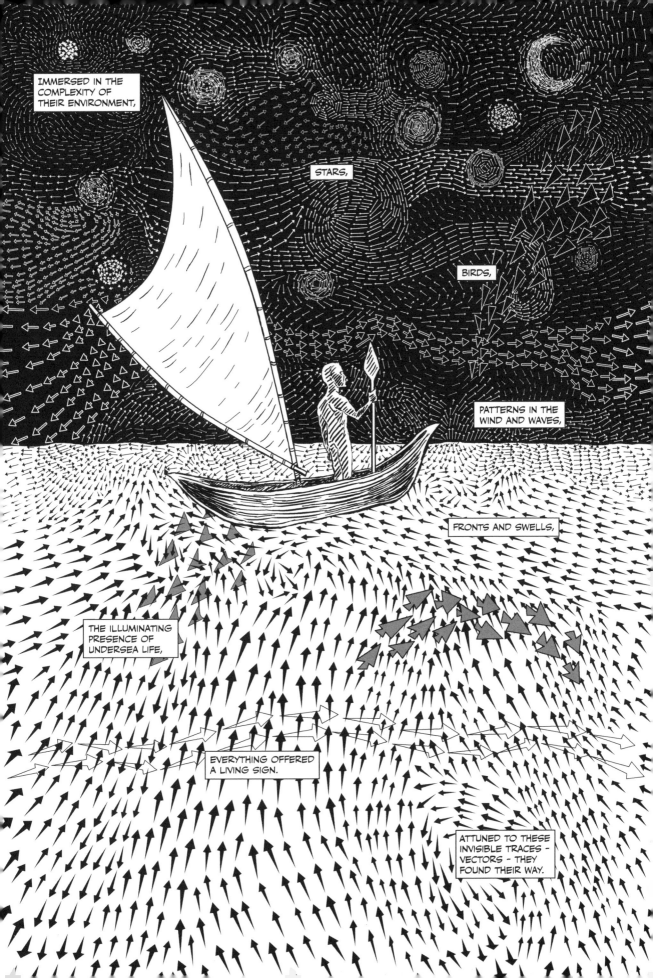

LET'S THEN REFLECT ONCE MORE ON WHAT MAKES US WHO WE ARE. JOHN DEWEY DEFINED CAPACITY NOT AS AN EMPTINESS TO BE FILLED FROM AN OUTSIDE SOURCE,

RATHER AS A "FORCE POSITIVELY PRESENT,"

POTENTIAL TO BE DEVELOPED.

REACHING OUT, WHILE DRAWING IN,

IT'S HARD TO DEFINE WHERE WE BEGIN AND END.

WE ARE NOT STATIC, NOR FINISHED —

FOR WE EMERGE FROM THE INTERACTION OF FORCES IN MOTION — AN ASSOCIATION OF VECTORS,

MUTABLE AND CAPABLE OF CHANGE

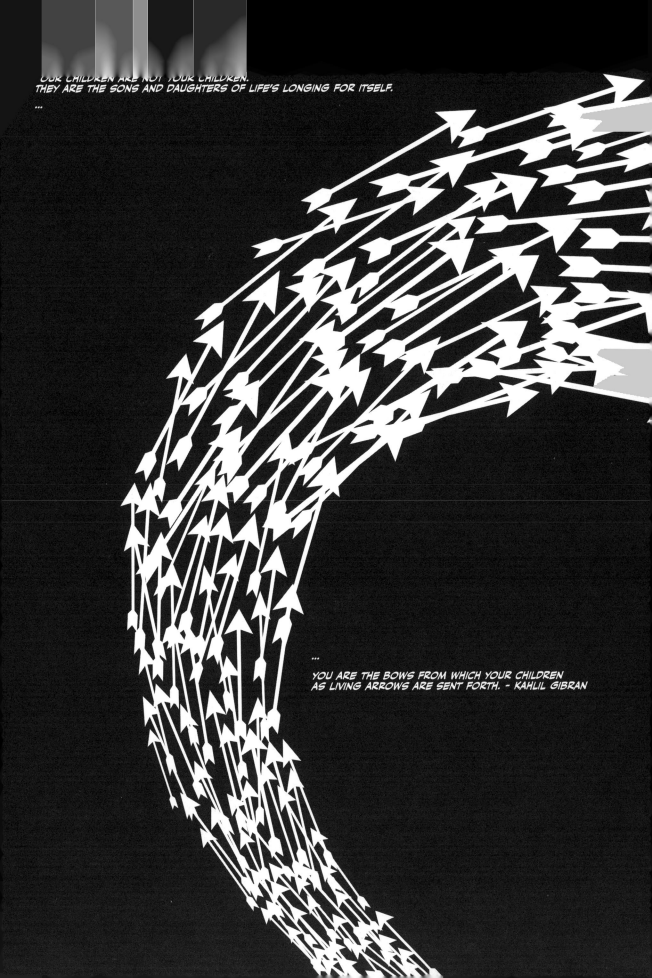

OUR CHILDREN ARE NOT YOUR CHILDREN.
THEY ARE THE SONS AND DAUGHTERS OF LIFE'S LONGING FOR ITSELF.

...

...

YOU ARE THE BOWS FROM WHICH YOUR CHILDREN
AS LIVING ARROWS ARE SENT FORTH. - KAHLIL GIBRAN

eight

AWAKING

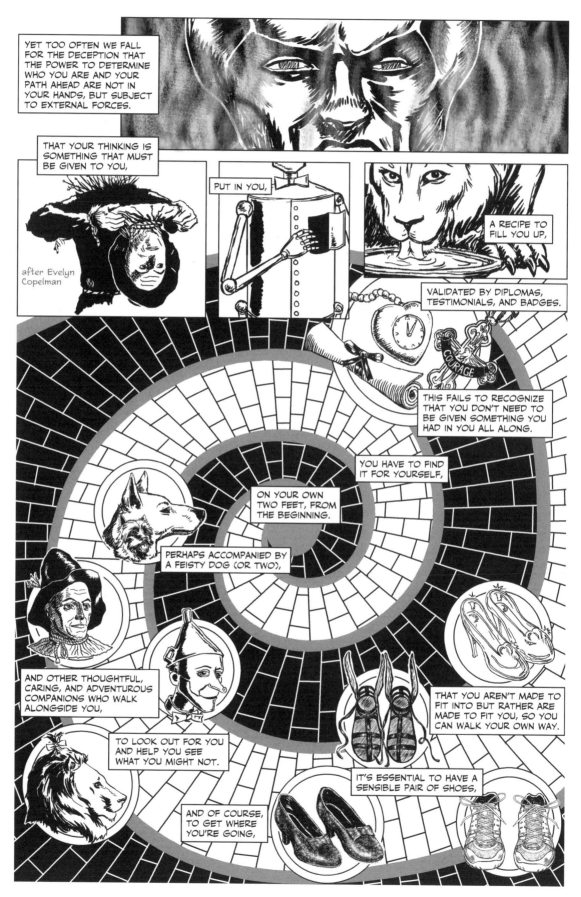

YET TOO OFTEN WE FALL FOR THE DECEPTION THAT THE POWER TO DETERMINE WHO YOU ARE AND YOUR PATH AHEAD ARE NOT IN YOUR HANDS, BUT SUBJECT TO EXTERNAL FORCES.

THAT YOUR THINKING IS SOMETHING THAT MUST BE GIVEN TO YOU,

after Evelyn Copelman

PUT IN YOU,

A RECIPE TO FILL YOU UP,

VALIDATED BY DIPLOMAS, TESTIMONIALS, AND BADGES.

THIS FAILS TO RECOGNIZE THAT YOU DON'T NEED TO BE GIVEN SOMETHING YOU HAD IN YOU ALL ALONG.

YOU HAVE TO FIND IT FOR YOURSELF,

ON YOUR OWN TWO FEET, FROM THE BEGINNING.

PERHAPS ACCOMPANIED BY A FEISTY DOG (OR TWO),

AND OTHER THOUGHTFUL, CARING, AND ADVENTUROUS COMPANIONS WHO WALK ALONGSIDE YOU,

TO LOOK OUT FOR YOU AND HELP YOU SEE WHAT YOU MIGHT NOT.

THAT YOU AREN'T MADE TO FIT INTO BUT RATHER ARE MADE TO FIT YOU, SO YOU CAN WALK YOUR OWN WAY.

IT'S ESSENTIAL TO HAVE A SENSIBLE PAIR OF SHOES,

AND OF COURSE, TO GET WHERE YOU'RE GOING,

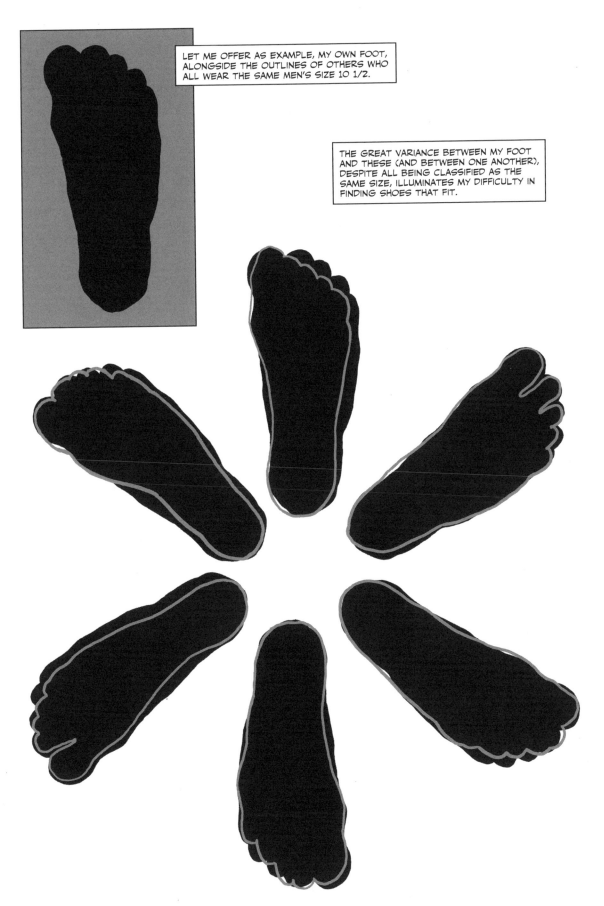

LET ME OFFER AS EXAMPLE, MY OWN FOOT, ALONGSIDE THE OUTLINES OF OTHERS WHO ALL WEAR THE SAME MEN'S SIZE 10 1/2.

THE GREAT VARIANCE BETWEEN MY FOOT AND THESE (AND BETWEEN ONE ANOTHER), DESPITE ALL BEING CLASSIFIED AS THE SAME SIZE, ILLUMINATES MY DIFFICULTY IN FINDING SHOES THAT FIT.

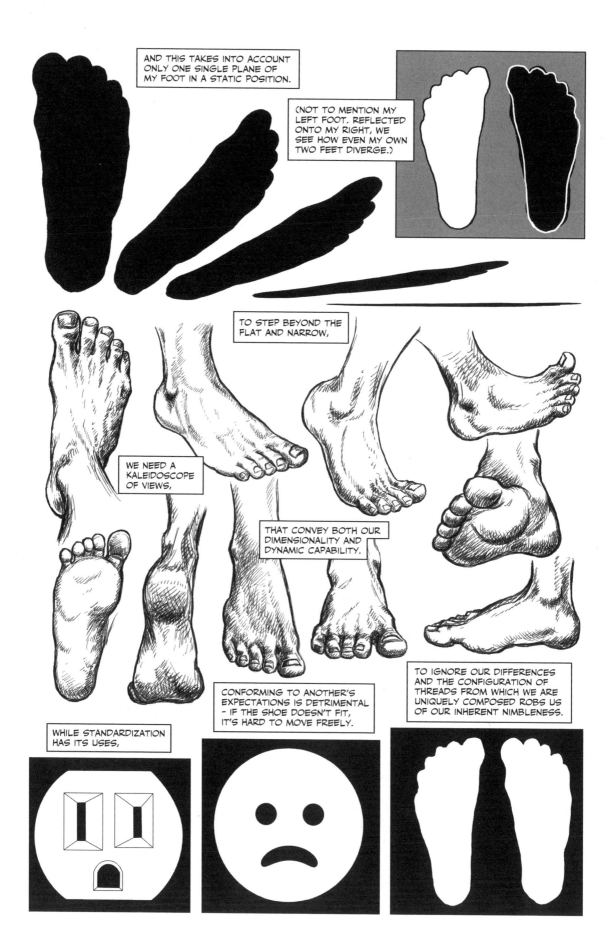

AND THIS TAKES INTO ACCOUNT ONLY ONE SINGLE PLANE OF MY FOOT IN A STATIC POSITION.

(NOT TO MENTION MY LEFT FOOT. REFLECTED ONTO MY RIGHT, WE SEE HOW EVEN MY OWN TWO FEET DIVERGE.)

TO STEP BEYOND THE FLAT AND NARROW,

WE NEED A KALEIDOSCOPE OF VIEWS,

THAT CONVEY BOTH OUR DIMENSIONALITY AND DYNAMIC CAPABILITY.

TO IGNORE OUR DIFFERENCES AND THE CONFIGURATION OF THREADS FROM WHICH WE ARE UNIQUELY COMPOSED ROBS US OF OUR INHERENT NIMBLENESS.

CONFORMING TO ANOTHER'S EXPECTATIONS IS DETRIMENTAL – IF THE SHOE DOESN'T FIT, IT'S HARD TO MOVE FREELY.

WHILE STANDARDIZATION HAS ITS USES,

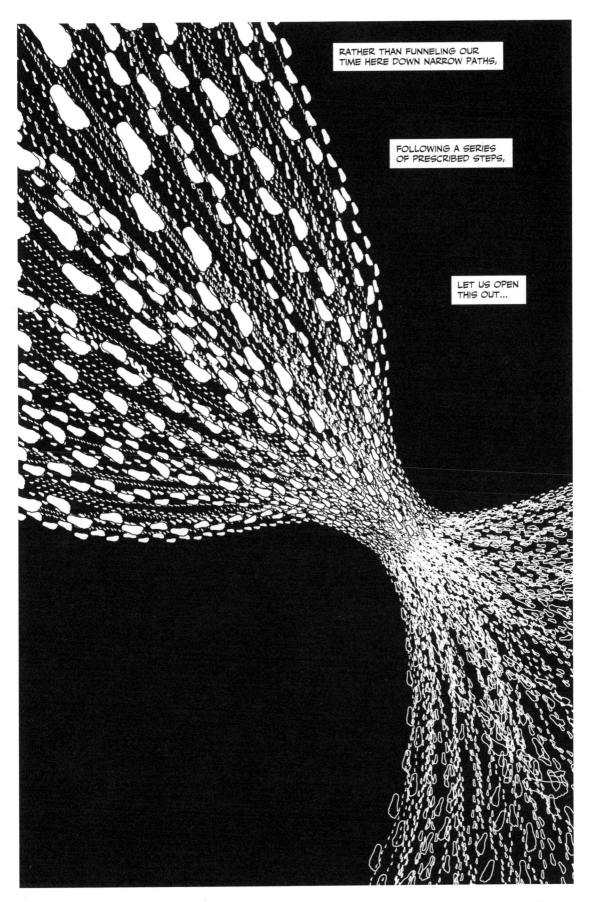

RATHER THAN FUNNELING OUR TIME HERE DOWN NARROW PATHS,

FOLLOWING A SERIES OF PRESCRIBED STEPS,

LET US OPEN THIS OUT...

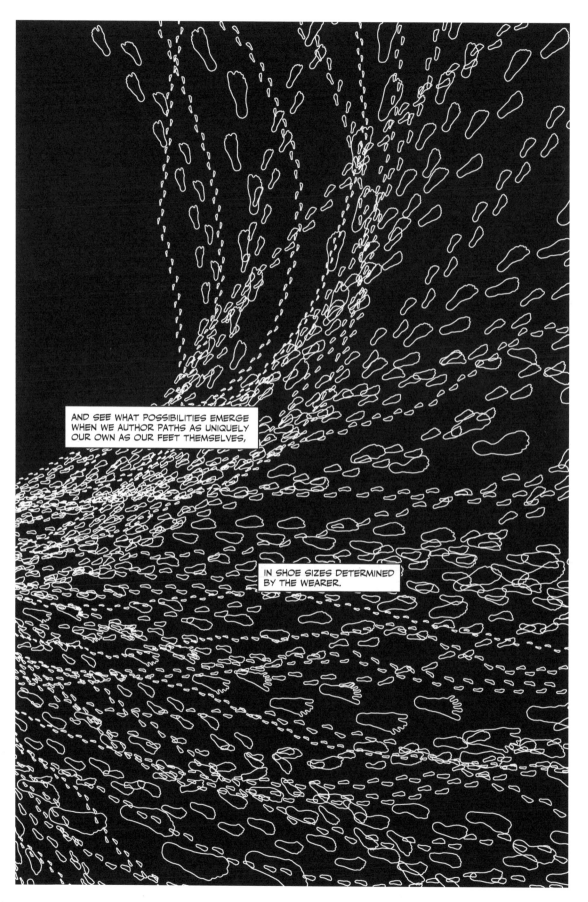

AND SEE WHAT POSSIBILITIES EMERGE
WHEN WE AUTHOR PATHS AS UNIQUELY
OUR OWN AS OUR FEET THEMSELVES,

IN SHOE SIZES DETERMINED
BY THE WEARER.

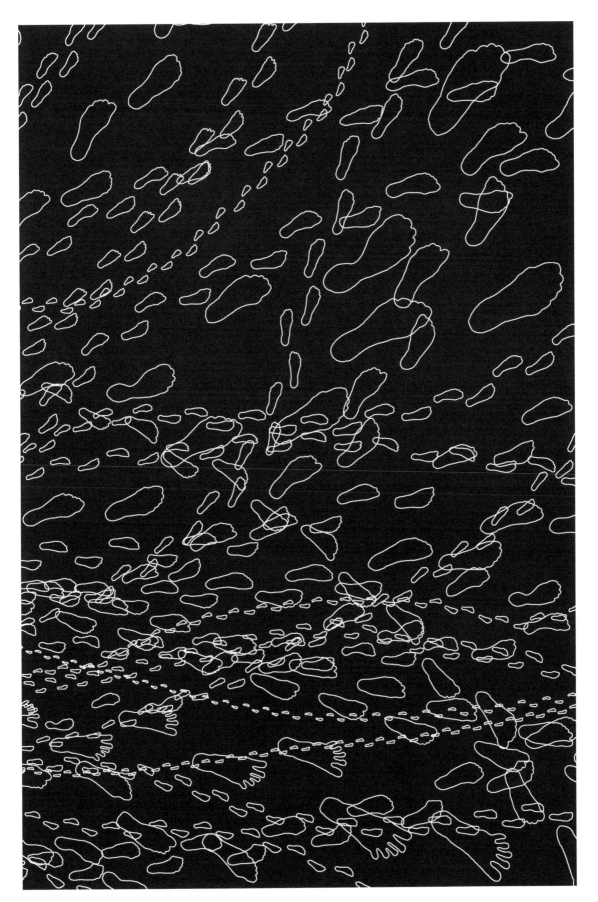

UNDERSTANDING, LIKE SEEING, IS GRASPING *THIS* ALWAYS IN RELATION TO *THAT*.

EVEN AS WE HOLD AND STITCH DISTINCT VIEWPOINTS TOGETHER, THE SPACE BETWEEN THEM DOESN'T COLLAPSE –

IT'S NOT A PROCESS OF CLOSING, OF BEING FINISHED.

RATHER, EACH NEW ENGAGEMENT GENERATES ANOTHER VANTAGE POINT FROM WHICH TO CONTINUE THE PROCESS ANEW.

A DISTANCE BETWEEN ALWAYS REMAINS.

THERE ARE ALWAYS GAPS:

SPACES FOR THE UNKNOWN, OPENINGS FOR IMAGINATION TO SPILL INTO.

INCOMPLETENESS REVEALS THAT THERE IS ALWAYS MORE TO DISCOVER.

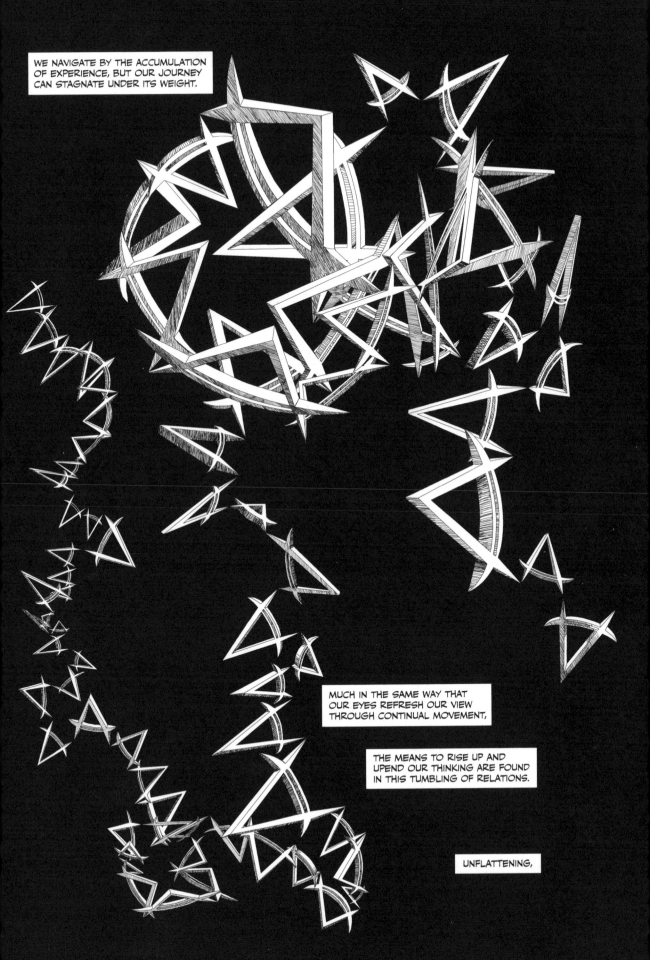

WE NAVIGATE BY THE ACCUMULATION OF EXPERIENCE, BUT OUR JOURNEY CAN STAGNATE UNDER ITS WEIGHT.

MUCH IN THE SAME WAY THAT OUR EYES REFRESH OUR VIEW THROUGH CONTINUAL MOVEMENT,

THE MEANS TO RISE UP AND UPEND OUR THINKING ARE FOUND IN THIS TUMBLING OF RELATIONS.

UNFLATTENING,

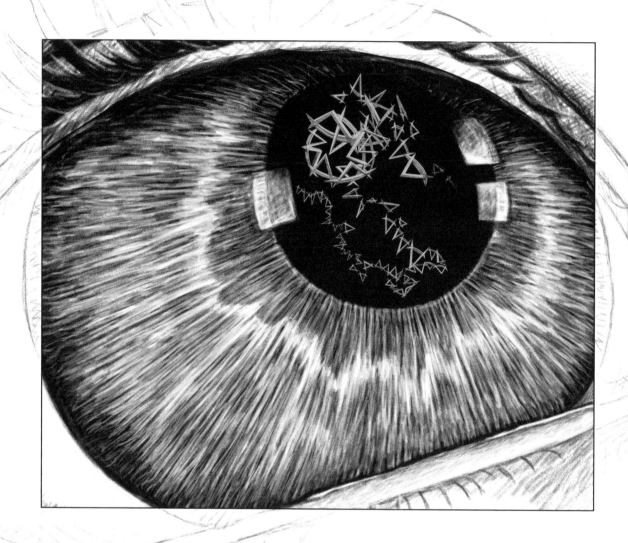

notes

bibliography

acknowledgments

early sketches

NOTES

The following serves as notes to the visual and textual references. You need not read these notes to understand, enjoy, or disagree with *Unflattening*. But some of you may be curious to see the backstory, the hidden influence, behind my words and drawings.

CHAPTER 1: FLATNESS

Pages 3–5: Piranesi's *Carceri*, Fritz Lang's *Metropolis,* Diego Rivera's industrial mural in Detroit, and Anton Furst's architectural designs for the film version of Gotham City influence the opening pages. The sleepwalking figures themselves reference the Borg from *Star Trek*, shrink-wrapped, stone, or plaster statues (Denise Fanning's Detroit installation of plaster figures came to mind), Munch's *Scream*, Käthe Kollwitz's anguished figures (though I never let mine be anywhere near as expressive), Giacometti's almost alien figures, and Death from *The Seventh Seal.*

The sleepwalking, marching figures first raised—or, rather, lowered—their heads during my time in Detroit and were the centerpiece of the public art billboard I installed along Woodward Avenue in April of 2004. For the project, I sought to address and depict transformation by embedding two images—two concepts—in one piece. The primary image used space as standard, flat billboards do. On a series of equally spaced slats, I encoded a second image, the edges of which faced oncoming traffic such that they were nearly invisible. However, coming alongside it, drivers would witness a fleeting transformation as the slats lined up to reveal the second image.

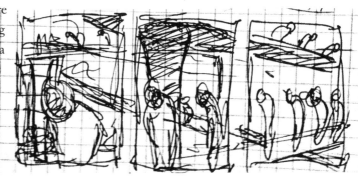

The motorist's own movement brought about the metamorphosis, a conceptual transformation; the two-in-one speaks to what this project is seeking to do as well. As I wrote in my artist statement from that time, "Can art awaken something dormant within us?" I sought to offer a rebuttal and a reminder of our complexity, asking commuters to open their eyes to "a glimmer of possibility often obscured." Imagery and information about the project are online at http://www.thedetroiter.com/APR04/ns_billboard.html.

The flatlander's body positioning was influenced by Cathy Davidson's (2011) description of students marched down their hallways with hands kept behind their backs. At the time that I was working on this chapter, my dad, a teacher of physics for over four decades in the sort of experiential way that John Dewey would have liked, had retired and then taken a job mid-year at a different school, filling in for a teacher who'd been using worksheets as his mode of instruction apparently for his entire career. My dad's frustration at trying to push at the boundaries of what students had come to expect served as much of the inspiration for the images more directly referencing school institutions. He reported their being weighed down by having to carry their AP test prep books, and while they were good at taking tests, they couldn't make connections or ask questions. The "great weight" references his accounts, as well as Italo Calvino's (1993) discussion of "heaviness," which will be referenced again in the Flatland Interlude.

Page 6: Marcuse (1991, p. 14); the reference to lacking "a critical dimension" comes from the introduction by Kellner (p. xxvii).

Page 8: Julie Bosman's (2010) article in the *New York Times* on the declining sale of children's picture books due to pressures on parents to get their kids reading chapter books at earlier and earlier ages to prepare for tests horrified me and inspired the imagery on this page.

Page 10: While I do not cite it explicitly, the images draw on Tagore's description of the "education factory" in which students

are put in boxes and become

> "lifeless, colorless, dissociated from the context of the universe, within bare white walls staring like eyeballs of the dead. We are born with that God-given gift of taking delight in the world, but such delightful activity is fettered and imprisoned, muted by a force called discipline which kills the sensitiveness of the child mind which is always on the alert, restless and eager to receive first-hand knowledge from mother nature. We sit inert, like dead specimens of some museum, while lessons are pelted at us from on high, like hail stones on flowers" (Tagore, 1966, pp. 213–214).

Page 11: An allusion to a splash page from a Batman comic I read as a child. I made the sketch first and felt a trace of recognition. I tracked down the image, which turned out to be two different images, one on the cover and the other on the inside splash page, in which Batman's profile also contains a scene within; both images are from Detective Comics 457 vol. 1, published in 1975.

Page 12: A visual reference to Illich (1972), "the fundamental approach common to all schools—the idea that one person's judgment should determine what and when another person must learn" (p. 42).

Pages 16–17: I first used tops as metaphorical stand-ins for people in my piece for Maxine Greene's class. It appears in the 2010 book *Dear Maxine: Letters from an Unfinished Conversation*, edited by Robert Lake.

INTERLUDE: FLATLAND

Page 22–23: Text from the Flatlander sequence is derived nearly directly or paraphrased from Abbott's original 1884 novel.

Page 25: Hermes is (among other things) the god of boundaries and

gave the winged sandals to Perseus. Perseus is often depicted riding the winged horse Pegasus. This gift of winged sandals was intended to transport Perseus to Medusa so he could slay her. In Greek mythology, Medusa can render inanimate all who look upon her. We see another angle of this story in Chapter 6.

Page 26: Calvino (1993, p. 7) from his chapter on "lightness."

CHAPTER 2: THE IMPORTANCE OF SEEING DOUBLE AND THEN SOME

Page 29: The spider is an orb-weaving, common garden variety. The jumping spiders often have more exotic eyes, but this spider had to have good-looking eyes and also be a web spinner. I can't make these up—my mother is a naturalist, and incorrect spiders won't fly.

Page 31: A reworking of a nearly similar page in my piece "Mind the Gaps" (2011). The stars in the original were from the Orion constellation; here they are from the Perseus constellation. I worked out the relative distances for each star.

Page 32: I was familiar with Eratosthenes's method for calculating the circumference of the earth from my dad's physics class; we used the opportunity of students traveling from Michigan to Florida on spring break to perform a similar calculation. Carl Sagan's explanation of this from his *Cosmos* TV series was quite helpful—in it, he bends a cardboard mockup of Alexandria to Syene—and a similar bend shows up in my drawing.

Page 33: Information on Copernicus (and Kepler, who is hinted at but not mentioned as one of the "others" to expand on Copernicus) is drawn from Koestler (1963), as well as the NOVA documentary *Hunting the Edge of Space: How Telescopes Have Expanded Our View of the Universe* (PBS, originally aired June 4, 2010) and various websites detailing epicycles and other backflips required of the geocentric model.

Page 34: Draws on Horkheimer and Adorno (2002), Condorcet (1796), and Wilson (1998),

in which I found the passage attributed to Francis Bacon (p. 24).

Pages 35–37: These sequences are informed by the field of interdisciplinarity as delineated by Klein (1990), Repko (2008), and Welch (2011). The dialogue on page 36 is from L. Frank Baum's *The Wonderful Wizard of Oz* (1900), ch. 15.

Page 38: Snow (1964/1993, p. 4) and Dreyfuss (2011, p. 74). The dance steps and dance notations are my amalgamation of actual notation.

Page 39: Bakhtin (1981, p. 29). Oskin's (2009) article on Scott Page's work on the value of divergence and diversity for the creation of new ideas within groups (p. 48) informed some of my thinking here but wasn't directly cited. The composition of many eyes had me thinking back to the cover of Madeleine L'Engle's *A Wind in the Door* and the "drive of dragons" pictured on it. Deleuze and Guattari (1987). (I think their writing really lends itself to being presented in comics form.)

Page 40: For more about canine senses, see Bilger (2012) and Williams (2011).

Page 41: The ship is my recollection of a carved wooden canoe my parents have.

Page 42: Carse (1986) offers a notion of "horizonal vision," and the passage comes from p. 75. James (1907, p. 21), Cavafy (2002, p. 80). The walking figures reference Muybridge's photographic examinations of movement.

Page 43: My friend and mentor Fred Goodman suggests that tetrahedrons enclose a single space in such a way that they "beg" to be "turned over in one's mind." For Fred's 80th birthday, I made him a card depicting different turns of a tetrahedron, which I subsequently reworked for this page. Latour (2005, pp. 145–146) suggests that an object's dimensionality allows us to move around it. The page also references sculptor David Barr's globe-spanning "Four Corners Project"—the largest sculpture ever made (with the least amount of material).

Page 44: The explanation of fractal coastlines and related concepts is drawn from Peak and Frame (1994), Peitgen, Jürgens, and Saupe (1992), Mandelbrot (1983), Briggs and Peat (1999), and McGuire (1991), from which the passage by Mandelbrot is also drawn. The coastline explored here is that of Ithaca, Greece.

Page 45: The passage "Did it flow?" is from James Joyce's *Ulysses* (1934, p. 655), ch. 17 (Ithaca). A trace of some text from my mom, Anne Sousanis (1987), remains in the text: "Our ecosystems may have visual boundaries but they are not isolated from one another." And Heraclitus, who needs no citation at this point, "one cannot step into the same waters twice."

CHAPTER 3: THE SHAPE OF OUR THOUGHTS

Page 49: I had previously used the title of this chapter for an essay in comics form in the journal of *Visual Arts Research* (Sousanis, 2012), and this chapter reworks and greatly expands upon ideas from that previously published piece. Page 62 is most directly drawn from that earlier piece; it's a new drawing, but with the same composition and scene for the most part, with altered text.

Page 53: The terms "anchor" and "relay" are a nod to Roland Barthes's theory of the interaction of image and text, which is quite applicable to thinking on comics as well.

Page 54: I did set fire to several pages in an attempt to get this to look just right. That did not go well and I can't recommend trying it at home. In the dissertation version of this work, I was required by the Office of Doctoral Studies to include a "List of Figures" at the front of the document to refer solely to the "figure" on this page—the page on which I most directly break the fourth wall as to what academic scholarship is supposed to look like. Their insistence upon having a list of figures to point to the sole page of text in a work made of figures quite poetically emphasized the point I was already making here.

Page 56: Stems from Descartes's *Discourse on Method* (1637/2001): "Of refraction" (pp. 75–83); "Of the eye" (pp. 84–126); and "Of the rainbow" (pp. 332–345). The moon and telescope belong to Galileo, who is never mentioned in the text but has his fingerprints all over it. Adam Gopnik's (2013) article on Galileo helped inform both the imagery and the integration of reason and perception that closes the page—what he called a "fluid mixture of sense impression and strong argument."

Page 57: Hayakawa (1944/1995, p. 9). You can learn more about the Dymaxion Map and other projects on the Buckminster Fuller Institute website, www.bfi.org.

Page 58: Langer (1957, p. 80), Baxandall (1985, p. 1), and Kosslyn et al. (2006) draw an important distinction between verbal and visual in terms of how they function as a means of representation and how they make "different sorts of information explicit and accessible" (Kosslyn et al., p. 12). The sentence diagram was provided by Russell Willerton, who kindly responded to my request for assistance on social media. Everett Maroon came up with an alternative approach of which I incorporated a few elements.

Page 59: Langer (1957) claims that due to its linear form, language falls short in conveying feelings and emotions, and thus discursive forms are seen as intelligent, while everything else is relegated to the realm of the irrational (p. 143). My final line references Wallace Stevens, who said of poems, "not ideas about the thing but the thing itself." The Cartesian coordinate planes/walls are made from poems by the following authors: Sappho, Dorothy Wordsworth, Emily Dickinson, Sylvia Plath, Maya Angelou, Adrienne Rich, Anais Nin, and Georgia Douglas Johnson.

Page 60: Various alternative names for comics are listed or integrated into the imagery here (for a list of alternative names for comics, see Duncan and Smith, 2009, p. 18). *Manga, bandes dessinées,* and *fumetti* are terms for comics in Japan, France, and Italy (specifically of the photo-comics variety),

respectively. McCloud (1993) and Hogben (1949) connect comics back in time to a lineage that began with the cave paintings at Lascaux. "A rose by any other name would smell as sweet" stems (ha!) from *Romeo and Juliet*.

Page 61: McCloud (1993, p. 9). The lunar calendar is redrawn from a 30,000-year-old Paleolithic calendar produced at the same time as the cave paintings in Lascaux. While the connection between cave art and comics is often made, I was thrilled to link this calendar to comics—as here, time is literally written in space.

Page 62: Groensteen (2007, p. 146). It should also be noted that while I initially happened upon the Banyan tree because of the imagery, it turns out that, like comics themselves, the Banyan, as Thompson (2012) writes, can be seen as "both hierarchical and rhizomatic!"

Page 63: McGilchrist (2010). Also, on a related note, Hatfield (2009) discusses comics as an art of tensions. Though I do not mention it explicitly here, Hatfield's point merits further discussion.

Page 64: Harvey (1979), Lewis (2001, p. 69), and Tufte (1990, p. 12). The text, appearing alongside Botticelli's *The Birth of Venus* in the upper left, is from the opening to Hemingway's *The Old Man and the Sea* (1952).

Page 65: Nodelman (2012, p. 438). The broader discussion of multimodality (though not named as such here) draws on Jewitt and Kress (2003), Kress (2010), Kress and van Leeuwen (1996), and Kress, Jewitt, Ogborn, and Tsatsarelis (2001).

Page 66: The Spiegelman quote is from Witek (2007, pp. 276–277), and Ware from Ball and Kuhlman (2010, p. 182). My composition on the lower left borrows from Frank Quitely's wonderful perspectival panels in *W.E.3*, and in the lower right, his collaged compositions from *Flex Mentallo*. The imagery also plays with "you're nothing but a pack of cards" from *Alice's Adventures in Wonderland* to go along with giant Alice in the house.

Page 67: Langer (1957, p. 81).

CHAPTER 4: OUR BODIES IN MOTION

Page 69: The dancers are alighting across an image drawn from a cloud chamber—a machine made for detecting particles invisible to our eyes.

Page 72: Arnheim (1969, p. 54). Though not cited, Merleau-Ponty is worth remembering here: "Vision is a palpation by means of the gaze."

Page 73: Noë (2004, p. 164).

Page 74: Rosand (2002, p. 1). Gombrich (1960) discusses recognition, "Making comes before matching" (pp. 105–106). He also discusses recognizing something in marks, connecting to a resemblance (p. 38). Lakoff and Núñez (2000) discuss the visual system as linked to the motor system; this allows one to trace out a structure with our hands (p. 34). The tracks come from various field guides to animal tracks supplied by my mom and the web, and include mouse in the snow, turtle in sand, bear claw swipe, turkey wing impressions, earthworm trails, rolling rocks (on Mars!), rivers, and more.

Page 75: Arnheim (1965, p. 259). The images visually reference Bang (2000)—an absolutely wonderful enactment of Arnheim's theories.

Page 76: Lakoff and Johnson (1980, 1999), Lakoff and Núñez (2000). The formation of our most basic concepts (what they call conceptual metaphors) is grounded in our seeing and being in the world, ideas shaped, as Lakoff and Núñez (2000) suggest, "by our bodily experiences" (p. xiv). They use the term "image schemas" (which I chose not to include). Image schemas are both perceptual and conceptual, and bridge "language, reasoning, and vision" (p. 31), from which we derive conceptual metaphors.

Page 79: Suwa and Tversky (1997, pp. 385–386).

Page 80: Moffett (2011, p. 137). The page also gestures toward Crockett Johnson's *Harold and the Purple Crayon*.

Page 81: Stafford (1999, p. 29), Root-Bernstein (1985), and also

draws on Burton, Horowitz, and Abeles's (1999) work on the importance of the arts in curriculum.

CHAPTER 5: THE FIFTH DIMENSION

Page 85: The title references Rod Serling from the Twilight Zone equating imagination with the fifth dimension. I picked it up from a Grant Morrison–written Batman comic.

Page 87: As with prior instances, the text here hews closely to Abbott's original.

Page 89: Greene (1995, p. 37).

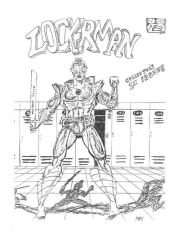

Page 90: Pelaprat and Cole (2011); the diagram of eye movement (saccadic motion) is based on Yarbus (1967) mapped onto da Vinci's *Mona Lisa*.

Page 91: The reference to gap-spanning is drawn partially from Johnson (1987). For more on "conceptual blending," see Fauconnier and Turner (1998, 2002).

Page 92: Lockerman first appeared in print in 1986 and was distributed courtesy of the Almont High School copy machines.

Page 93: My brother takes issue with my use of "tall tales" here.

Page 95: The opening depicts scenes from *The 1001 Arabian Nights*. The turn to science here draws on Saliba's (1999) description of the works of Nasir al-Din al-Tusi, whose works aided Copernicus's discoveries. Goodman (1978, p. 2).

Page 96: After Bill Watterson's *Calvin and Hobbes*, Superman changing in a phone booth, and the Tardis from *Dr. Who*. Bachelard (1964/1994, p. 134). String theorists surmise that dimensions we can't experience are curled up tightly within those we can.

CHAPTER 6: RUTS

Page 107: The handprints are my redrawing of Paleolithic prints made on cave walls.

Page 109: Mumford (1967, p. 286).

Page 110: The column and upper panel backdrop are both redrawn from the stele upon which the Code of Hammurabi was written.

Page 111: Dewey (1916/1966, p. 49). For the record, it took me a long time to go slowly enough to consciously break down the steps of how I tie my shoes. I consulted the web and was relieved that my method was a proper and effective one.

Page 112: My wife mapped six of her actual daily commutes. Regarding the dérive, see Debord (1957–1961/1992).

Page 113: The walking man is from John Cleese's classic *Monty Python* "Ministry of Silly Walks" sketch. The last two figures are inspired by *Singin' in the Rain* (1952).

INTERLUDE: STRINGS ATTACHED

Page 120: An allusion to Eric Carle's *The Very Hungry Caterpillar.*

Page 122: "Who are you?" is the first line the caterpillar says to Alice in *Alice's Adventures in Wonderland* (1865). Monarch caterpillars do turn over into an upside-down question mark.

CHAPTER 7: VECTORS

Page 125: Artemis is not only the goddess of the hunt and the moon, but also a midwife.

Page 129: Besides looping back to the opening pages, the text also references the Calvino (1993) passage from the Flatland Interlude that comes from his chapter on "lightness"—to work against forces of heaviness and inertia.

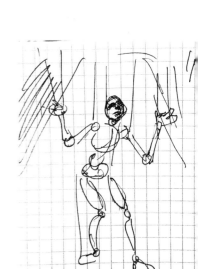

Page 131: The box within a box, this higher dimension, is a three-dimensional representation of a four-dimensional hypercube or tesseract.

Page 132: Elements on this page are drawn from a wide variety of sources, including Zimmer (2006): eye development, squid eye, lancelet; Davies (2014): DNA proteins, heart development; Shlain (1991): grasping hand; Pilcher (2013): grasping hand, eyes; Lisieska (2010): squid eye; Robson (2014): stone tools and evolution. The central figure is from Vesalius's "On the Fabric of Human Body."

Page 133: Building on Latour (2005) and his notion of "trace of associations" as part of Actor-Network-Theory.

Pages 134–135: For more on description of actors as puppets, see Latour (2005, pp. 59–60). Also see Latour (pp. 215–218) for further discussion of emancipation not as being free from bonds but as being well attached.

Pages 136–137: Draws on Strongman's (2008) wonderful breakdown of the differences between European and Pacific Islander navigation methods.

Page 138: Dewey (1916/1966, p. 41).

Page 139: Gibran's poem "On Children" (1923, pp. 21–22).

CHAPTER 8: AWAKING

Page 144: Illich (1972) considered the "fundamental approach common to all schools—the idea that one person's judgment should determine what and when another person must learn" (p. 42). Also references Freire's (2000) "banking model" of education.

Pages 145, 147–149: Attributions for the feet depicted here are listed in the acknowledgments. People sent me feet from at least three continents based on a call I broadcast on social media. The call read as follows:

Trace the outline of each one of your feet and then label it *right/left, male/female* (what shoe you wear, not your gender), and *US shoe size*. In my case, this looks like *R, M, 10.5*, and *L, M, 10.5*. Then scan or take a digital photo of the tracing, low-resolution is fine (and preferred), as all I need is a clear outline. Label the picture/scan as above without any additional identifying information. Send it to me at nsousanis@gmail.com with subject heading "foot project" (or some clever pun if you'd prefer).

I will not identify your feet in any way in the work, and will save all the image files in a folder without retaining the sender's information. I'll be redrawing the outlines, for visual clarity and consistency as well.

Pages 150–151: Draws on the following discussions—on the semiotics of Charles Peirce: Kockelman (2006), Liszka (1996), Daniel (1984), and Whipple (2005); on the importance of diversity in dialogue: Oskin (2009), Freire (2000), and Greene (1995); on cell destruction being the key to renewal: Zimmer (2009); on "creative destruction": Schumpeter (1942/1976).

BIBLIOGRAPHY

In the process of making this book I read and was influenced by many books and images. Some of them are named in the preceding pages; others have left an invisible, yet no less important, imprint on my words and drawings. Traditional bibliographies are partial to the written word and list mostly books and articles. Images of all sorts have been just as important to me as I made this book. If you wish to learn more about these images and their influence on *Unflattening,* please turn to the section titled Notes.

Abbott, Edwin Abbott. *Flatland: A Romance in Many Dimensions.* London: Seeley, 1884. Reprint, New York: Dover, 1952.

———. *Flatland: An Edition with Notes and Commentary.* Notes and commentary by William F. Lindgren and Thomas F. Banchoff. New York: Cambridge University Press, 2010.

Abel, Jessica, and Matt Madden. *Drawing Words and Writing Pictures: Making Comics.* New York: First Second, 2008.

Aiken, Nancy E. *The Biological Origins of Art.* Westport, CT: Praeger, 1998.

Alaniz, José. "Into Her Dead Body: Moore & Campbell's 'From Hell.'" In *Alan Moore: Portrait of an Extraordinary Gentleman,* edited by Gary Spencer Millidge. Leigh-On-Sea, England: Abiogenesis Press, 2003.

Allen, P. Lawrence. "Am I Relevant to History? The Environment." In *Teaching American History: The Quest for Relevancy,* edited by Allan O. Kownslar. National Council for the Social Studies Yearbook 44. Washington, DC: National Council for the Social Studies, 1974.

Ananthaswamy, Anil. "Mind over Matter? How Your Body Does Your Thinking." *New Scientist* 205, no. 2753 (2010): 8–9.

Arnheim, Rudolf. *Art and Visual Perception: A Psychology of the Creative Eye.* Berkeley: University of California Press, 1965.

———. *Entropy and Art: An Essay on Order and Disorder.* Berkeley: University of California Press, 1974.

———. *Visual Thinking.* Berkeley: University of California Press, 1969.

Avidan, Galia, Michal Harel, Talma Hendler, Dafna Ben-Bashat, Ehud Zohary, and Rafael Malach. "Contrast Sensitivity in Human Visual Areas and Its Relationship to Object Recognition." *Journal of Neurophysiology* 87 (2002): 3102–3116.

Ayers, William, and Ryan Alexander-Tanner. *To Teach: The Journey, in Comics.* New York: Teachers College Press, 2010.

Bachelard, Gaston. *The Poetics of Space.* Translated by Maria Jolas. New York: Orion Press, 1964. Reprint, Boston: Beacon Press, 1994.

Bakhtin, Mikhail Mikhailovich. *The Dialogic Imagination: Four Essays.* Translated by Caryl Emerson and Michael Holquist. Austin: University of Texas Press, 1981.

Bakis, Maureen. *The Graphic Novel Classroom: Powerful Teaching and Learning with Images.* Thousand Oaks, CA: Corwin Press, 2012.

Ball, David M., and Martha B. Kuhlman, eds. *The Comics of Chris Ware: Drawing Is a Way of Thinking.* Jackson: University Press of Mississippi, 2010.

Bang, Molly. *Picture This: How Pictures Work.* San Francisco: Chronicle Books, 2000.

Banita, Georgiana. "Chris Ware and the Pursuit of Slowness." In Ball and Kuhlman, *The Comics of Chris Ware.*

Barry, Lynda. *Picture This.* Montreal: Drawn and Quarterly, 2010.

Bateson, Mary Catherine. *Peripheral Visions: Learning along the Way.* New York: HarperCollins, 1994.

Baxandall, Michael. *Patterns of Intention: On the Historical Explanation of Pictures.* New Haven, CT: Yale University Press, 1985.

Becker, Carol, and Romi Crawford. "An Interview with Paul D. Miller a.k.a. DJ Spooky—That Subliminal Kid." *Art Journal* 61, no. 1 (2002): 82–91.

Bennardo, Giovanni. "Map Drawing in Tonga, Polynesia: Accessing Mental Representations of Space." *Field Methods* 14, no. 4 (2002): 390–417.

Bergmann, Frithjof. *On Being Free.* Notre Dame, IN: Notre Dame University Press, 1977.

Bilger, Burkhard. "Beware of the Dogs," *New Yorker,* 27 February 2012, 46–57. Available at http://www.newyorker.com/reporting/2012/02/27/120227fa_fact_bilger.

Bitz, Michael. *When Commas Meet Kryptonite: Classroom Lessons from the Comic Book Project.* New York: Teachers College Press, 2010.

Bosman, Julie. "Picture Books No Longer a Staple for Children," *New York Times,* 8 October 2010, A1.

Brew, Angela, Michelle Fava, and Andrea Kantrowitz. "Drawing Connections: New Directions in Drawing and Cognition Research." *TRACEY* (Design Research Network open-access journal), 2012. Available at http://www.academia.edu/2374877/Drawing_Connections_new_directions_in_drawing_and_cognition_research.

Briggs, John, and F. David Peat. *Seven Life Lessons of Chaos.* New York: HarperCollins, 1999.

Bronowski, Jacob. *The Ascent of Man.* Boston: Little, Brown, 1973.

Bruhn, Mark J. "Romanticism and the Cognitive Science of Imagination." *Studies in Romanticism* 48, no. 4 (2009): 543–564.

Burton, Judith, Robert Horowitz, and Hal Abeles. "Learning in and through the Arts: Curriculum Implications." In *Champions of Change: The Impact of the Arts on Learning,* edited by Edward B. Fiske. Washington, DC: Arts Education Partnership, President's Committee on the Arts and Humanities, 1999. Available at http://artsedge.kennedy-center.org/champions/pdfs/ChampsReport.pdf.

———. *Learning in and through the Arts: Transfer and Higher Order Thinking.* New York: Center for Arts Education Research, Teachers College, Columbia University, 1999.

———. "Learning in and through the Arts: The Question of Transfer." *Studies in Art Education* 41, no. 3 (2000): 228–257.

Calvino, Italo. *Six Memos for the Next Millennium*. New York: Vintage International, 1993.

Campbell, Joseph. *The Hero with a Thousand Faces*. 2nd ed. Princeton, NJ: Princeton University Press, 1972.

Carey, Benedict. "Tracing the Spark of Creative Problem-Solving," *New York Times,* 7 December 2010, D2.

Carle, Eric. *The Very Hungry Caterpillar.* 1969. New York: Philomel Books, 1987.

Carrier, David. *The Aesthetics of Comics*. University Park: Pennsylvania State University Press, 2000.

Carroll, Lewis. *Alice in Wonderland and Through the Looking Glass*. New York: Grosset and Dunlap, 1946.

Carse, James P. *Finite and Infinite Games*. New York: Free Press, 1986.

Carter, James Bucky, ed. *Building Literacy Connections with Graphic Novels: Page by Page, Panel by Panel*. Urbana, IL: National Council of Teachers of English, 2007.

Cavafy, Constantine P. *What These Ithakas Mean: Readings in Cavafy.* Edited by Artemis Leontis, Lauren E. Talalay, and Keith Taylor. Athens: Hellenic Literary and Historical Archive, 2002.

Chute, Hillary. "History and Graphic Representation in *Maus.*" In Heer and Worcester, *A Comics Studies Reader.*

Clandinin, D. Jean, and F. Michael Connelly. *Narrative Inquiry: Experience and Story in Qualitative Research*. San Francisco: Jossey-Bass, 2000.

Condorcet, Marie Jean Antoine Nicolas de Caritat, Marquis de. *Outlines of an Historical View of the Progress of the Human Mind*. Translated from the French. Philadelphia: Lang and Ustick, 1796.

Connelly, F. Michael, and D. Jean Clandinin. "Stories of Experience and Narrative Inquiry." *Educational Researcher* 19, no. 5 (1990): 2–14.

Critchley, Simon. "The Dangers of Certainty: Lessons from Auschwitz," *New York Times,* Opinionator: opinion pages online, 2 February 2014. Available at http://opinionator.blogs.nytimes.com/2014/02/02/the-dangers-of-certainty/.

Csikszentmihalyi, Mihaly. *Flow: The Psychology of Optimal Experience.* New York: Harper Perennial, 1991.

Daniel, E. Valentine. *Fluid Signs: Being a Person the Tamil Way.* Berkeley: University of California Press, 1984.

Davidson, Cathy N. *Now You See It: How the Brain Science of Attention Will Transform the Way We Live, Work, and Learn.* New York: Viking, 2011.

Davies, Jamie A. *Life Unfolding: How the Human Body Creates Itself.* New York: Oxford University Press, 2014.

Davis, Whitney. *Replications: Archaeology, Art History, Psychoanalysis.* University Park: Pennsylvania State University Press, 1996.

De Bono, Edward. *Lateral Thinking: Creativity Step by Step.* New York: Harper and Row, 1970.

Debord, Guy. "Writings from the Situationist International (1957–1961)." In *Art in Theory, 1900–1990: An Anthology of Changing Ideas,* edited by Charles Harrison and Paul Wood. Oxford: Blackwell, 1992.

De Lange, Catherine. "Bilingual Brain Boost: Two Tongues, Two Minds." *New Scientist* 214, no. 2863 (2012): 30–33.

Deleuze, Gilles, and Félix Guattari. *A Thousand Plateaus: Capitalism and Schizophrenia.* Minneapolis: University of Minnesota Press, 1987.

Denzin, Norman K., and Yvonna S. Lincoln, eds. *The Qualitative Inquiry Reader.* Thousand Oaks, CA: Sage, 2002.

Descartes, René. *Discourse on Method, Optics, Geometry, and Meteorology.* 1637. Translated by Paul J. Olscamp, rev. ed. Indianapolis: Hackett, 2001.

Dewey, John. *Art as Experience.* 1934. Reprint, New York: Perigee Books, 2005.

———. *Democracy and Education: An Introduction to the Philosophy of Education.* 1916. Reprint, New York: Free Press, 1966.

———. *Experience and Education.* 1938. Reprint, New York: Collier Books, 1963.

———. *The Public and Its Problems.* 1927. Reprint, Athens, OH: Swallow Press, 1954.

Dillard, Annie. *Pilgrim at Tinker Creek*. 1974. Reprint, New York: Harper Perennial Modern Classics, 2007.

Doxiadis, Apostolos, and Christos Harilaos Papadimitriou. *Logicomix: An Epic Search for Truth*. Art by Alecos Papadatos. Color by Annie Di Donna. New York: Bloomsbury Publishing, 2009.

Dreyfuss, Simeon. "Something Essential about Interdisciplinary Thinking." *Issues in Integrative Studies,* No. 29 (2011): 67–83.

Duckworth, Eleanor. *"The Having of Wonderful Ideas" and Other Essays on Teaching and Learning*. 3rd ed. New York: Teachers College Press, 2006.

Duncan, Randy, and Matthew J. Smith. *The Power of Comics: History, Form, and Culture*. New York: Continuum, 2009.

Eisner, Will. *Comics and Sequential Art*. Tamarac, FL: Poorhouse Press, 1985.

———. *A Contract with God and Other Tenement Stories*. 1978. Reprint, New York: W. W. Norton, 2006.

Elkins, James. *The Poetics of Perspective*. Ithaca: Cornell University Press, 1994.

Ellis, Eugenia Victoria. "Learning to Forget: Architectural Recreation, Spatial Visualization and Imaging the Unseen." *Architectural Theory Review* 5, no. 2 (2000): 44–60.

Farthing, Stephen. "The Bigger Picture of Drawing." In Kantrowitz, Brew, and Fava, *Thinking through Drawing*.

Fauconnier, Gilles, and Mark Turner. "Conceptual Integration Networks." *Cognitive Science* 22, no. 2 (1998): 133–187.

———. *The Way We Think: Conceptual Blending and the Mind's Hidden Complexities*. New York: Basic Books, 2002.

Fish, Jonathan, and Stephen Scrivener. "Amplifying the Mind's Eye: Sketching and Visual Cognition." *Leonardo* 23, no. 1 (1990): 117–126.

Fitch, Doug. "Drawing from Drawing." In Kantrowitz, Brew, and Fava, *Thinking through Drawing*.

Flink, James J. *The Car Culture*. Cambridge, MA: MIT Press, 1975.

Fracasso, Alessio, Alfonso Caramazza, and David Melcher. "Continuous Perception of Motion and Shape across Saccadic Eye Movements." *Journal of Vision* 10, no. 13 (2010): 1–17.

Freire, Paulo. *Pedagogy of the Oppressed*. Translated by Myra Bergman Ramos. 30th anniv. ed. New York: Continuum Publishing, 2000.

Gardner, Howard. *Creating Minds*. New York: Basic Books, 1993.

———. *Intelligence Reframed: Multiple Intelligences for the 21st Century*. New York: Basic Books, 1999.

Geary, James. *I Is an Other: The Secret Life of Metaphor*. New York: HarperCollins, 2011.

Ghiselin, Brewster, ed. *The Creative Process: A Symposium*. Mentor Book. New York: New American Library, 1952.

Gibran, Kahlil. *The Prophet*. New York: Alfred A. Knopf, 1923.

———. *Sand and Foam: A Book of Aphorisms*. New York: Alfred A. Knopf, 1926.

Gibson, James J. *The Perception of the Visual World*. Boston: Houghton Mifflin, 1950. Reprint, Westport, CT: Greenwood Press, 1974.

———. *The Senses Considered as Perceptual Systems*. Boston: Houghton Mifflin, 1966. Reprint, Westport, CT: Greenwood Press, 1983.

Goble, Ryan R., and Nick Sousanis. "A Different Kind of Diversity: Collaboration across Content Areas Intensifies Learning." *Journal of Staff Development* 31, no. 5 (2010): 34–37.

Goel, Vinod. *Sketches of Thought*. Cambridge, MA: MIT Press, 1995.

Gombrich, Ernst H. *Art and Illusion: A Study of the Psychology of Pictorial Representation*. New York: Pantheon, 1960. Millennium ed., with new preface, Princeton, NJ: Princeton University Press, 2000.

Goodman, Nelson. *Languages of Art: An Approach to the Theory of Symbols*. 2nd ed. Indianapolis: Hackett, 1976.

———. *Ways of Worldmaking*. Indianapolis: Hackett, 1978.

Gopnik, Adam. "Moon Man: What Galileo Saw," *New Yorker*, 11 February 2013.

Gottschall, Jonathan. *The Storytelling Animal: How Stories Make Us Human.* Boston: Houghton Mifflin Harcourt, 2012.

Gravett, Paul. *Graphic Novels: Everything You Need to Know.* New York: Collins Design, 2005.

Greene, Maxine. *The Dialectic of Freedom.* New York: Teachers College Press, 1998.

———. *Releasing the Imagination: Essays on Education, the Arts, and Social Change.* San Francisco: Jossey-Bass, 1995.

———. "The Spaces of Aesthetic Education." *Journal of Aesthetic Education* 20, no. 4 (1986): 56–62.

———. *Teacher as Stranger: Educational Philosophy for the Modern Age.* Belmont, CA: Wadsworth, 1973.

———. "What Happened to Imagination?" Unpublished manuscript, Teachers College, Columbia University, c. 1990.

———. "Wide-Awakeness in Dark Times." *Educational Perspectives* 21, no. 1 (1982): 6–13.

Groensteen, Thierry. *The System of Comics.* Translated by Bart Beaty and Nick Nguyen. Jackson: University Press of Mississippi, 2007.

Hadamard, Jacques. *The Mathematician's Mind: The Psychology of Invention in the Mathematical Field.* 1945. With a new preface by P. N. Johnson-Laird. Princeton, NJ: Princeton University Press, 1996.

Hajdu, David. *The Ten-Cent Plague: The Great Comic-Book Scare and How It Changed America.* New York: Farrar, Straus and Giroux, 2008.

Hampe, Beate, ed. *From Perception to Meaning: Image Schemas in Cognitive Linguistics.* New York: Mouton de Gruyter, 2005.

Hansen, David T., ed. *John Dewey and Our Educational Prospect.* Albany: State University of New York Press, 2006.

Harvey, Robert C. "The Aesthetics of the Comic Strip." *Journal of Popular Culture* 12, no. 4 (1979): 640–652.

———. *The Art of the Comic Book: An Aesthetic History.* Jackson: University Press of Mississippi, 1996.

Hatfield, Charles. "An Art of Tensions." In Heer and Worcester, *A Comics Studies Reader.*

Hayakawa, Samuel Ichiye. "The Revision of Vision" (introductory essay). In Kepes, *Language of Vision.*

Heer, Jeet, and Kent Worcester, eds. *A Comics Studies Reader.* Jackson: University of Mississippi Press, 2009.

Hoffman, Donald D. *Visual Intelligence: How We Create What We See.* New York: W. W. Norton, 1998.

Hofstadter, Douglas, and Emmanuel Sander. "Analogy: The Vital Talent that Fuels Our Minds," *New Scientist* 218, no. 2915 (2013): 30–33.

Hogben, Lancelot. *From Cave Painting to Comic Strip: A Kaleidoscope of Human Communication.* London: Max Parrish, 1949.

Horkheimer, Max, and Theodor W. Adorno. *Dialectic of Enlightenment: Philosophical Fragments.* Edited by G. S. Noerr. Translated by E. Jephcott. Stanford, CA: Stanford University Press, 2002.

Illich, Ivan. *Deschooling Society.* London: Marion Boyars, 1972.

Iser, Wolfgang. *The Fictive and the Imaginary: Charting Literary Anthropology.* Baltimore: Johns Hopkins University Press, 1993.

Jackson, Naomi. "Goethe's Drawings." *Germanic Museum Bulletin* 1, no. 7/8 (1938): 41–43, 45–62.

Jackson, Philip W. *John Dewey and the Philosopher's Task.* New York: Teachers College Press, 2002.

James, William. "What Pragmatism Means." In *Pragmatism: A New Name for Some Old Ways of Thinking.* New York: Longmans, Green, 1907.

Jay, Martin. *Downcast Eyes: The Denigration of Vision in Twentieth-Century French Thought.* Berkeley: University of California Press, 1994.

Jensen, Derrick. *Walking on Water: Reading, Writing, and Revolution.* White River Junction, VT: Chelsea Green, 2004.

Jewitt, Carey. *The Visual in Learning and Creativity: A Review of the Literature.* London: Arts Council England, Creative Partnerships, 2008. Available at http://www.creativitycultureeducation.org/wp-content/uploads/the-visual-in-learning-and-creativity-92.pdf.

————, and Gunther Kress, eds. *Multimodal Literacy*. New York: Peter Lang, 2003.

Johnson, Mark L. *The Body in the Mind: The Bodily Basis of Meaning, Imagination, and Reason*. Chicago: University of Chicago Press, 1987.

Joyce, James. *Ulysses*. New York: Random House, 1934.

Kantrowitz, Andrea. "Drawn to Discover: A Cognitive Perspective," *TRACEY* (Design Research Network open-access journal), 2012. Available at http://www.academia.edu/1593263/Drawn_to_Discover_a_cognitive_perspective.

————. "The Man Behind the Curtain: What Cognitive Science Reveals about Drawing." *Journal of Aesthetic Education* 46, no. 1 (2012): 1–14.

————, Angela Brew, and Michelle Fava, eds. *Thinking through Drawing: Practice into Knowledge*. New York: Teachers College, Columbia University, Art and Art Education Program, 2011.

Karasik, Paul, and David Mazzucchelli. *Paul Auster's* City of Glass: *Script Adaptation*. Neon Lit. New York: Avon Books, 1994.

Kellner, Douglas. "Introduction to the Second Edition." In Marcuse, *One-Dimensional Man*.

Kepes, György. *Language of Vision*. Chicago: P. Theobald, 1944. Reprint, New York: Dover Books, 1995.

Kirsh, David. "Using Sketching: To Think, To Recognize, To Learn." In Kantrowitz, Brew, and Fava, *Thinking through Drawing*.

Kisida, Brian, Jay P. Greene, and Daniel H. Bowen. "Art Makes You Smart," op-ed, *New York Times,* 24 November 2013, SR12.

Klein, Julie Thompson. *Interdisciplinarity: History, Theory, and Practice*. Detroit: Wayne State University Press, 1990.

Kockelman, Paul. "A Semiotic Ontology of the Commodity." *Journal of Linguistic Anthropology* 16, no. 1 (2006): 76–102.

Koestler, Arthur. *The Sleepwalkers: A History of Man's Changing Vision of the Universe*. 1959. Universal Library 159. New York: Grosset and Dunlap, 1963.

Kosslyn, Stephen M., William L. Thompson, and Giorgio Ganis. *The Case for Mental Imagery.* New York: Oxford University Press, 2006.

Kourtzi, Zoe, and Nancy Kanwisher. "Representation of Perceived Object Shape by the Human Lateral Occipital Complex." *Science* 293, no. 5534 (2001): 1506–1509.

Kress, Gunther. *Multimodality: A Social Semiotic Approach to Contemporary Communication.* London: Routledge, 2010.

———, Carey Jewitt, Jon Ogborn, and Charalampos Tsatsarelis. *Multimodal Teaching and Learning: The Rhetorics of the Science Classroom.* London: Continuum Publishing, 2001.

———, and Theo van Leeuwen. *Reading Images: The Grammar of Visual Design.* London: Routledge, 1996.

Kuhn, Oliver. "Polynesian Navigation." *CSEG* (Canadian Society of Exploration Geophysicists) *Recorder* 33, no. 7 (2008): 58–63. Available at http://csegrecorder.com/features/view/science-break-200809.

Lake, Robert, ed. *Dear Maxine: Letters from an Unfinished Conversation.* New York: Teachers College Press, 2010.

Lakoff, George. "The Death of Dead Metaphor." *Metaphor and Symbolic Activity* 2, no. 2 (1987): 143–147.

———. "Image Metaphors." *Metaphor and Symbolic Activity* 2, no. 3 (1987): 219–222.

———, and Mark Johnson. *Metaphors We Live By.* Chicago: University of Chicago Press, 1980.

———, and Mark Johnson. *Philosophy in the Flesh: The Embodied Mind and Its Challenge to Western Thought.* New York: Basic Books, 1999.

———, and Rafael E. Núñez. *Where Mathematics Comes From: How the Embodied Mind Brings Mathematics into Being.* New York: Basic Books, 2000.

Langer, Susanne K. *Philosophical Sketches.* Baltimore: Johns Hopkins Press, 1962. Reprint, New York: Barnes and Noble, 2009.

———. *Philosophy in a New Key: A Study in the Symbolism of Reason, Rite, and Art.* 3rd ed. Cambridge, MA: Harvard University Press, 1957.

Latour, Bruno. *Politics of Nature: How to Bring the Sciences into Democracy.* Translated by Catherine Porter. Cambridge, MA: Harvard University Press, 2004.

———. *Reassembling the Social: An Introduction to Actor-Network-Theory.* Oxford: Oxford University Press, 2005.

Lewis, David. *Reading Contemporary Picturebooks: Picturing Text.* London: Routledge Falmer, 2001.

Lisieska, Mike. "The Octopus Visual System." Cephalove blog, posted 31 May 2010, available at http://cephalove.blogspot.com/2010/05/octopus-visual-system.html.

Liszka, James Jakób. *A General Introduction to the Semeiotic of Charles Sanders Peirce.* Bloomington: Indiana University Press, 1996.

Livingstone, Margaret. *Vision and Art: The Biology of Seeing.* New York: Harry N. Abrams, 2002.

Lockhart, Paul. *A Mathematician's Lament.* New York: Bellevue Literary Press, 2009.

Lyotard, Jean-François. *The Postmodern Condition: A Report on Knowledge.* Translated by Geoff Bennington and Brian Massumi. Minneapolis: University of Minnesota Press, 1984.

Madden, Matt. *99 Ways to Tell a Story: Exercises in Style.* New York: Chamberlain Bros., 2005.

Mandelbrot, Benoît B. *The Fractal Geometry of Nature.* San Francisco: Freeman, 1983.

Marcuse, Herbert. *One-Dimensional Man: Studies in the Ideology of Advanced Industrial Society.* 2nd ed. Boston: Beacon Press, 1991.

May, Rollo. *The Courage to Create.* New York: Norton, 1975.

Mazzucchelli, David. *Asterios Polyp.* New York: Pantheon Books, 2009.

McClintock, Robbie. *Homeless in the House of Intellect: Formative Justice and Education as an Academic Study.* New York: Laboratory for Liberal Learning, Columbia University, 2005.

McCloud, Scott. *Making Comics: Storytelling Secrets of Comics, Manga and Graphic Novels*. New York: Harper, 2006.

———. *Understanding Comics: The Invisible Art*. Northampton, MA: Tundra, 1993.

McGilchrist, Iain. *The Master and His Emissary: The Divided Brain and the Making of the Western World*. New Haven, CT: Yale University Press, 2010.

McGuire, Michael. *An Eye for Fractals: A Graphic and Photographic Essay*. Redwood City, CA: Addison-Wesley, 1991.

McLuhan, Marshall, and Quentin Fiore. *The Medium Is the Massage*. New York: Random House, 1967.

Mead, George Herbert. "The Genesis of the Self and Social Control." *International Journal of Ethics* 35, no. 3 (1925): 251–277.

Melnick, Michael D., Bryan R. Harrison, Sohee Park, Loisa Bennetto, and Duje Tadin. "A Strong Interactive Link between Sensory Discriminations and Intelligence." *Current Biology* 23, no. 11 (2013): 1013–1017.

Merleau-Ponty, Maurice. *The Phenomenology of Perception*. Translated by Colin Smith. London: Routledge and Kegan Paul, 1962. Reprint, London: Routledge, 2002.

———. *The Primacy of Perception*. Edited and with an introduction by James M. Edie. Evanston, IL: Northwestern University Press, 1964.

Miller, Ann. *Reading Bande Dessinée: Critical Approaches to French-Language Comic Strip*. Chicago: Intellect Books, 2007.

Miller, Frank. *Batman: The Dark Knight Returns*. Inks and colors by Klaus Jansen and Lynn Varley. New York: DC Comics, 1986. Reprint, 10th anniv. ed., New York: DC Comics, 1996.

Miller, Paul D. [DJ Spooky That Subliminal Kid]. *Rhythm Science*. Cambridge, MA: Mediawork/MIT Press, 2004.

Moffett, Chris. "The Big Toe: A Constrained History of Tight Footwear." Slide presentation, posted 19 June 2013. Available at http://prezi.com/bp3fpzpztmuc/the-big-toes/.

———. "Drawing Bodies: A Kinaesthetics of Attention." In Kantrowitz, Brew, and Fava, *Thinking through Drawing*.

Monnin, Katie. *Teaching Graphic Novels: Practical Strategies for the Secondary ELA Classroom*. Gainesville, FL: Maupin House, 2010.

Moore, Alan. *Watchmen*. Illustrations and lettering by Dave Gibbons. Colorist John Higgins. New York: DC Comics, 1987.

Moore, Michael G. "Drawing Drawings." In Kantrowitz, Brew, and Fava, *Thinking through Drawing*.

Mumford, Lewis. *The Myth of the Machine*. 2 vols. New York: Harcourt, Brace and World, 1967, 1970.

Murdoch, Iris. *The Fire and the Sun: Why Plato Banished the Artists*. Oxford: Clarendon Press, 1977.

Nodelman, Perry. "Picture Book Guy Looks at Comics: Structural Differences in Two Kinds of Visual Narrative." *Children's Literature Association Quarterly* 37, no. 4 (2012): 436–444.

Noë, Alva. *Action in Perception*. Cambridge, MA: MIT Press, 2004.

Oskin, Becky. "Bringing It All Together." *New Scientist* 203, no. 2717 (2009): 48–49.

Owens, Craig. "The Allegorical Impulse: Towards a Theory of Postmodernism" (1980, excerpt). In *Art in Theory 1900–1990*, edited by Charles Harrison and Paul Wood. Oxford: Blackwell, 1992.

Peak, David, and Michael Frame. *Chaos under Control: The Art and Science of Complexity*. New York: W. H. Freeman, 1994.

Peitgen, Heinz-Otto, Hartmut Jürgens, and Dietmar Saupe. *Chaos and Fractals: New Frontiers of Science*. New York: Springer-Verlag, 1992.

Pelaprat, Etienne, and Michael Cole. "'Minding the Gap': Imagination, Creativity, and Human Cognition." *Integrative Psychological and Behavioral Science* 45, no. 4 (2011): 397–418.

Pentland, Alex. "The Death of Individuality." *New Scientist* 221, no. 2963 (2014): 30–31.

Pilcher, Helen. "How Flower Power Paved the Way for Our Evolution." *New Scientist* 218, no. 2912 (2013): 42–45.

Pratt, Caroline. *I Learn from Children: An Adventure in Progressive Education.* New York: Simon and Schuster, 1948.

Rancière, Jacques. *The Ignorant Schoolmaster: Five Lessons in Intellectual Emancipation.* Translated by Kristin Ross. Stanford, CA: Stanford University Press, 1991.

Repko, Allen F. *Interdisciplinary Research: Process and Theory.* Thousand Oaks, CA: Sage, 2008.

Riello, Giorgio, and Peter McNeil. "Footprints of History." *History Today* 57, no. 3 (2007): 30–36.

Robinson, Ken. *Out of Our Minds: Learning to Be Creative.* Oxford: Capstone, 2001.

Robson, David. "The Story in the Stones." *New Scientist* 221, no. 2958 (2014): 34–39.

———. "What's in a Name? The Words behind Thought." *New Scientist* 207, no. 2776 (2010): 30–33.

Root-Bernstein, Robert S. "Creative Process as a Unifying Theme of Human Cultures." *Daedalus* 113, no. 3 (1984): 197–219.

———. *Discovering.* Cambridge, MA: Harvard University Press, 1989.

———. "On Paradigms and Revolutions in Science and Art: The Challenge of Interpretation." *Art Journal* 44, no. 2 (1984): 109–118.

———. "Visual Thinking: The Art of Imagining Reality." *Transactions of the American Philosophical Society* n.s. 75, no. 6 (1985): 50–67.

———. "Problem Generation and Innovation." In *The International Handbook on Innovation,* edited by L. V. Shavinina. Oxford: Pergamon, 2003.

Rosand, David. *Drawing Acts: Studies in Graphic Expression and Representation.* Cambridge: Cambridge University Press, 2002.

Sacco, Joe. *Palestine.* Seattle: Fantagraphic Books, 2001.

Saint-Exupéry, Antoine de. *The Little Prince.* 1943. New York: Harcourt, Brace and World, 1971.

Saliba, George. "Rethinking the Roots of Modern Science: Arabic Scientific Manuscripts in European Libraries." Occasional paper, Center for Contemporary Arab Studies, Edmund A. Walsh School of Foreign Service, Georgetown University, Washington, DC, 1999.

Satrapi, Marjane. *The Complete Persepolis.* New York: Pantheon Books, 2007.

Sattler, Peter R. "Past Imperfect: 'Building Stories' and the Art of Memory." In Ball and Kuhlman, *The Comics of Chris Ware.*

Schumpeter, Joseph Alois. *Capitalism, Socialism and Democracy.* 1942. Reprint, New York: Harper Perennial, 1976.

Shlain, Leonard. *Art and Physics: Parallel Visions in Space, Time, and Light.* New York: Morrow, 1991.

Simmel, Georg. *The Conflict in Modern Culture, and Other Essays.* Translated by K. P. Etzkorn. New York: Teachers College Press, 1968.

Snow, C. P. *The Two Cultures.* 1964. Cambridge: Cambridge University Press, 1993.

Solnit, Rebecca. *A Field Guide to Getting Lost.* New York: Viking, 2005.

Sousanis, Anne. "We All Live in an Open House," *Kingsbury School Newsletter.* Oxford, MI: Kingsbury School, Spring 1987.

Sousanis, Nick. "Mind the Gaps." In Vinz and Schaafsma, *On Narrative Inquiry.*

———. "The Shape of Our Thoughts: A Meditation On and In Comics." *Visual Arts Research* 38, no. 1 (2012): 1–10.

Spennemann, Dirk H. R. "Traditional and Nineteenth Century Communication Patterns in the Marshall Islands." *Micronesian Journal of the Humanities and Social Sciences* 4, no. 1 (2005): 25–52.

Spiegelman, Art. *Maus: A Survivor's Tale.* New York: Pantheon Books, 1997.

———. *Metamaus.* New York: Pantheon Books, 2011.

Stafford, Barbara Maria. *Visual Analogy: Consciousness as the Art of Connecting.* Cambridge, MA: MIT Press, 1999.

Steinhart, Peter. *The Undressed Art: Why We Draw.* New York: Alfred A. Knopf, 2004.

Strongman, Luke. "'When Earth and Sky Almost Meet': The Conflict between Traditional Knowledge and Modernity in Polynesian Navigation." *Journal of World Anthropology: Occasional Papers* 3, no. 2 (2008): 48–110.

Sullivan, Graeme L. *Art Practice as Research: Inquiry in the Visual Arts.* 2nd ed. Thousand Oaks, CA: Sage, 2010.

Sundstrom, Lynne. "A Scroll to the Editor: We Love to Read!" *New York Times* (online), 13 April 2011. Available at http://www.nytimes.com/2011/04/14/opinion/l14scroll.html.

Suwa, Masaki, and Barbara Tversky. "Constructive Perception in Design." In *Computational and Cognitive Models of Creative Design V,* edited by John S. Gero and M. L. Maher. Sydney: University of Sydney, 2001.

———. "What Do Architects and Students Perceive in Their Design Sketches? A Protocol Analysis." *Design Studies* 18 (1997): 385–403.

———, John Gero, and Terry Purcell. "Seeing into Sketches: Regrouping Parts Encourages New Interpretations." In *Visual and Spatial Reasoning in Design II,* edited by John Gero, Barbara Tversky, and Terry Purcell. Key Centre of Design Computing, University of Sydney, 2001.

Tagore, Rabindranath. *A Tagore Reader.* Edited by Amiya Chakravarty. Boston: Beacon Press, 1966.

Thomas, Paul L. *Challenging Genres: Comics and Graphic Novels.* Rotterdam: Sense, 2010.

Thompson, Matt. Review of *Freedom in Entangled Worlds,* by Eben Kirksey, Savage Minds group blog, posted 11 June 2012, available at http://savageminds.org/2012/06/11/book-review-freedom-in-entangled-worlds-by-eben-kirksey/.

Tufte, Edward R. *Envisioning Information.* Cheshire, CT: Graphics Press, 1990.

Tversky, Barbara. "Obsessed by Lines." In Kantrowitz, Brew, and Fava, *Thinking through Drawing.*

Versaci, Rocco. *This Book Contains Graphic Language: Comics as Literature.* New York: Continuum, 2007.

Vinz, Ruth, and David Schaafsma. *On Narrative Inquiry: Approaches to Language and Literacy Research.* New York: Teachers College Press, 2011.

Vygotsky, Lev. *Mind in Society: The Development of Higher Psychological Processes.* Edited by M. Cole, V. John-Steiner, S. Scribner, and E. Souberman. Cambridge, MA: Harvard University Press, 1978.

———. *Thought and Language.* Translation revised and edited by A. Kozulin. Cambridge, MA: MIT Press, 1986.

Ware, Chris. *Jimmy Corrigan: The Smartest Kid on Earth.* New York: Pantheon Books, 2000.

Ware, Colin. *Visual Thinking for Design.* Burlington, MA: Morgan Kaufmann, 2008.

Welch, James J. "The Emergence of Interdisciplinarity from Epistemological Thought." *Issues in Integrative Studies* 29 (2011): 1–39.

Whipple, Mark. "The Dewey-Lippmann Debate Today: Communication Distortions, Reflective Agency, and Participatory Democracy." *Sociological Theory* 23, no. 2 (2005): 156–178.

Williams, Caroline. "Crittervision: What a Dog's Nose Knows." *New Scientist* 211, no. 2826 (2011): 36–37. Available at http://www.newscientist.com/article/mg21128262.000-crittervision-what-a-dogs-nose-knows.html.

Wilson, Edward O. *Consilience: The Unity of Knowledge.* New York: Alfred A. Knopf, 1998.

Witek, Joseph, ed. *Art Spiegelman: Conversations.* Jackson: University Press of Mississippi, 2007.

Woo, Yen Yen Joyceln. "Engaging New Audiences: Translating Research into Popular Media." *Educational Researcher* 37, no. 6 (2008): 321–329.

Wood, James. *How Fiction Works.* New York: Picador, 2008.

———. "Why? The Fictions of Life and Death," *New Yorker,* 9 December 2013, 34–39.

Yarbus, Alfred L. *Eye Movements and Vision*. Translated by B. Haigh. New York: Plenum Press, 1967.

Zimmer, Carl. *Evolution: The Triumph of an Idea*. New York: Harper Perennial, 2006.

———. "Self-Destructive Behavior in Cells May Hold Key to a Longer Life," *New York Times*, 6 October 2009, D3.

Zukerman, Wendy. "How to Move the Brain with a Japanese Line Drawing." *New Scientist* 205, no. 2752 (2010): 15.

ACKNOWLEDGMENTS

We don't get where we're going alone.

A big thank you

To my advisors and dissertation committee for embracing unfamiliar territory: Professors Ruth Vinz, Robbie McClintock, Maxine Greene, and Mary Hafeli.

To Professor Graeme Sullivan and his wife Mary for their steadfast counsel even at a distance.

To Professors Judith Burton, Barbara Tversky, Yolanda Sealey-Ruiz, Lalitha Vasudevan, Olga Hubard, Sheridan Blau, and the late Frank Moretti.

To my mentors and friends Charles McGee and Professor Fred Goodman.

To the Provost's Doctoral Dissertation Grant, Teachers College, Columbia University.

To Vice Provost William Baldwin and Provost Thomas James.

To Rocky Schwarz and his team for dealing with my continual printing requests.

To Professor Cathy Davidson (and her HASTAC network) for championing this work.

To Donald Brinkman for supreme generosity in putting on an amazing exhibition of the work at Microsoft Research.

To my cohort Andrea Kantrowitz, Marta Cabral, Tara Thompson, Daiyu Suzuki, Razia Sadik, and co-conspirators Suzanne Choo and Ryan Goble.

To friends and collaborators Timothy K. Eatman, Adam Bush, Christy Blanch, Yen Yen Woo, Stergios Botzakis, Jarod Roselló, Marcus Weaver-Hightower, Brooke Sheridan, Matt Finch, Donald Blumenfeld-Jones, Bill Ayers, Jim Hall, Anastasia Salter, Adam Bessie, Jill A. Perry, Leigh Graves Wolf, Ben Bennett-Carpenter, Adrian Holme, Sharon Farb, Andrew

Wales, Paul Thomas, Susanne Beechey, Andy Malone, Matt Sikora, Sambuddha Saha, Andrew Butler, Adam McGovern, Remi Holden, Alexander Rothman, Andrea Tsurumi, Paul Hirsch, Louis Bury, Mike Rohde, Morna McDermott, Daniel Powell, Meg Lemke, and Natalya Rolbin.

To Leo Tarantino and Stephanie Huffaker, who read and responded to chapters as I finished them.

To Sydni Dunn and Nick DeSantis of *The Chronicle of Higher Education*, Katya Korableva of Russia's *Theory&Practice*, John O'Reilly of the UK's *Varoom Magazine*, Anthony Salcito for Microsoft's *Daily Edventures*, Maureen Bakis, Nate Matias, Hannah Means-Shannon, Patrick Cox, Chris Malmberg, and Brett Terpstra.

To the support of the Stanford Graphic Narrative Project and my colleagues, Angela Becerra Vidergar, Vanessa Chang, and Haerin Shin.

To Imagining America and the Association for Interdisciplinary Studies and the support of their individual members.

To my students at Teachers College, Parsons, Wayne State University, and on the tennis courts.

To Scott McCloud, David Small, Ben Katchor, Lynda Barry, Matt Madden, R. Sikoryak, Jim Ottaviani, Karen Green, Kent Worcester, Gene Kannenberg, Jr., Charles Hatfield, and the New York Comics and Picture-stories Symposium.

To my earliest comics collaborators Joe Jokinen, Matt Kaspari, Kyle Roberts, and Tim Newell.

To all the participants from around the world who shared their feet! Ruud & Maudi Cox, Hattie Kennedy, Damon Herd, Carly Piirainen Davis & family, Alyssa Niccolini, Linda Allen, Marta Cabral & anonymous, Sarah Chauncey, Paddy Johnston, Leigh Graves Wolf, A. David Lewis, J. Nathan Mattias, Devin Berg, Cathy Peet, Russell Willerton, Chris Moffett, Paul Tritter, Charles Shryock IV, Cathy Rosamond & Family, Adam Bush, Marcus Weaver-Hightower & family, Kathleen Moore, +M, Jennifer, Louis Bury, Rebecca Kuhlmann Taylor, Gray Evelyn Taylor, Remi Holden, Marcelle, Marcos, Tim, Steph, Anna Smith, Sharon Farb, Leslie M, Todd Grappone, Eliza Lamb, Donald Davenport, Vanessa Chang, Sean Kleefeld, Lauren Albert, Ivory Kris, Maggie Whitten, Kurt Hozak,

@cogdog, Edgar Castro, Ronelle Kallman, Sue Uhlig, Pedro Cabral, Adele Holoch & boys, Tracy Dawson & Parkes High School—NSW Australia, Elizabeth Branch Dyson, Samantha Cooper, Jesse Carbonaro, Tracy Scholz, Michael Hoffman, and Dean Sousanis.

To Russell Willerton and Everett Maroon, who pitched in on my sentence diagramming.

To Professor Bart Beaty and the University of Calgary Eyes High Postdoctoral Fellowship.

To the bestest editor ever Sharmila Sen and the entire team at Harvard University Press.

To my dear, departed dog Sledge whose ways of seeing run through this work.

To my brother Dan and my brother John, his wife, Autumn, and their growing family.

To my parents, Anne and Dean, educators in the best sense of the word.

And to my wife, Leah.

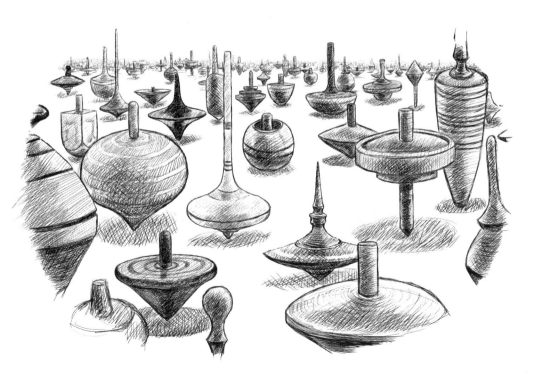

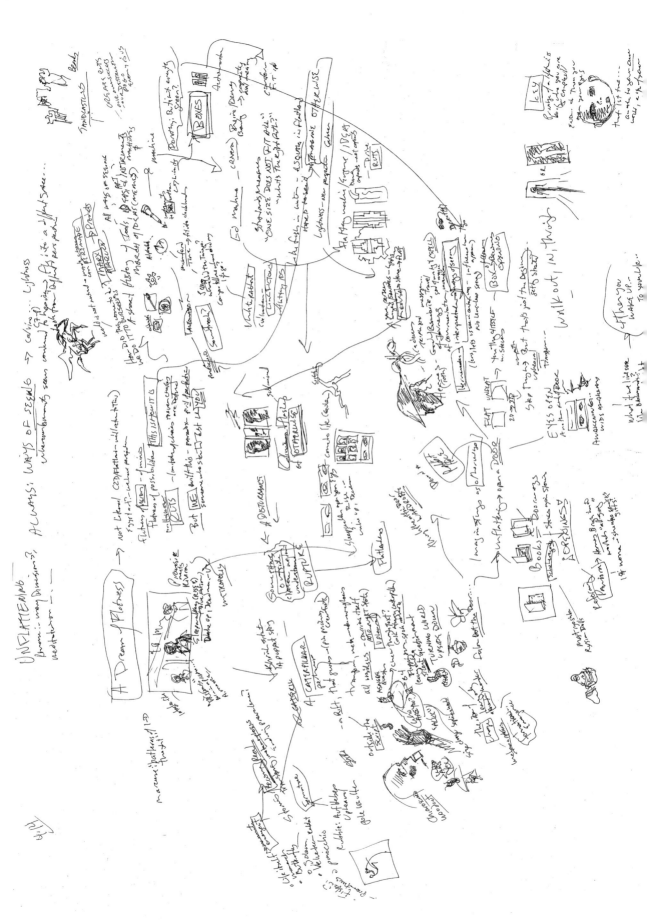

First idea map for *Unflattening*, April 14, 2011

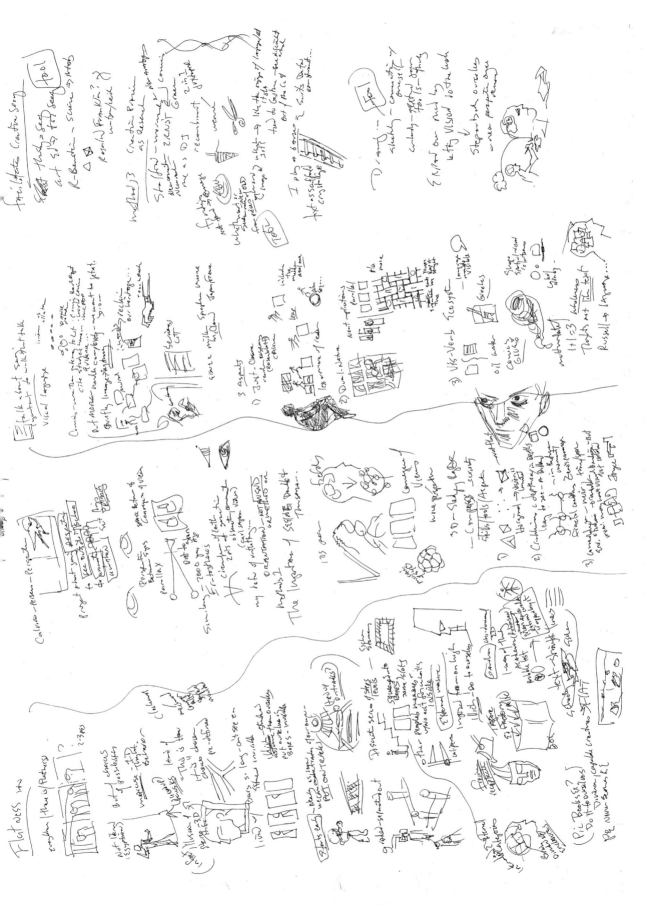

Initial working roadmap (part 1), January 20, 2012

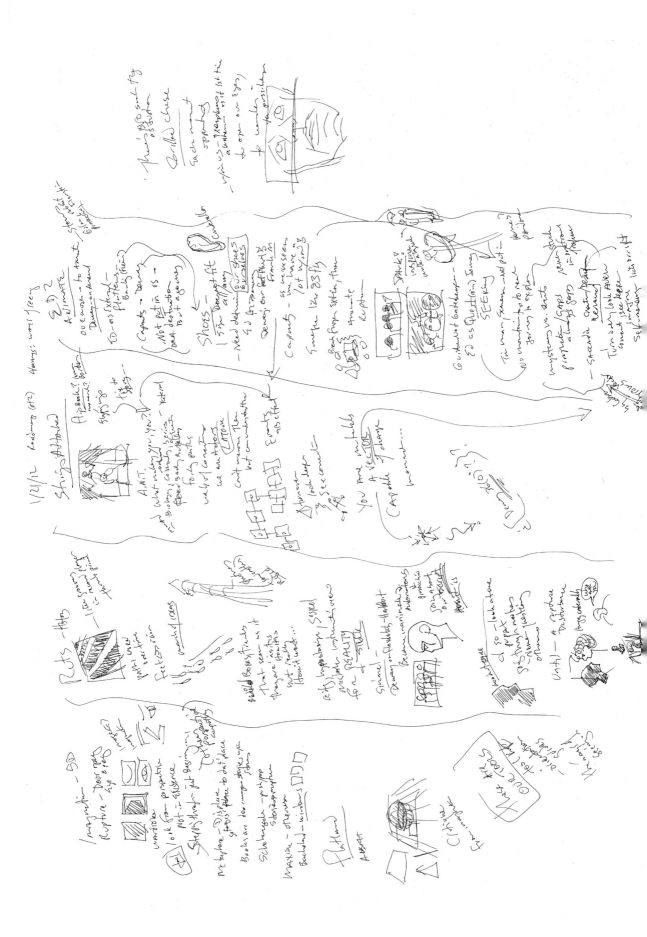

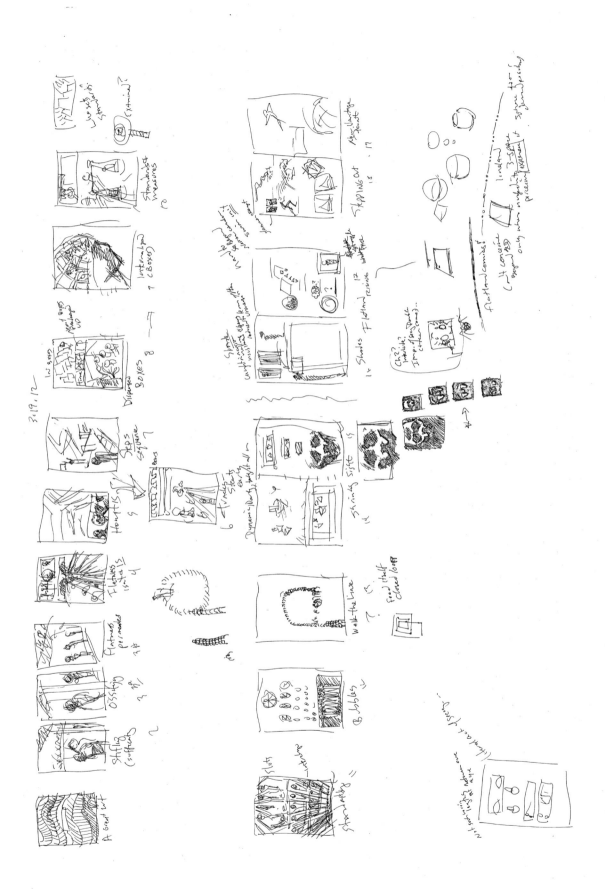

Roadmap (chapter 6), January 21, 2014